beginner's guide to digital painting in Photoshop:
characters

beginner's guide to digital painting in Photoshop:
characters

3DTOTAL**PUBLISHING**

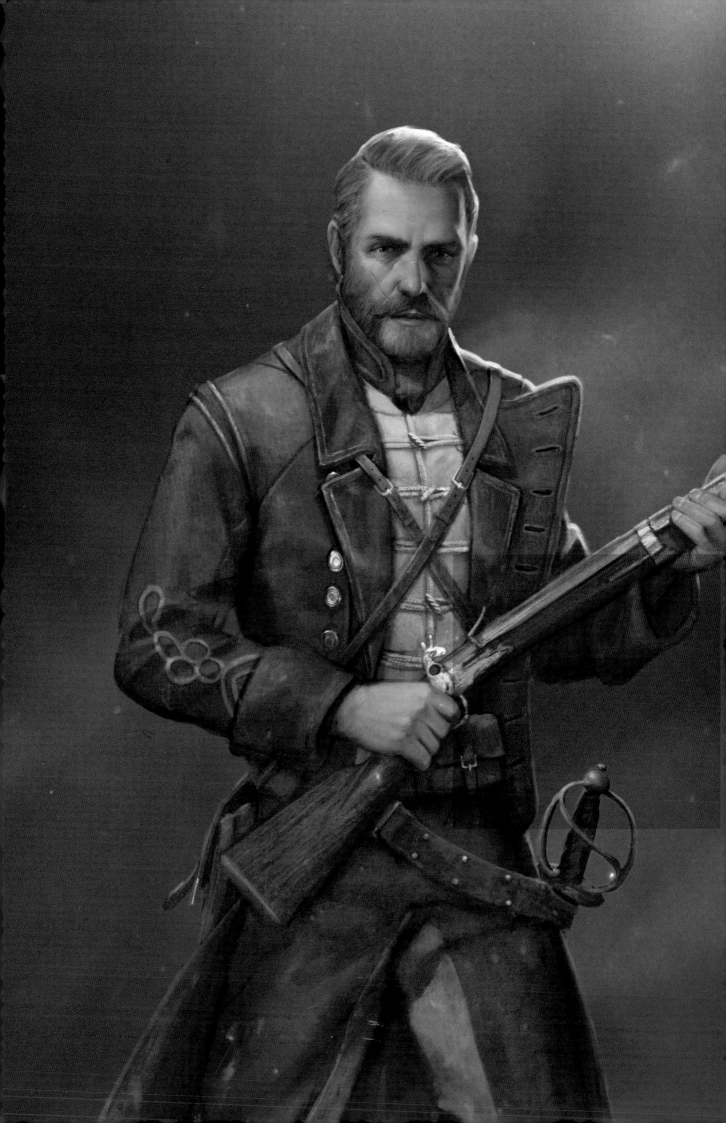

3DTOTAL PUBLISHING

Correspondence: publishing@3dtotal.com

Website: www.3dtotal.com

Every effort has been made to ensure the credits and contact information listed are
present and correct. In the case of any errors that have occurred,
the publisher respectfully directs readers to the
www.3dtotalpublishing.com website for any updated information and/or corrections.

First published in the United Kingdom, 2015, by 3dtotal Publishing.
3dtotal.com Ltd, 29 Foregate Street, Worcester WR1 1DS, United Kingdom.

Soft cover ISBN: 978-1-909414-14-3

Printing and binding: Everbest Printing (China)

www.everbest.com

Reprinted in 2016 by 3dtotal Publishing.

Visit **www.3dtotalpublishing.com** for a complete list of available book titles.

Deputy editor: Jess Serjent-Tipping

Proofreader: Melanie Smith

Lead designer: Imogen Williams

Cover design: Matthew Lewis

Designers: Matthew Lewis, Aryan Pishneshin

Managing editor: Lynette Clee

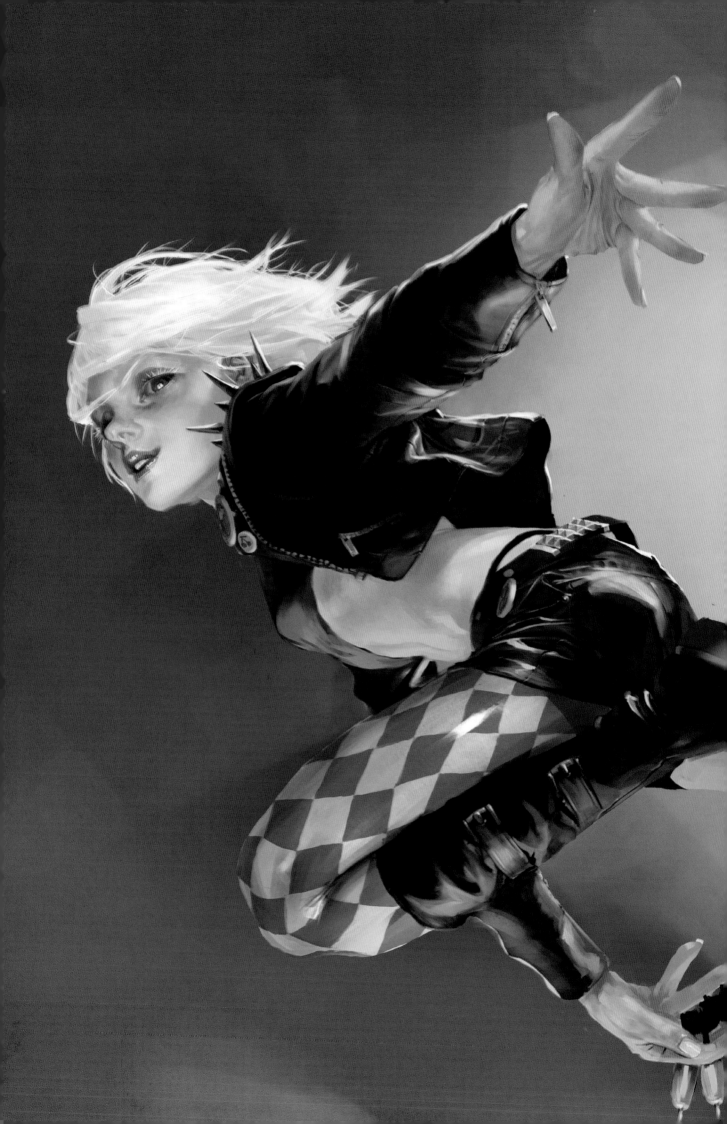

Contents

Introduction

The entertainment industry relies on the narrative pull and believability of a character, and that character starts its life in the hands of a concept artist. With a need for powerful and flexible tools to create these unique and refined character designs, the popular method of choice among concept artists in the industry is digital painting in Photoshop. Offering not only the advantages of ease and speed, but also the ability to dramatically alter the colors of your image and use custom brushes to create impressive and credible textures, it really is an extraordinary outlet in which to hone your creative skill set.

Browsing through the most impressive 2D character concepts online, as well as in books, films, and games, you will find a vast variety of designs in many different styles. So how do you begin to find the right style for you and put your ideas into practice? Figuring out the way your characters will look and act is definitely not an easy task. Shapes, colors, textures, and values are an

important part of character design, holding the power to dramatically change the mood, narrative, and those all-important elements that make a character recognizable.

To guide you through your creative learning, we have gathered a selection of skilled, professional digital artists to lead you through the fundamentals behind digitally painting characters. At the back of the book you'll find an invaluable glossary written by the brilliant Bram "Boco" Sels, covering all the essentials to get you started – plus you can refer back to it while reading through the more detailed project overviews that the book has to offer.

From setting up your interface and tools with characters in mind, to in-depth creative workflows packed full with top tips and advice, *Beginner's Guide to Digital Painting in Photoshop: Characters* provides a definitive resource for anyone on the path to becoming a digital character artist.

Jess Serjent-Tipping
Deputy Editor, 3dtotal Publishing

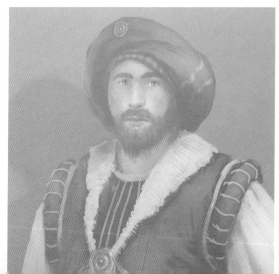

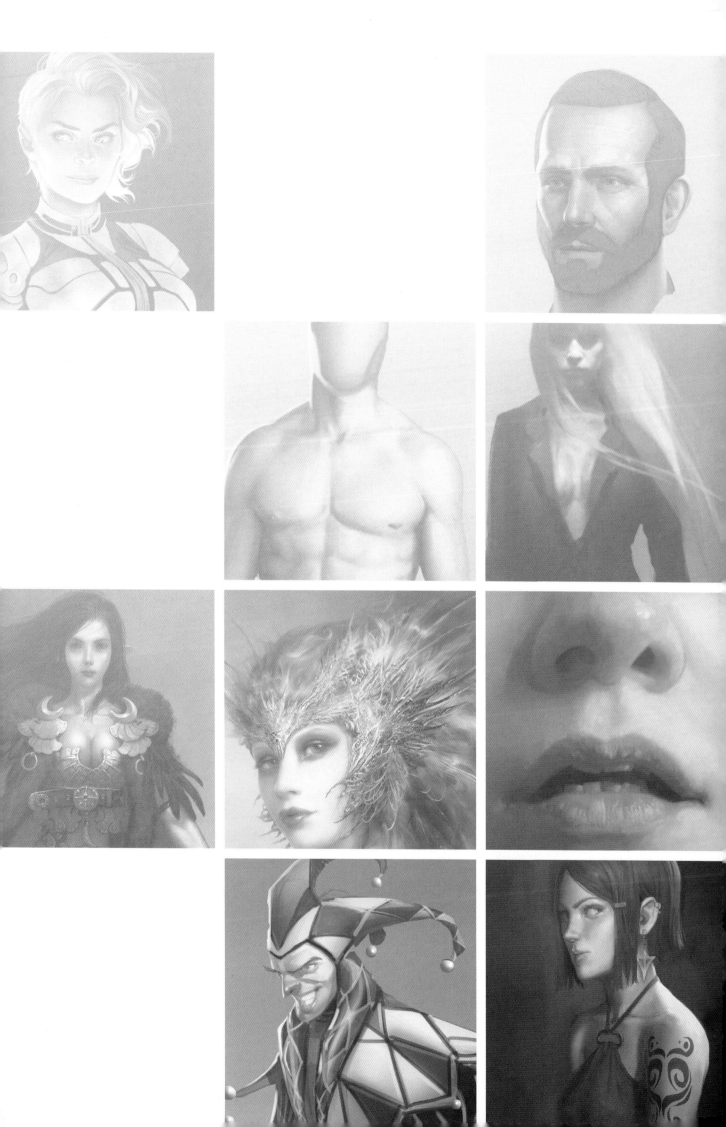

Getting started

**Find out how to successfully set up your
workspace and functions in Photoshop.**

Learning how to use Photoshop for character design can be
daunting. To get you setup and ready to start painting, Benita
Winckler will guide you through the features, tools, and useful
functions that will become a staple in your workflow. In this section,
Benita will give a breakdown on setting up your canvas and
layers ready for painting, overcoming a blank canvas, creating
your own brush library, and defining your color palette, all of
which will provide a solid foundation for the tutorials to come!

Setting up your canvas

How to prepare your workspace to start painting characters

by Benita Winckler

In this introductory chapter we will look at Photoshop CC and how to use it for character design. If you are a traditional artist (beginner-level or with some experience), but you have never really worked with the software before – perfect! You are in the right place.

Before we begin, let me say right away: Photoshop is a massive program. On first sight it can be a real beast (although a nice one). Mastering all of its powerful features up to the very last button will not happen overnight. We are in here for results though, right?

We'll start with a character that has already been developed and use it as an example to set up our document for the actual painting process. The next steps will give you a solid overview and foundation for the tutorials that will follow in this book. Here is what you'll need:

• basic knowledge of drawing traditionally

• Photoshop CC – if you have an older version, say CS5, that will work as well, it's just that the example images here might look a bit different for you

• a good graphics tablet, preferably one with a high range of pressure sensitivity; but for now simply use what you have

• a bit of creative madness (very useful!).

You will learn how to:

• set up your canvas

• set up your layers for painting

• create your own brush library

• define your color palette.

▲ The splash screen of Photoshop CC　**01**

▲ This is how the interface of Photoshop will look, with the workspace set to default Essentials　**02a**

Step 01

Who else uses Photoshop?

One major thing to understand about Photoshop is the wide range of professionals who use it, all with varying needs (now it makes sense, why Photoshop is such a massive program). There are illustrators and retouch artists working for high-gloss magazines, animators who work their magic for online games, and matte painters whose artworks have to fit into a strictly defined pipeline set up by film studios; there are fashion designers, concept artists, stylists, web and graphic designers, and photographers.

Now why is all of this interesting for you? It means that for character design you will *not* have to learn the whole package; just the best parts. Ready to go cherry-picking? Let's open Photoshop.

Step 02

Selecting a workspace

If you have a fresh installation, you will see the interface default, called Essentials workspace. It offers a basic arrangement of panels that are typically used (image 02a).

As discussed, Photoshop has different groups of users, so there are different presets for workspaces available. Being highly customizable, Photoshop also allows you to create your own arrangement and save it for maximum comfort. For us, the

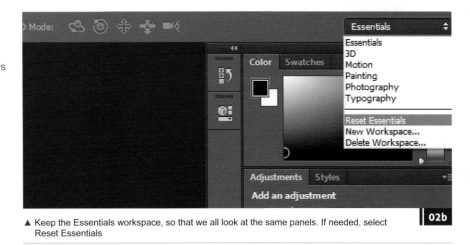

▲ Keep the Essentials workspace, so that we all look at the same panels. If needed, select Reset Essentials

02b

Essentials workspace will be sufficient; we will also be using the Adjustments panel a lot, so you can keep it like that with the Adjustments tab selected as in image 02a. (We will have a look at the Painting mode later, so that you can experiment with that as well.)

If you've opened Photoshop before, changed some values, or maybe closed some menus and don't know how to get them back, don't worry. There is a reset option inside the workspace menu on the top-right, where it says Essentials (image 02b). Hit Reset Essentials to get back to the default settings.

Step 03

Getting familiar with the interface

Let's further inspect the interface. Where are all the important buttons located? On the left-hand side, we have the Tools bar; on the right there are the panel columns holding the individual panels that you will work with most, all collected in tabbed groups. If you click a tab, it will bring the corresponding panel to the front and activate it (you will see the activated Layers panel in image 03a; you will need this all the time).

On top of the screen is the Menu bar, also called the Application bar (it sits above the Options bar, which will display options for the currently selected tool; change the tool and watch the Options bar update accordingly). The important icon to look out for is the panel's menu icon. For example, if you want to close a panel/panel group, you will find the option to do so in its panel drop-down menu (as well as many other options corresponding to a particular panel's topic).

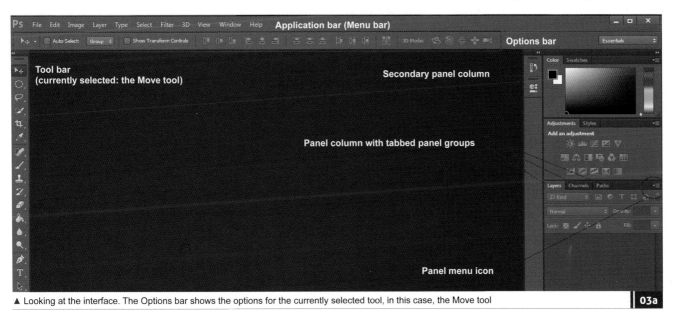

▲ Looking at the interface. The Options bar shows the options for the currently selected tool, in this case, the Move tool

03a

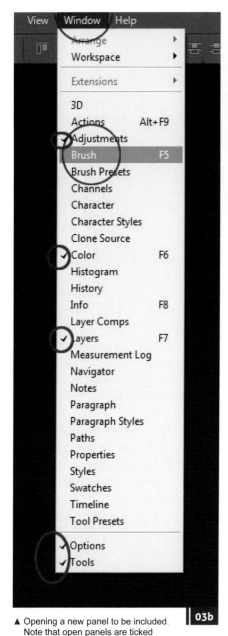

▲ Opening a new panel to be included. Note that open panels are ticked `03b`

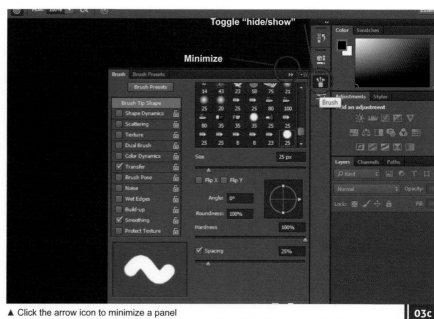

▲ Click the arrow icon to minimize a panel `03c`

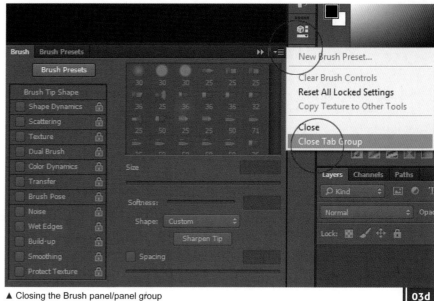

▲ Closing the Brush panel/panel group `03d`

If you want to open the Brush panel, simply go to Window > Brush (image 03b) and the panel will attach its icon to the column, as you can see in image 03c. If there is a check mark next to the option it means the panel is already open in the panel column tabs. Click the arrows to minimize and click the panel icon to toggle hide/show (image 03c). To close the Brush group panel, click Close Tab Group (image 03d).

Step 04

Canvas resolution – print or screen?

Depending on your needs, you will either want to create a file for screen purposes or

for printing. At the start of a project you might not always know if you'll need a print version later on or not. Keep in mind that if you create and polish your character in screen resolution (72 dpi), you will not be able to print it in high quality later on (image 04a). High-resolution print documents (300 dpi), however, can be converted into screen or web resolution easily without loss of quality.

Let's create a screen-resolution file (I'll explain the print preset as well, so you can decide on the output resolution you prefer for your artwork). In the top menu bar click File > New, then in the dialog box, select

Preset: Web and assign a name (or do so when saving your file). We will create a standing character, so we need portrait dimensions. Alter the default values to 600 pixels for width and 800 pixels for height. The Preset changes to custom, indicating custom-sized dimensions. Leave the other entries untouched and click OK (image 04b).

For print resolution, select Preset: International Paper, which gives you an A4-sized document at 300 dpi (image 04c). Your new document will appear. Click File > Save As; keep the default file format of PSD. Use the Zoom tool (Z) to navigate (image 04d).

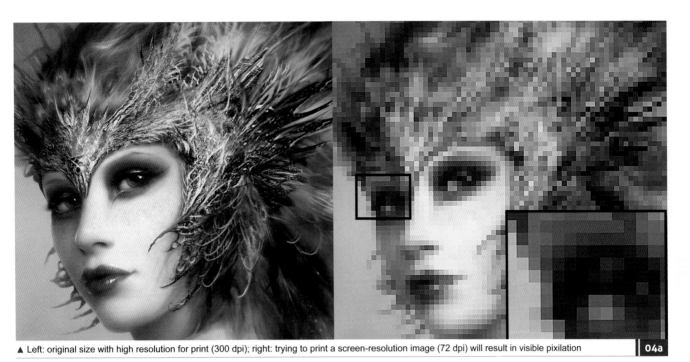

▲ Left: original size with high resolution for print (300 dpi); right: trying to print a screen-resolution image (72 dpi) will result in visible pixilation **04a**

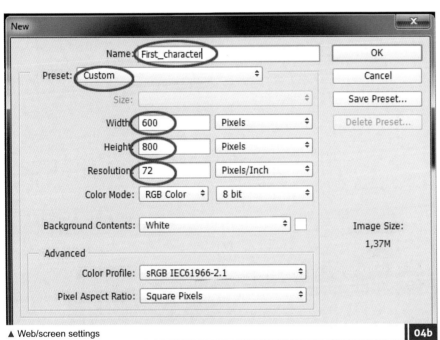

New			
Name: First_character		OK	

Preset: Custom

Size:

Width 600 Pixels

Height 800 Pixels

Resolution: 72 Pixels/Inch

Color Mode: RGB Color 8 bit

Background Contents: White

Advanced

Color Profile: sRGB IEC61966-2.1

Pixel Aspect Ratio: Square Pixels

OK
Cancel
Save Preset...
Delete Preset...

Image Size:
1,37M

▲ Web/screen settings **04b**

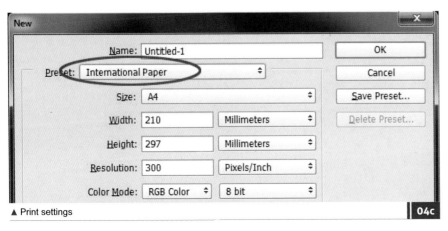

New

Name: Untitled-1

Preset: International Paper

Size: A4

Width: 210 Millimeters

Height: 297 Millimeters

Resolution: 300 Pixels/Inch

Color Mode: RGB Color 8 bit

OK
Cancel
Save Preset...
Delete Preset...

▲ Print settings **04c**

Ps File Edit Image Layer Type Sele

Resize Windows to Fit

first_character @ 100% (RGB/8) ×

Zoom Tool (Z)

▲ Your new document (size 600 × 800 pixels) at 100%. Try using the Zoom tool (Z) **04d**

Step 05

The secret of fine details: canvas size

Here's a trick to get nicer details into your artwork. Whatever the size of your canvas: double it! This will enable you to bring in some delicate brushwork that would be nearly impossible to paint otherwise. Once finished, the artwork can be scaled back down to the exact size needed. Another bonus is that minor irregularities will vanish because of the down-scaling. To do this, hit Image > Image Size in the top menu bar and enter 1600 pixels for height. The chain symbol is active, so width will be calculated automatically to 1200 pixels. Now hit OK.

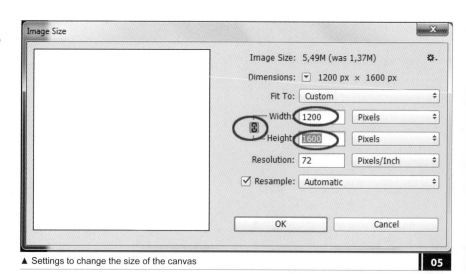

▲ Settings to change the size of the canvas

05

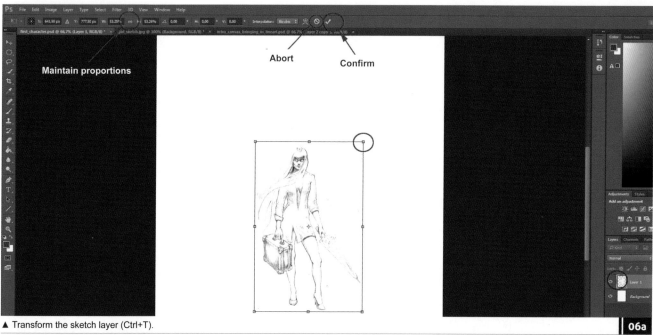

▲ Transform the sketch layer (Ctrl+T).

06a

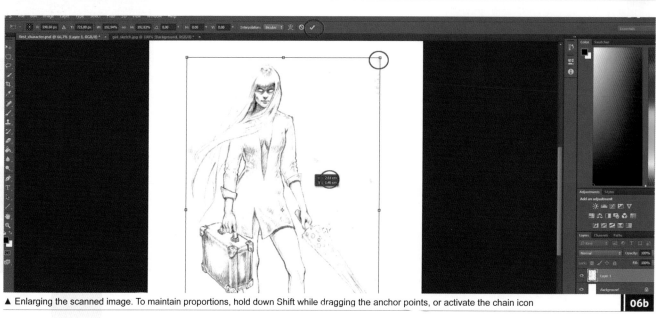

▲ Enlarging the scanned image. To maintain proportions, hold down Shift while dragging the anchor points, or activate the chain icon

06b

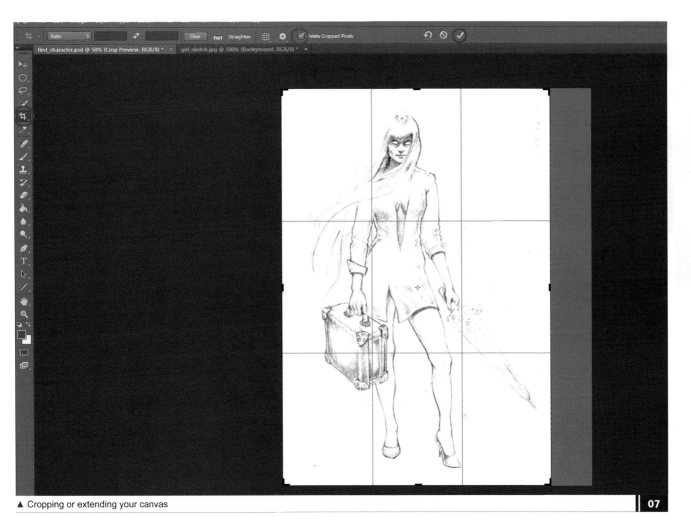

▲ Cropping or extending your canvas

Step 06
How to copy/paste content from one document to another

The goal for the next step is to practice how to copy and paste the content of one document into another and how to position the material on your canvas. We are going to need this technique in the next chapters.

To open a scanned pencil drawing go to File > Open and select the entire new file by hitting Ctrl+A. Then copy the content of that selection (Ctrl+C). Activate the first tab (main document) to bring it to the front, then hit Ctrl+V to paste everything in.

Now, depending on the size of your scanned character, it may appear too big or too small on your canvas. Hit Ctrl+T to activate the Transform tool and click-drag the anchor points to scale and position your sketch layer and confirm (see image 06b). Then save your file.

"For a very intuitive way to resize your canvas, simply use the Crop tool. You'll love it"

Step 07
Refining canvas dimension and orientation

Right now our canvas is portrait in orientation. For one character, this is a good choice. But what if we want to change the dimension later on in the painting process? Maybe we decide that we need more space to the left of our character and less space at the bottom? Or maybe we want to switch dimensions completely and turn the portrait canvas into landscape to display the same character several times on the canvas, with each figure wearing a variety of different clothing.

For a very intuitive way to resize your canvas, simply use the Crop tool. You'll

love it – it can be used for cropping as well as extending your canvas (image 07).

Let's see how it works. Select the Crop tool (keyboard shortcut is C), mark the preferred area for your canvas with a Marquee selection (the box that appears when you drag the Crop tool over your canvas, marking out the area that will be left when you confirm to crop), then grab the anchor points and precisely drag them around until you are happy with the new dimensions. If you confirm by hitting Return (or clicking on the check mark icon in the top menu bar) the new canvas dimension will be defined.

Pixels outside the Marquee selection will appear grayed out and will get deleted if the checkbox for Delete Cropped Pixels in the top menu bar is checked. If unchecked, Photoshop will turn your crop into a layer, where the cropped pixels lie safely hidden outside your visible frame. To enlarge the

canvas, simply drag the anchor points outside the original canvas size and confirm, then save your file (Ctrl+S).

Step 08
Creating Actions for an efficient workflow

If you want to work quickly and efficiently, you need "Actions". Without Actions, it will take 10 times as long to do the simplest things and this can really kill off any creative momentum. We should be happily painting and not search-clicking, "Now where was it... in the Edit menu or in the Layers panel?" The solution: for every important task we regularly need, we will create an Action and assign it a shortcut key. So instead of having to learn whole menu structures by heart, we reduce the hassle to the simple click of one button. Sounds good? Okay, here is the downside: You will

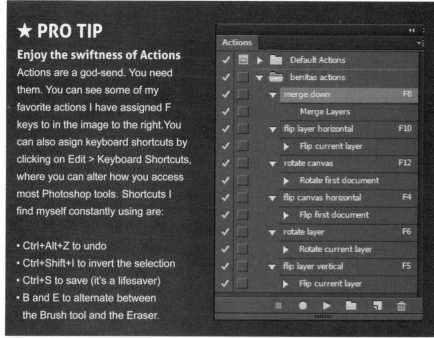

★ PRO TIP
Enjoy the swiftness of Actions

Actions are a god-send. You need them. You can see some of my favorite actions I have assigned F keys to in the image to the right. You can also assign keyboard shortcuts by clicking on Edit > Keyboard Shortcuts, where you can alter how you access most Photoshop tools. Shortcuts I find myself constantly using are:

• Ctrl+Alt+Z to undo
• Ctrl+Shift+I to invert the selection
• Ctrl+S to save (it's a lifesaver)
• B and E to alternate between the Brush tool and the Eraser.

▲ Record your Actions and collect them in sets, or set up keyboard shortcuts to speed up your workflow

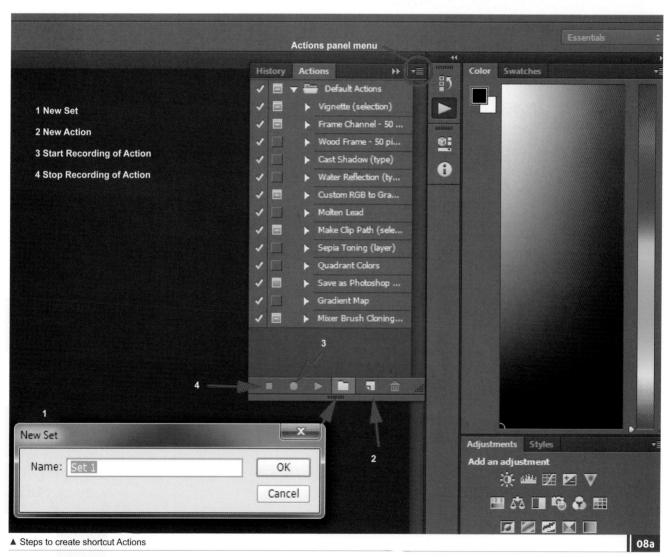

1 New Set

2 New Action

3 Start Recording of Action

4 Stop Recording of Action

▲ Steps to create shortcut Actions

08a

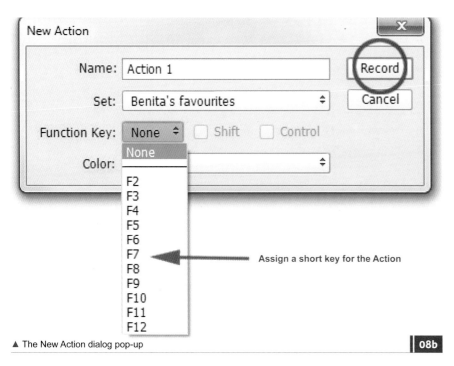

Name: Action 1

Set: Benita's favourites

Function Key: None ☐ Shift ☐ Control

None
F2
F3
F4
F5
F6
F7 ← Assign a short key for the Action
F8
F9
F10
F11
F12

▲ The New Action dialog pop-up | 08b

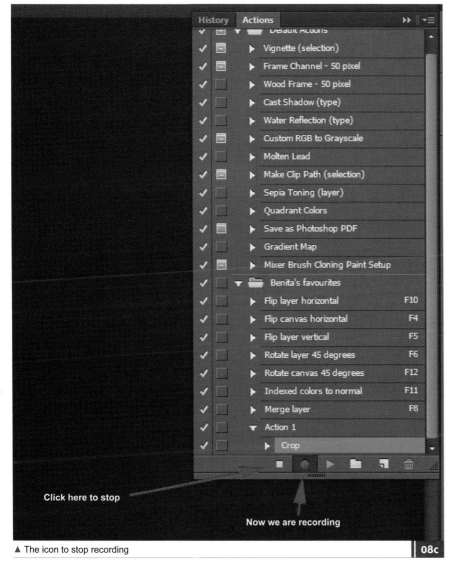

Click here to stop

Now we are recording

▲ The icon to stop recording | 08c

have to create those Actions and you will have to learn the buttons you assign to them. But create once, enjoy forever!

You can create Actions for your favorite tasks such as Flip Canvas (very useful to check the balance of your composition with the push of a button), Flip Layer, Rotate Layer, Merge Layer (needed all the time), and Rotate Canvas. Assigning them to Function keys (F4, F5, F6, and so on) means they are comfortable to reach.

To get some practice, let's create a simple Action for ourselves. You will see that it's fast and easy.

Say we want to create an Action for flipping the canvas. From the top menu bar, select Window > Actions, and a panel will open up showing a default set of Actions called Default Actions. We could add our new Actions to this default set, but it is more organized to have our own set.

Click the folder icon (see 1 in image 08a) to create a new set (this will hold our new Actions) and name it. Now we are ready to create an Action in our new set. To create the Action, click on the small page icon (see 2 in image 08a) or select New Action from the Actions panel menu. A panel will pop up; name the action "Flip canvas horizontal". Assign a function key that you would like to use for this command (you can always alter the Action later) and hit Record (image 08b). The dialog box will close and a little red dot in the Action panel will indicate that we are recording (image 08c).

Now do exactly the steps that you want to record. For example, from the top menu bar select Edit > Transform > Flip Horizontal (the image will be flipped). Next hit the stop symbol in the Actions panel to stop recording (image 08c). That's it! If you accidentally recorded some other steps with it, you can delete the Action and start again fresh. To delete an Action click the small trash bin icon or do so via the Actions panel menu. To play your new action simply, hit the function key you assigned.

Overcoming a blank canvas

How to generate ideas and take them to the next step

by Benita Winckler

We now have a basic understanding about the workspace and feel comfortable about handling our canvas. We have also gained knowledge about how to copy and paste content between files (we will need this soon).

In this chapter, let's do a bit of time traveling and go right back to the starting point of any character design!

> "Some projects will demand a highly polished result, while for other projects a number of rough sketches will be sufficient"

Step 01

What does the client need?

What do we need in the beginning? A concept. If we are working as a character designer for a client they will give us the necessary descriptions along with the guidelines for the preferred style of the illustration. We will also be given additional information such as whether the design will be used as reference for a 3D model later on. The more information we receive at this stage, the better.

Depending on the general purpose of your illustration, some projects will demand a highly polished result, while for other projects a number of rough sketches will be sufficient.

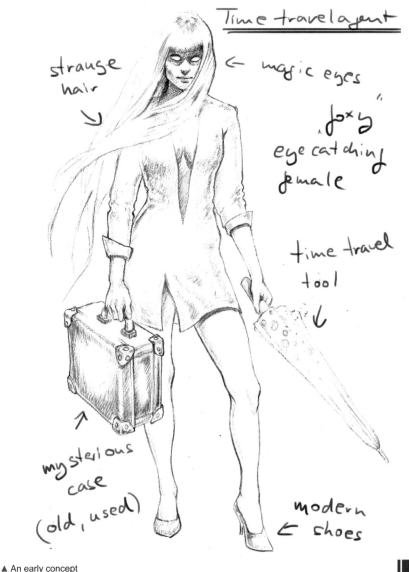

▲ An early concept

01

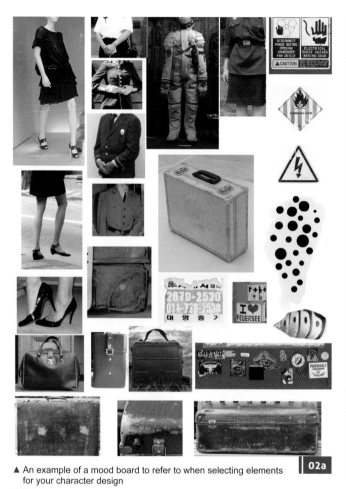

▲ An example of a mood board to refer to when selecting elements for your character design **02a**

▲ The layers' thumbnail size can be changed via the panel menu **02b**

Another factor to consider is how to communicate your vision and ideas effectively. Conveying moods and feelings rather than technical ideas, for example, is better done in color (we will discuss this in later chapters – see pages 36 and 74).

The concept shown in this chapter was to create a realistic figure of a time-traveling agent – think Dr. Who mixed with Mary Poppins, but more modern and a bit crazier; a foxy eye-catcher who would get noticed.

Step 02
Creating a mood board

You have read the brief and all the information; you have some ideas floating around in your mind. Now it's time to fill your head with inspiration. Photoshop is a perfect tool to assist you. Simply capture all your material in an extra document and name it "mood board". Collect reference images: everything that inspires you – from pictures for costume parts and important

details of the surroundings, to equipment and supporting accessories, and anything that visually describes your idea and helps to communicate your vision. Look for unusual combinations and follow your instincts. Sometimes you will get inspiration from unexpected areas; combine and experiment!

For the example character of a time-traveling agent, I collected various images of old suitcases (visually indicating the travel aspect). I looked at images of stewardesses, pin-up girls, and women in uniforms for example (image 02a). As a source for references, everyone knows Google, but be careful with copyright. To be safe, check out **http://freetextures.3dtotal. com**, or **www.cgtextures.com**. Also take your own pictures to build your personal texture and reference library!

To create a mood board go to File > New (Preset: Web, say 2500 × 3500), and copy and paste the elements into it. You will get

★ PRO TIP
How to use clipping masks

A clipping mask is a layer that sits on top of another layer, being clipped to the exact size of the main layer below it. Select a layer containing an element that you want to paint on then create a new layer. Hit Ctrl+Shift+G and whatever you paint on it will get clipped. Clipped layers can be stacked to any number you like. Hit Ctrl+Shift+G again and the clipping will be released, showing you the complete original layer in its complete size.

lots of layers. Select a layer from the panel, then use the Transform tool (Ctrl+T) and the Move tool (V) to arrange everything nicely. To delete a layer, right-click it in the Layers panel; select Delete Layer. To change your Layers panel's thumbnail size, select Panel Options from its panel menu (image 02b).

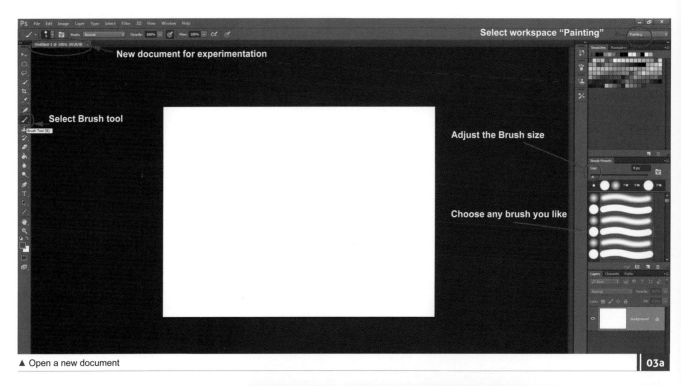

Select workspace "Painting"

New document for experimentation

Select Brush tool

Adjust the Brush size

Choose any brush you like

▲ Open a new document

03a

Step 03
Sketching the suitcase element

In the next step let's get some sketching
practice! We will start with a basic drawing
to get things going and later look at
some useful techniques to help break
up the white canvas background.

Select File > New (Preset: Web and
1600 × 1200 pixels) and Save the file
as "suitcase.psd". This will be our new
canvas for experimenting on. It's good
practice to get in the habit of saving often
and in numbered versions; this is so that
you can go back to your last version
just in case something goes wrong!

In the workspace drop-down menu
select Painting, so that we have easy
access to the Brush panel (image 03a).
Now instead of sketching directly on
the white canvas background, we will
use a new layer for our line art.

In the Layers palette create a new layer.
You can do this by either clicking on the
new layer icon or selecting a new layer via
the Layers panel menu. You can delete a
layer by clicking on the trash bin icon. New
layers are transparent, which is indicated
by the checkered pattern (image 03b).

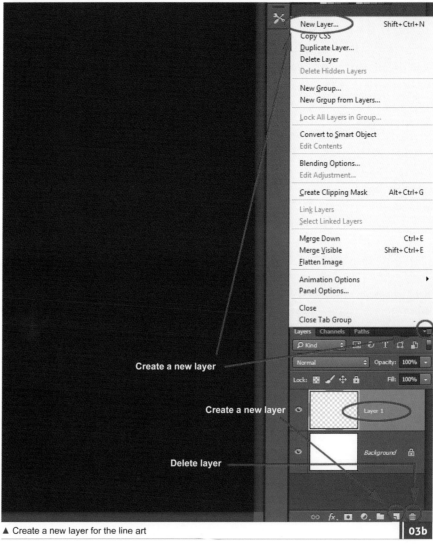

Create a new layer

Create a new layer

Delete layer

▲ Create a new layer for the line art

03b

To continue with our example topic of a time-traveling agent, let's sketch the line art of a suitcase. It is a simple shape, nothing challenging, so you can fully concentrate on how to use Photoshop. Select the Brush tool (B). Select any brush and set its size to something small, such as 3 pixels (see image 03a), and from the color swatches palette pick black by clicking on it. Now on your new layer you can start sketching (image 03c).

"To move a layer, grab it in the Layers panel and drag it to its new position"

Step 04
Setting up a layer structure
Let's go through a simple layer setup for our painting. We have our example sketch on the new layer, with a white background canvas. Why did we sketch on a new layer? Because we want to be able to use our sketch as a guideline, so that we can paint on the layers below it easily.

Next create a new layer for painting. If needed, move its position in the layer stack between the background canvas and the line art layer. To move a layer,

grab it in the Layers panel and drag it to its new position. The background canvas itself cannot be moved (indicated by a lock symbol); to turn the background into a normal layer, simply double-click it in the Layers panel (image 04a).

A note on scanned drawings
When bringing in a scanned drawing, Photoshop will give us an opaque white layer with the sketch on it, blocking the sight of everything else. To get rid of all

the white areas and to only have the actual dark line art visible, you can use the Layer blending mode called Multiply. It will do the trick! All white pixels of that layer will appear 100% transparent, and the dark ones will stay visible.

To do this, select the layer in the Layers panel, then in the Layers blending mode menu (the field where it says Normal), select Multiply (see the red circled parts in image 04b below).

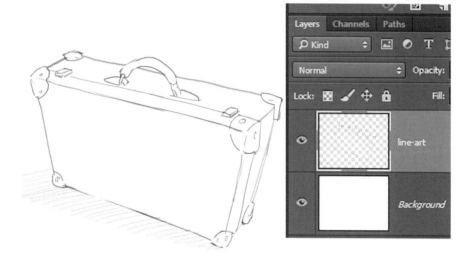

▲ Sketch of a suitcase right on the new layer. Use the Eraser tool (E) if needed | 03c

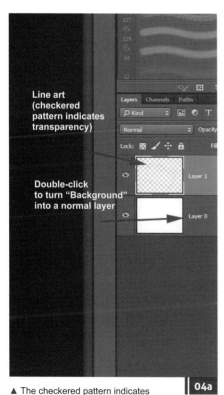

Line art (checkered pattern indicates transparency)

Double-click to turn "Background" into a normal layer

▲ The checkered pattern indicates transparency | 04a

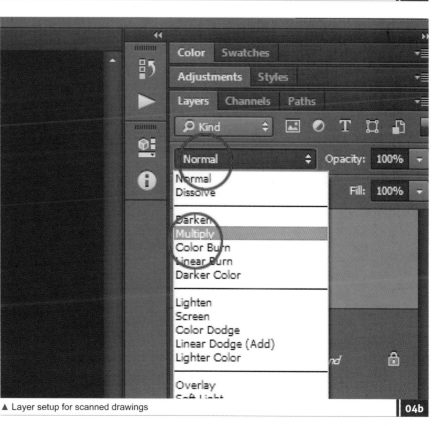

▲ Layer setup for scanned drawings | 04b

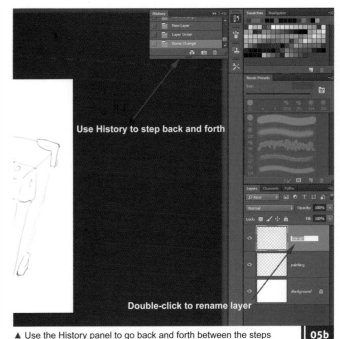

▲ The Layer Style menu: a wondrous tool that we don't need for now but that you can use to change settings of blending modes in | **05a**

▲ Use the History panel to go back and forth between the steps | **05b**

Step 05

Painting the suitcase accessory

Our layer stack for the painting of the suitcase now should be ordered like this: line art layer; painting layer; background canvas.

You can re-name the layers by double-clicking on their name. If you don't hit the name properly (it is easy to miss), it will bring up the Layer Style menu instead (image 05a). If this pops up, simply

close it again and try to hit exactly the area of the layer name to re-name it.

Now activate the middle layer for our painting. From the color swatches panel pick a brown color and with any basic brush (size set to something bigger, say 40 pixels) paint the area marked by your line art. To go back and forth in the history of your steps, use the History panel. Try playing with the Opacity settings of your

brush, so that the brushstrokes' opacity will build up while you are painting.

To delete, use the Eraser tool, where you can select any shape, just like you can with brushes. Right-click on your canvas with the Eraser tool active and select a new brush tip for it (image 05c). If you like, you can explore different shapes for your character's item to achieve different variations of the bag accessory (image 05d).

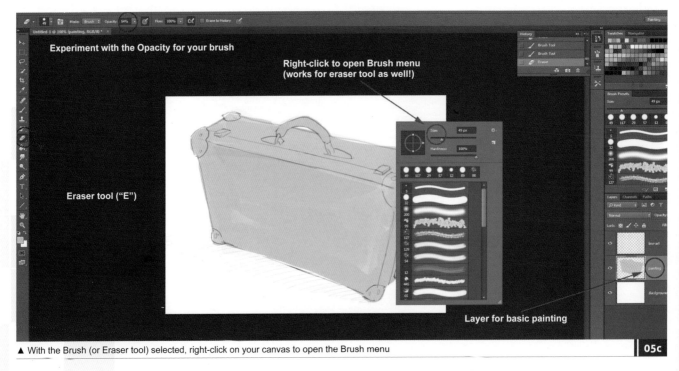

▲ With the Brush (or Eraser tool) selected, right-click on your canvas to open the Brush menu | **05c**

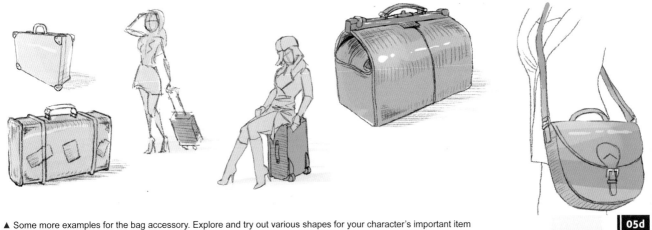

▲ Some more examples for the bag accessory. Explore and try out various shapes for your character's important item `05d`

In the next step we'll look at adding some interesting textures to our basic painting, and then we'll refine the painting further.

Step 06
Working with textures

Save a copy of your last document. We need the layer set up like before: line art layer on top, paint layer, then background canvas.

Starting with a mid-value background

Instead of a white background we'll start with a mid-value background. That way it

▲ Basic shape and midtone background `06a`

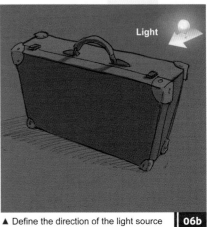

▲ Define the direction of the light source `06b`

▲ Adding texture to the suitcase `06c`

provides us with the ground for working in both lighter and darker values.

From the tool menu on the left of the screen, select the Paint Bucket tool (shortcut G). In the Layers palette activate the background, select a nice brownish gray from the swatches (not too dark, not too saturated), and fill the background by clicking on it.

Painting the suitcase shape

Next, activate the paint layer (between the canvas and line art) with a click in the Layers palette. Select a slightly darker value and paint the basic shape of the suitcase. The result could look like image 06a.

Define the light source and light direction. In our example the light comes from the top-right. Select a lighter brown from the swatches for the areas that will receive light (image 06b).

Selecting a texture

Next we will break up the CG look by bringing in a texture. As an example we will use a photographic leather texture taken from the free library at **http://freetextures.3dtotal.com**.

Using a clipping mask

Now for the textures, we'll create a clipping mask so that our texture will be clipped to the exact boundaries of the painting of our suitcase area. Clipping masks on layers are really helpful whenever you are working with individual elements in a painting.

Copy and paste a leather texture on a new layer above the suitcase painting, but below the line art. Transform and rotate the layer as needed (Edit > Transform or Ctrl+T). Select the paint layer, as this is the layer we want to apply the clipping mask to, and then from the Layers panel menu select Create Clipping Mask (image 06c). Now the texture will only be visible in the boundaries of the suitcase outline; the rest will be clipped/deleted (image 06d).

Blending the texture

For a smooth effect we'll have to adjust the texture a bit more. First, reduce the

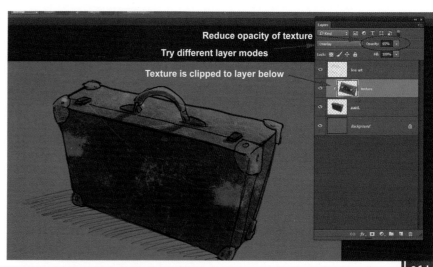

▲ Clipping the texture layer. Note the small indent in the Layers panel indicating that the layer is now clipped to the layer below it | 06d

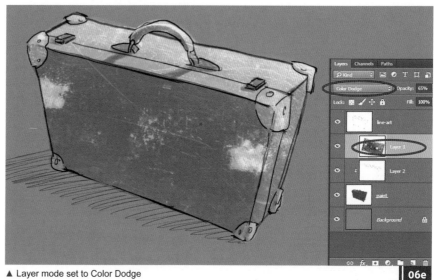

▲ Layer mode set to Color Dodge | 06e

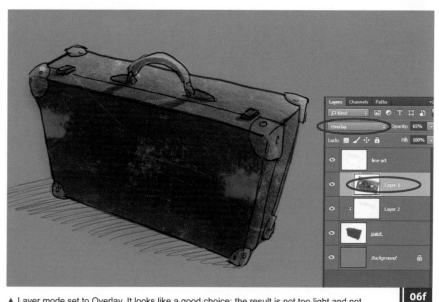

▲ Layer mode set to Overlay. It looks like a good choice; the result is not too light and not too obtrusive | 06f

opacity of the texture layer. Now, to further blend the texture with our painting, we will try some of the layer modes. The best effect will depend on the overall lightness or darkness of your texture.

Image 06e shows a layer mode with the texture layer set to Color Dodge (which is a little too bright for our purpose), while image 06f shows the effect with the layer mode set to Overlay, which is just what we are looking for! Experiment with the other layer modes as well (image 06g).

Painting the background

In the next steps you could add a basic texture for the floor layer as well. There will be no need for a clipping layer. Instead, simply copy and paste a texture in, so that the new layer lies between the background and the suitcase. Adjust the opacity for a subtle effect and erase and re-paint the floor as you like (image 06h).

Covering up the line art

Next we want to cover up our line art by painting over it. To do so, add a new layer on top of the line art layer. To achieve a coherent look, bring in some of the colors of your background to your main object and vice versa. Use the Eyedropper tool (I) to do the color-picking or use the Color Picker (image 06h). Tip: to quickly switch between the Brush tool and Eyedropper tool, use the Alt key.

Textures are a great way to get a painting going (or to add some final touches). However, don't rely on them too much – bring in your brushwork as well!

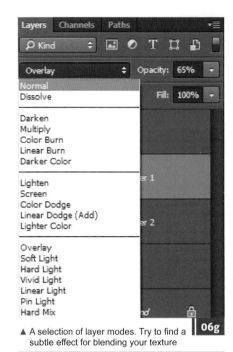

▲ A selection of layer modes. Try to find a subtle effect for blending your texture

06g

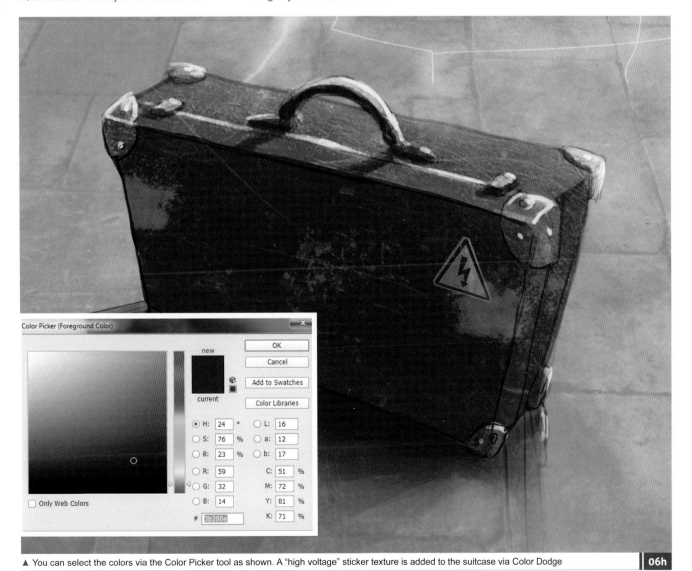

▲ You can select the colors via the Color Picker tool as shown. A "high voltage" sticker texture is added to the suitcase via Color Dodge

06h

Setting up your brushes

How to organize your brush sets for a faster workflow

by Benita Winckler

If you want to work efficiently, a well-equipped and organized brush set is essential. Certain brushes are more suitable for particular tasks than others. On the pages that follow, we will discuss how to use the Brush panel and how to save a set of brushes of our own. We will also look at how to create custom brushes for various purposes, such as for painting the skin of our character. You can see other uses of custom brushes on pages 154 and 156.

▲ Use custom brushes and textured brushes to bring "life" into your artwork

01

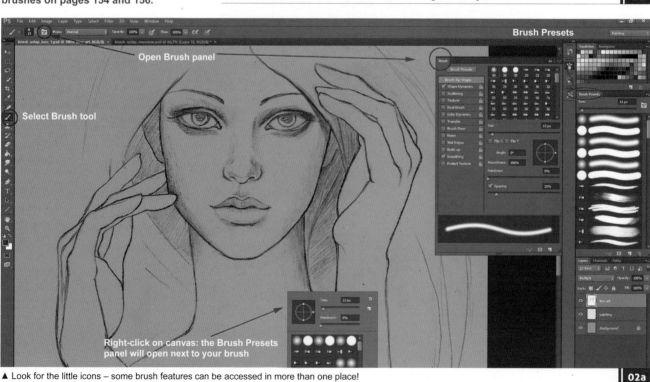

Open Brush panel

Select Brush tool

Right-click on canvas: the Brush Presets panel will open next to your brush

▲ Look for the little icons – some brush features can be accessed in more than one place!

02a

"If we want to create a believable character, we need to somehow get rid of that clean computer look. Custom brushes (and textures as well) can really help with this!"

Step 01

The challenge of working digitally

Closely related to the brushes topic is one major challenge that digital artists usually need to face. The term "digital" already gives it away; it is the danger of creating an artwork that looks too computer-generated. If we want to create a believable character, we need to somehow get rid of that clean computer look. Custom brushes (and textures as well) can really help with this!

As always, the human eye loves a bit of contrast. So, if we try to bring in some little imperfections while painting, we'll be able to better mimic the features of the real world around us. As a result our artwork will look more convincing and also way more sensual. Think about putting a hint of dust or some scratches on an otherwise pristine surface to break up that CG perfection. The key is to aim for variation!

Step 02

Creating a new brush set

Photoshop has a wonderful brush engine. However, on first sight the panels can look confusing with the options to alter the brushes quite spread out (image 02a). Let's see where we can find the important parts!

Looking at a fresh installation (in Painting mode), you will be presented with the default set of brushes in the Brush Presets panel (image 02b). Photoshop calls the brushes "Brush Presets" because for each brush displayed, a number of features have been defined, such as hardness, spacing, size, and Pen Pressure sensitivity.

We want to create our own set, then alter and create new ones, and importantly, change their position in the list, so that we have easy access to the ones that we need most. Create a new brush set by selecting

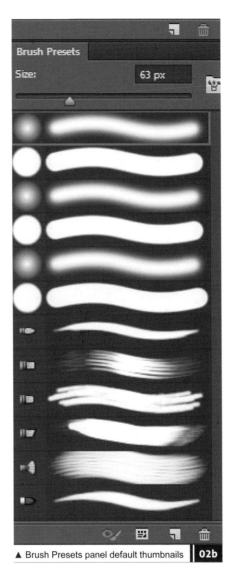
▲ Brush Presets panel default thumbnails | 02b

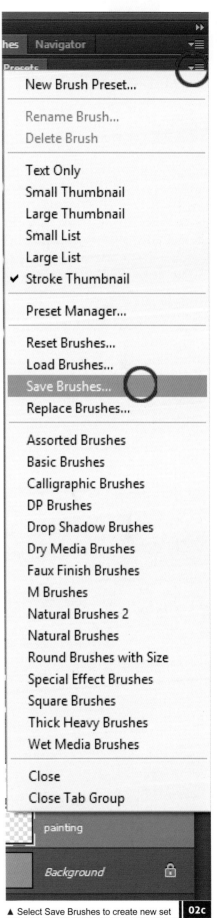
▲ Select Save Brushes to create new set | 02c

Save Brushes from the Brush Presets panel menu (image 02c). In the Save dialog box assign a name for your set and save it in a location that you can remember. Right now the set will hold a copy of the default brushes because we haven't changed anything yet.

To get the defaults back, hit Reset Brushes in the panel menu. You can experiment with other brush defaults from the menu, too. Either Reset or Append (you can choose between these two options in the dialog box once you hit Reset Brushes). The latter will add those brushes to your set.

Appending brushes can cause your list to grow quite big, so it is good to be able to arrange and delete brushes to make your brush library more manageable. Let's see how in the next step.

"You can create new brushes by using the Brush panel. The new brush will hold exactly the settings that are currently selected"

Step 03

Using the Brush panel

We have saved our brush set, now let's explore how to create new brushes and then arrange them for an efficient workflow. You can create new brushes by using the icon on the Brush panel (image 03a). The new brush will hold exactly the settings that are currently selected. Assign a name and hit OK. The new brush will be added to the list (scroll down to see your new brush). In the following chapter we will explore the Brush panel, settings, and custom brushes in more detail. For now though, just try creating a new brush by hitting the icon as shown in image 03a.

Using the Preset Manager

Now let's discuss how we can rearrange and delete brushes. We will use the Preset Manager.

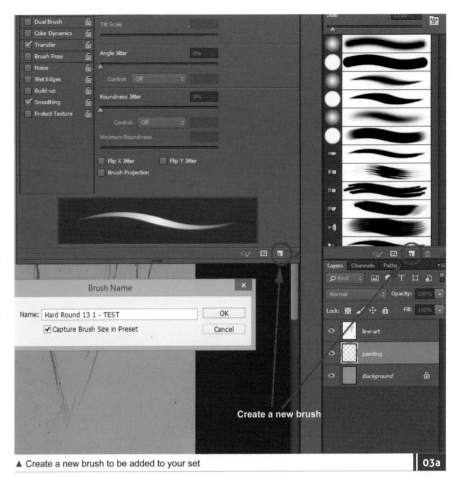

▲ Create a new brush to be added to your set

03a

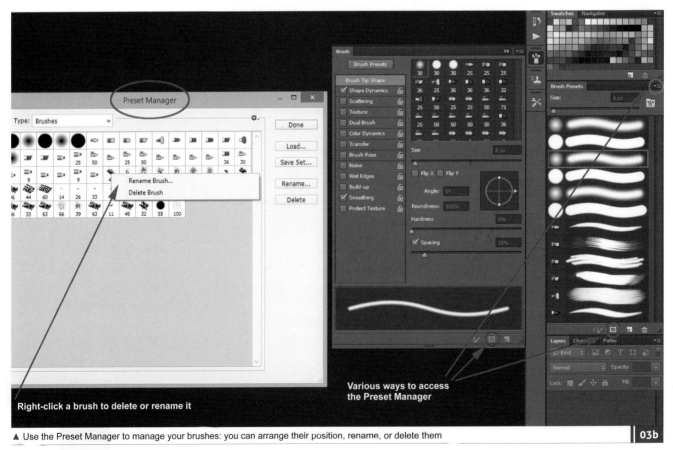

▲ Use the Preset Manager to manage your brushes: you can arrange their position, rename, or delete them

03b

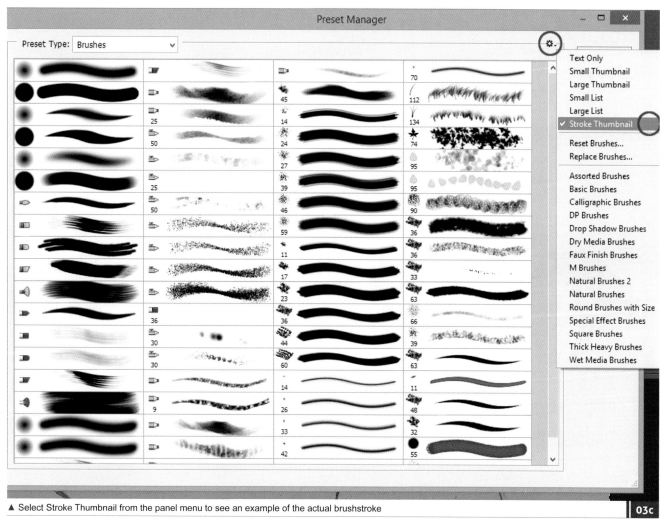

▲ Select Stroke Thumbnail from the panel menu to see an example of the actual brushstroke

03c

"Don't forget to save your altered brush set once you have made changes to it – it is easy to forget!"

To rearrange the brushes, simply grab them and pull them to their new position. Explore various brushes to find your own personal favorites and then arrange them in a fashion that feels most comfortable to you. If you want to delete (or rename) a certain brush from your set, right-click and select Delete (or Rename) Brush (see image 03b). To see the actual brushstroke of our brushes, select Stroke Thumbnail (see image 03c).

Don't forget to save your altered brush set once you have made changes to it (see step 02) – it is easy to forget! Also save your set if you want to reset your brushes or want to explore the other interesting defaults such as Dry Media or Calligraphic brushes.

★ PRO TIP

You can control the opacity of the brush via the individual brush setting itself (Transfer > Opacity Jitter: 0%; Control: Pen Pressure). You can also do so globally for all brushes via the icon in the top menu bar (see image below). If the icon is checked it will override all Brush presets and instead Pen Pressure will be used for all brushes. This is a great little feature; however, the really interesting trait lies in the Opacity slider itself. To have more control over your brushstrokes, you can globally set the opacity to a maximum of 40 or 50%. This way every brushstroke you make will gently blend into the whole and add to the painting. This can be very useful, especially if you work on delicate areas where you need soft transitions. For bold design choices, however, make sure you set the opacity back to 100%.

▲ Control the level of opacity of your brush individually via the Brush menu

★ PRO TIP

Altering brush hardness and tip shape

The Brush menu offers some simple but effective ways to alter your brushes. Not only can you adjust the size, but also the hardness of a brush. Right-click with your tablet/mouse to open the Brush menu. Pull the slider for Hardness to 0% to get a soft, fuzzy brush edge and pull the slider to 100% to get a hard edge. (Note: the slider will not be available for custom brushes, just for basic ones.)

You may have noticed that most brush tips are circular – however this can be changed easily! Want a nice oval to work with? Simply adjust the two anchor points in the circle icon as indicated in the image below. You can also adjust the angle of the tip, by pulling at the small arrow. Oval brush tips are highly useful as they offer a varied brushstroke which will give you more control in your work (this feature works for custom brushes as well).

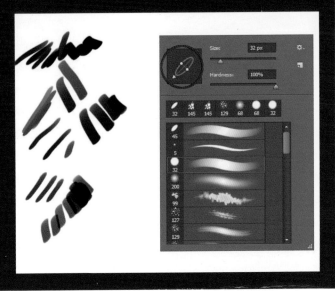

▲ You can alter the hardness of the basic brushes via the Brush menu. An oval brush tip can be useful for control

"You'll need a brush that assists you in making bold statements. No fluff or fuzziness but a hard edge"

Step 04

The secret of the hard-edged brush

Let me highlight one of the basic brushes that is particularly useful for character design! It is the solid hard-edged brush. Why is this one useful? Because in the early design phases, you'll need a brush that assists you in making bold statements. No fluff or fuzziness but a hard edge.

The trick is that it will force you to focus on the basic shape of your character design, which is highly important, because shapes are among the first things we notice and it is vital to get them right (see the chapter on form and anatomy in the next section).

Set Shape Dynamics to Pen Pressure, to achieve a nice brushstroke (image 04a); hard-edged brushes are ideal

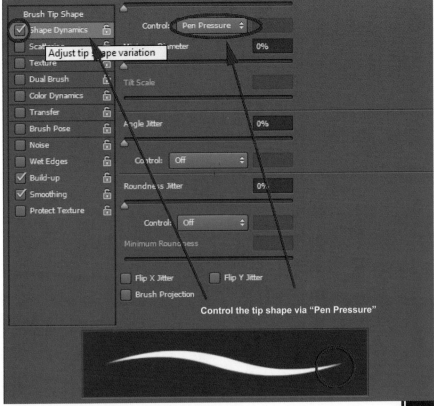

▲ Brush panel with settings for a simple hard-edged brush

04a

▲ Explore the silhouettes of your character. Use a hard-edged brush to find out which shapes are needed to tell your story

<div style="text-align: right">04b</div>

to explore the silhouettes of your character design (image 04b).

Good silhouettes are easy to read and this will enhance the effect your character has on your audience and give your viewer some visual clues about what to expect from your character. To achieve this, you don't need thousands of tiny little details. Keep it simple; reduce and enhance. Which features are needed to tell your story? Which can be omitted?

Step 05
Brushes suitable for painting skin

When painting characters, eventually at some point the topic of "how to paint skin" will crop up. There is no secret formula for how to paint skin; however, some brushes will be better suited for the task than others.

Try to start with a hard-edged brush, either pressure sensitive or non-sensitive (image 05a). Once the planes and the lighting are defined you can switch over to some speckled brushes (see image 05b on the next page) and finally you can go over the painting with a soft-edged brush to smooth out some of the harsh edges.

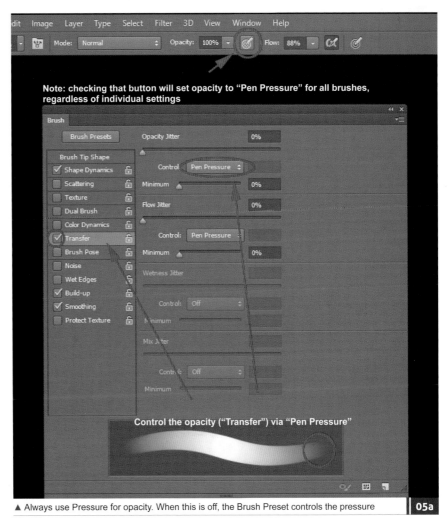

▲ Always use Pressure for opacity. When this is off, the Brush Preset controls the pressure

<div style="text-align: right">05a</div>

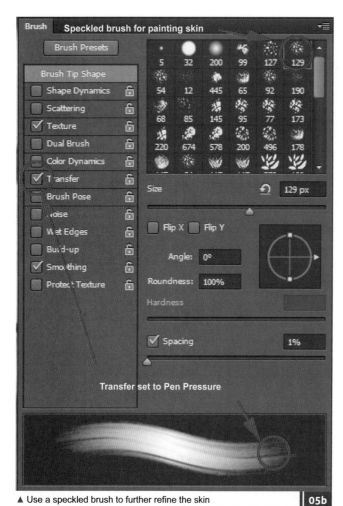

▲ Use a speckled brush to further refine the skin **05b**

▲ If you need to paint freckles, use a speckled brush at the final stage **05c**

▲ The process of how to create a custom brush **06a**

Skin is soft, but the underlying structure is not. It is a common mistake to start painting the skin with a soft brush, only to end up with a blurry, shapeless mess. Keep in mind that the skin is just the top layer of something that has volume and form. Always start with the idea that you are painting an object in 3D space. If you notice towards the end that your painting has lost its life, it could be due to the fact that you overdid it with the soft brush. Get back in there and bring in some brushstrokes, add texture, and do everything to avoid the clean CG look that we talked about earlier.

Also remember that a character's impact on the viewer will not depend on how many freckles we paint on the skin – don't over use custom brushes or rely on them as a foundation for your character. If you absolutely need to paint freckles, as your character close-up demands it, you can use a special brush for it (image 05c).

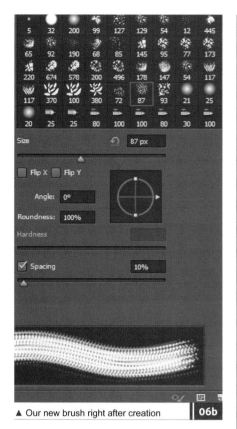

▲ Our new brush right after creation | **06b**

"Using a variety of brushes will lead to greater variation in our brushwork and it will help you to communicate the material you are painting better"

Step 06
Create your own custom brushes

Using a variety of brushes will lead to greater variation in our brushwork and it will help you to communicate the material you are painting better. Let's go over the process of how to create your own custom brushes, so that you can make your own brushes for special tasks. As an example we'll create a speckled brush suitable for (but not limited to) painting hair.

Create a new document (set to Web) and set its size to 100 × 100, keeping the white background. This will be the basis of our brush. We will now paint what will be the tip of our brush with black.

Everything white will be transparent. Select any brush with a small size of 1–3 pixels. Now put down some dots onto

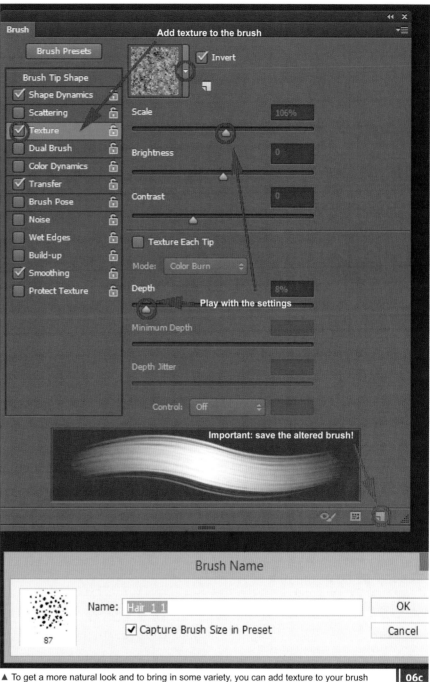

▲ To get a more natural look and to bring in some variety, you can add texture to your brush | **06c**

the canvas. From the Edit menu select Define Brush Preset and in the pop-up assign a name; confirm with OK (image 06a). The brush will now show up in the Brush Presets list (image 06b).

Let's refine its settings so that we can use it effectively. As discussed earlier, it is important to get variety into your brushwork to achieve a vivid look. The texture setting is especially interesting here, as it allows you to add textures and variety to your

brush (image 06c). If you want to paint fur or grass materials, you can create a brush tip consisting of small strokes instead of dots, and then combine it with Scattering (above Texture in the Brush Presets panel). You can also enhance the effect by using the Shape Dynamics: Size Jitter/Angle Jitter.

There are many possibilities so I highly recommended that you try out the various brush settings. Have fun – and don't forget to save!

Setting up your color swatches

How to work with complementary colors, use the Color Picker, and convey moods

by Benita Winckler

In addition to technical concerns (such as how to work with complementary colors or how to set up color swatches), we also need to know about the psychological and physical effects that colors can have on us (consciously or unconsciously). What is the response we want from our viewer? Which colors convey a certain mood most effectively? We need to ensure that we communicate the right things.

Step 01

Some colors and their effects

Image 01a shows an illustration of the spectrum of visible light. Let's break it down to get a quick overview.

- Red is eye-catching, exciting, and demands attention. It's a very active color. Hot, aggressive, and sensual. Think of glowing fire, blood, fruits, or poisonous fungus!

- Orange is an attention-grabber, it's not as demanding as red, but is still very warm and can be associated with youthfulness, fun, ambition, and high energy.

- Yellow draws attention and is associated with optimism, happiness, sunlight, and warmth. But it is also used as a warning color by some animals, such as wasps.

- Blue is cool and distant; you associate it with the sky, air, and water. It can be

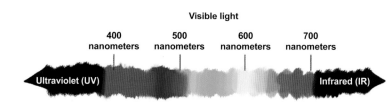

Visible light

400 nanometers 500 nanometers 600 nanometers 700 nanometers

Ultraviolet (UV) Infrared (IR)

▲ Color spectrum of visible light: warm red at one end, cool blue/violet at the other `01a`

calming or sad; think of "feeling blue" or being "ice-cold" (image 01b).

- Green is associated with nature, health, and growth. It has a calming and relaxing effect (image 01c).

- Violet is a combination of two very different colors: cool blue and fiery red. It can

be linked with solitariness, royalty, and spirituality. It can also be associated with mythical topics and otherworldliness.

We will explore the many effects and uses of different colors and color combinations further in the "Storytelling and moods" chapter of this book (see pages 74 and 76–78).

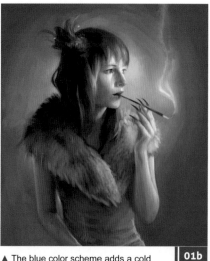

▲ The blue color scheme adds a cold atmosphere to the image `01b`

▲ The character is more approachable due to the warm, golden, green tones `01c`

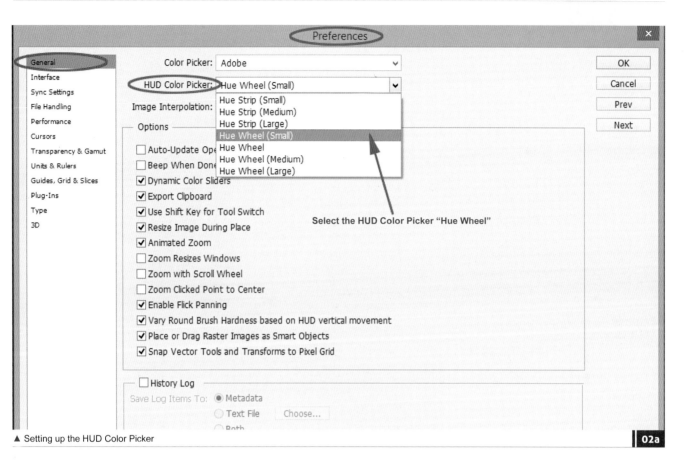

▲ Setting up the HUD Color Picker

02a

Step 02

Using the HUD Color Picker

There are several options you can use to select your colors in Photoshop. One feature is the HUD Color Picker. Let's set up this feature. In the top menu bar select the Edit menu and choose Preferences > General to open the Preferences panel. We want to look at the Hue Wheel, so select it in the drop-down menu (see image 02a

above). To use the Color Picker feature, select the Brush tool (B), go to your canvas, and practice the following:

• Alt+click the canvas to color-pick the normal way (image 02b).

• Next try holding down Alt+click while hovering over the canvas. You will get the option to alter your brush size by moving/hovering to the left/right (image

02c). If you move/hover up and down you can change your brushes' hardness.

• Hold down Alt+Shift and click; the canvas will set a color sampler on that spot. To get rid of it again, simply click it another time with that key combination held down and it will be removed (see image 02d).

▲ Exploring the HUD feature does take some practice

02b

▲ Alt+hover-click allows you to change the brush size

02c

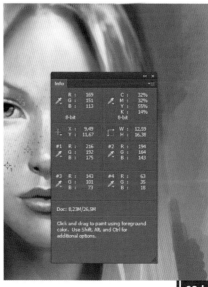

▲ Alt+Shift+clicking the canvas will set a color sampler. Click again to delete

02d

> "One useful technique for creating color swatches from a photographic reference image is to use the Mosaic Filter"

If instead of clicking the canvas directly you hover and click, the color wheel will open (see image 02e). Keep all the keys held down (also on your pen) and you can move around the wheel to select a new color, while being able to see the color's position on the color wheel. If you need to find a color that has the greatest contrast to another chosen color, have a look at its opposite position on the wheel.

Step 03
Creating color schemes

Color swatches are useful if you need to create your character within a certain given color scheme. Maybe your client has already given you a painted image with some colors for reference, and then you can color-pick from that (image 03a). Or maybe you were given some photographic references, to create something that will have the same look color-wise. In this case it can be a bit more difficult to do the color-picking.

One useful technique for creating color swatches from a photographic reference image is to use the Mosaic Filter, turning our photography into a mosaic.

Open a beautifully colored photograph to use as a base. We want to copy the background layer to have something to go back to, so select All (Ctrl+A), copy (Ctrl+C), and paste (Ctrl+V). The new layer will be used for the filter. Click on the layer to activate it, and from the Filter menu in the top menu bar select Pixelate > Mosaic (see image 03b). Depending on the size of the blocks, you will get a good variety of the major important colors.

Experiment with the size, to get a suitable result – that is, where you can clearly see the tiles of separated colors to pick from (image 03c). Next pick your colors from the mosaic and paint your own palette (either on a new document, or directly on a new layer of your main character document).

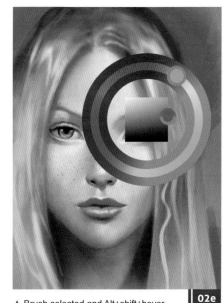

▲ Brush selected and Alt+shift+hover-clicking it will open the HUD color wheel | 02e

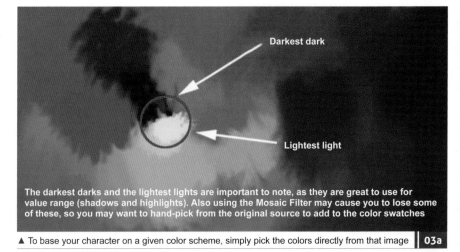

Darkest dark

Lightest light

The darkest darks and the lightest lights are important to note, as they are great to use for value range (shadows and highlights). Also using the Mosaic Filter may cause you to lose some of these, so you may want to hand-pick from the original source to add to the color swatches

▲ To base your character on a given color scheme, simply pick the colors directly from that image | 03a

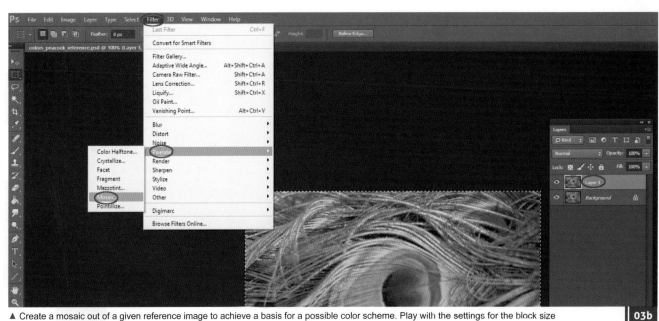

▲ Create a mosaic out of a given reference image to achieve a basis for a possible color scheme. Play with the settings for the block size | 03b

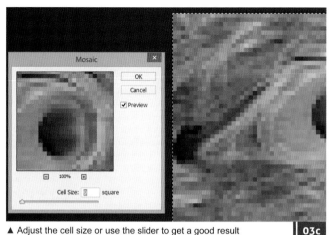

▲ Adjust the cell size or use the slider to get a good result　03c

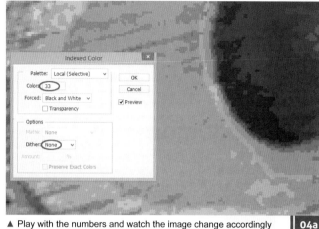

▲ Play with the numbers and watch the image change accordingly　04a

▲ Click on the empty slots to open the Color Picker and select a new color　04b

▲ To locate our new Color Table make sure to set the file type to Color Table ACT　04c

Due to the reduction of the colors, you might lose some pretty highlights and dark values (refer to image 03a). To add them to your color swatches, hand-pick them directly from the original photograph with the Eyedropper tool (I) and paint them on your palette.

Step 04
Color swatches from index mode

Indexed Color mode uses a color look-up table to create an image. It is a method for creating 8-bit, 256-color files. It is useful for saving disk space and creating web-based images.

Open your reference photo. To keep it simple, take an image of JPEG or PSD format. We will use peacock feathers again. We will be messing around with this image in a second, so make sure you save it under a new name so you can safely play with it.

What we want to do is extract a number of beautiful key colors, while omitting the

superfluous ones. But this time we want to create a set of Photoshop color swatches from the image. Color swatches can then be loaded, saved, or even exported to other programs such as Illustrator.

From the top menu bar select Image > Mode > Indexed Color. In the pop-up menu enter a small value and watch how the image changes accordingly (set Dither to None to achieve clear color shapes instead of dotted transitions) and hit OK (image 04a). To get our swatches from the indexed image, select Image > Mode > Color Table. In the pop-up menu you can see the swatches; hit Save, assign a name, and hit OK (image 04b).

Let's open our new Color Table (image 04c). In the Color Swatches panel menu,

▲ To add more colors click the icon as shown above　04d

either click Load Swatches (to add the new swatches to the existing ones; image 04d) or Replace Swatches to replace the existing ones with the new set. Note that you should make sure that in the pop-up menu you change the file type to Color Table (ACT), so that your new file will be displayed. Select your file and hit Load.

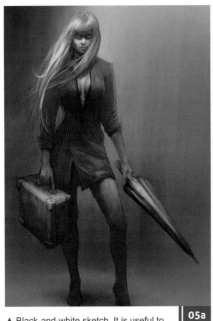

▲ Black-and-white sketch. It is useful to focus on the lighting first **05a**

▲ The chosen color scheme: red, electric blue-turquoise, yellows, and chartreuse green **05b**

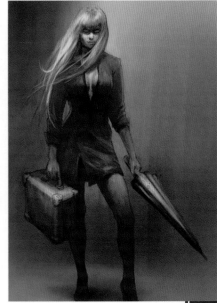

▲ Adding the dominating color. The color layer is above the sketch layer, toning everything **05c**

▲ Repaint the colors of some areas using a new layer with the blending mode set to Color **06a**

Step 05

Coloring the character

Paying attention to where the main light source is coming from, paint in your light and dark areas. Starting in grayscale helps to determine your values without getting distracted by color options. With your black-and-white character sketch finished (image 05a), the next step will be to add a new layer and bring in some colors.

The color scheme (image 05b) was chosen to communicate the features as discussed in the brief, with keywords such as modern, eye-catching, time-travel, futuristic, and unusual. The character design was supposed to work even when the accessories were put aside. To ensure this, I decided to add a recognizable feature: long, turquoise hair.

For her time-traveling equipment I chose the warning colors of a wasp to indicate the possible danger. Think about those yellow and black "Danger! High voltage!" signs.

For the background I selected a warm, friendly green tone, to communicate a light-hearted atmosphere. You can see the effect of a layer filled with green in image 05c. Set your layer mode to Color, and place the layer on top of the black-and-white sketch layer, so that it tones everything. It will be the dominating color for the artwork.

The next element to color was her suitcase. It holds something special that is of great importance. An attention-grabbing color is needed: red!

Step 06

How to alter colors

Sometimes we need to change the direction in which our painting is developing, color-wise. To make changes, we can use the Layer modes, or we can use the Adjustments command for Hue/Saturation. Let's start with the Layers mode for color changes.

In your document create a new layer on top of your current painting layer. In the Layers panel select the Layer blending mode, Color (image 06a). Now paint the areas you wish

> "Another really fun technique you can use is to invert the colors of your current layer by hitting Ctrl+I to give a photographic negative effect. If only used on one part of an area in your image it will give you the maximum color contrast"

to change the color of in the new color. When you have finished, merge down that layer (Layers panel menu > Merge Down).

To change the colors of an existing layer, or to alter the colors for the whole image, use the command Ctrl+U. This will bring up the Hue/Saturation dialog box (image 06b). You can play with the settings by moving the sliders to achieve some fresh ideas for possible color schemes!

Another really fun technique you can use is to invert the colors of your current layer by hitting Ctrl+I to give a photographic negative effect. If only used on one part of an area in your image it will give you the maximum color contrast.

Image 06c shows the final character so you can see the effect of the final colors chosen.

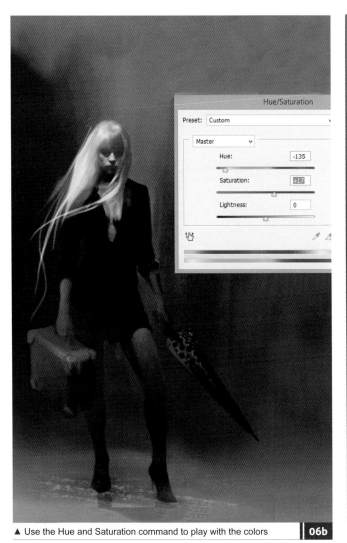

▲ Use the Hue and Saturation command to play with the colors **06b**

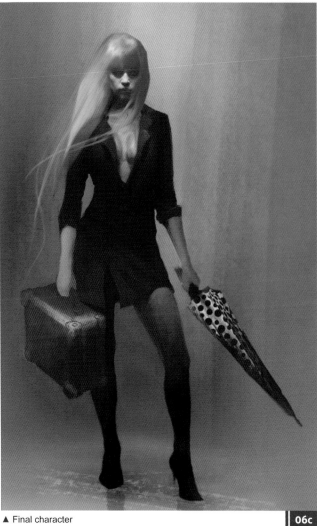

▲ Final character **06c**

★ PRO TIP

You have an iconic candidate!

When designing characters and you are not sure if your ideas work, it can be helpful to translate your design into a new style: say a comic figure, a children's drawing, or a caricature of your original. Something reduced, that will show the important parts. Are you are still able to recognize the character? If yes, there is your hint – you have a good thing going!

Children's drawing of the character

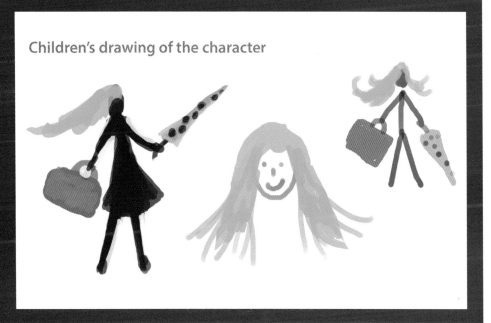

▲ A children's drawing of the character

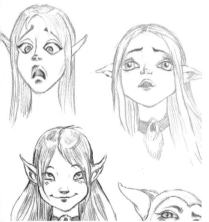
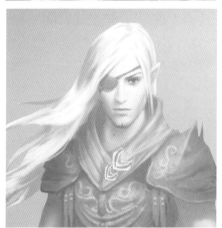
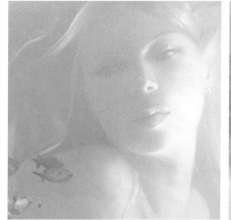
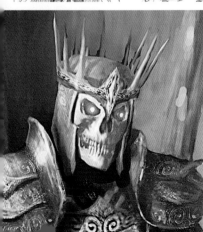
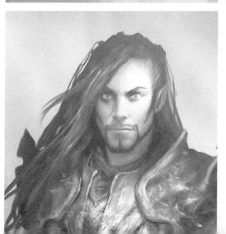

Establishing your character

Discover key art theory techniques and top tips to present compelling and recognizable character designs.

You now have the knowledge to set up your workspace and tools, but how do you go about designing a convincing character? In this section Benita Winckler will present some notably recognized theories linked to depicting a character. Starting with form and anatomy, Benita will then take you through character types, composition, storytelling, and moods, using images to demonstrate definitions and discuss the clues and tools behind communicating an effective character creation.

Form and anatomy

How to portray your character through the use of body types and gestures

by Benita Winckler

The human interest in portraying characters has a long history, in some ways making character design an ancient art form. Nowadays artists have the mighty Photoshop available, but the basic problems of how to present a character in the most compelling and recognizable way still remain. To make a character design work, you need to consider many different aspects, including form, shape, posture, and facial expression.

It's also important to understand that it all starts in the mind of our audience. The more we know about the clues and magic tools behind the art of communication, the more powerful and effective our creation will be.

A character consists of much more than just his or her high-tech armor. If we can manage to scratch at the surface and bring out what is behind the fabric, metal, or painted mermaid scales, then we can show our viewer a real "person" and they will be able to make the connection.

Step 01

Form and anatomy

Form is one of the first things we perceive when looking at a character. Based on the appearance, the anatomy, and the pose, we start to make assumptions on what we can expect from the character in front

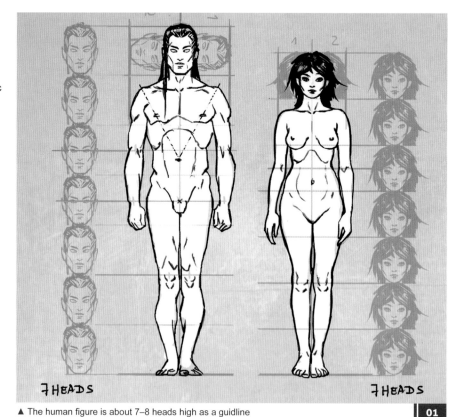

▲ The human figure is about 7–8 heads high as a guidline

01

of us: for example are they a friend or a predator? Strong or weak? Young or old?

When taking in the available information about the world around us, our brain starts to generalize; we run internal scripts and then certain responses are triggered. This happens lightening fast and often without our conscious awareness. The result can

be that we are afraid of someone, or that we feel drawn to them, for example.

Looking at a baby, for instance, will trigger emotions of protecting something helpless, while looking at an image of a powerful attacker will trigger feelings of fear, awe, or antipathy. This all happens on a deep, subconscious level.

Why is all of this interesting for us as character designers? Because we can play with these assumptions to communicate our stories and ideas to our audience!

Let's look at how to draw the basis of the human form from which we can then start our exploration. As a general guideline for proportions, the human figure falls between 7–8 heads in height (see image 01). Notice that the female form is rounder, softer, and less angular than the male. These kinds of differences in the overall shape can be used with great effect as we will discuss next.

Step 02
Shapes and personality

Why is it that the form and the overall shape are so important when it comes to designing our character? Based on our experience with the objects in our world, you could say that we are able to assign different personalities to different kinds of shapes (image 02a).

Think about a sharp object, like a knife or a shard of glass. What does its basic shape look like? It has a hard edge; it is pointy, spiky, and probably has some straight lines. Reduced to a basic shape this can give you a triangle. If this idea is taken further, you could enhance your character's design by adding triangular shapes to create a sense of evil and give them a dynamic edge.

Alternatively, think about a round object, like a pear or an apple. These create a sense of softness and gentleness often associated with female characters. You could use these attributes for a friendly character by giving it flowing curves and rounded forms.

Another basic shape we can use for our designs is the square or rectangle. Its attributes are that of strength and stability. It is static. Think of building blocks that can form a house. Rectangles are reliable. They will not fall over so easily. If used in your design, rectangular shapes can help to give an impression of a good, strong character.

You could use a combination of these shapes to develop different character ideas (image 02b).

Using shapes for character design

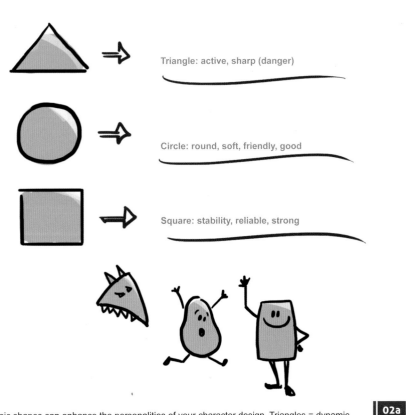

▲ Basic shapes can enhance the personalities of your character design. Triangles = dynamic, sharp, dangerous. Circles = calm, friendly, soft. Squares = static, strong

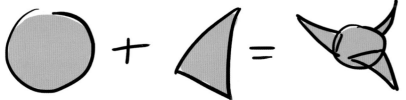

▲ Combine basic shapes for new character ideas! Here, a round head shape (friendly) plus some spikey triangles (possible danger) creates a rascally beastling

Step 03

Differences in female/male portraits
So, what is it that makes a male face look "male" and a female face look "female"?

If you take a look at image 03a, the generic male has hard lines, angularity, features as if chiseled from a rock, a strong jaw-line, and a square chin. The female portrait shows delicate, rounded features, overall soft curves, and no harsh angles.

To produce a male-looking portrait, draw the head shape a bit squarer and more angular, make the neck shorter and thicker, and add the Adam's apple.

For a female head, draw the lines rounded, with less sharp corners. Her neck will be longer and thinner with soft curves instead of straight lines. The skin tones can be darker for the male, indicating rough features and a hint of facial hair; for the female paint the skin light and silky.

For your female portraits, paint the eyebrows in a fine soft curve. You can see the effect of masculine bushy eyebrows on a female portrait in image 03b.

For females paint the eyes more open and bigger than the males'. To enhance the female touch you can add eyelashes and eye makeup. For females paint the nose delicate with finer features.

Female lips tend to be fuller; however males can be equipped with beautiful lips and still look masculine.

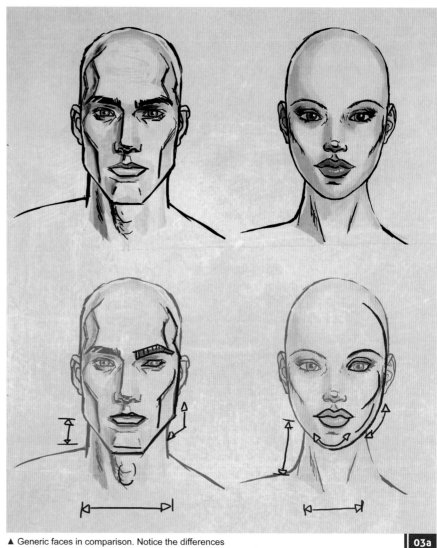

▲ Generic faces in comparison. Notice the differences 　　03a

Step 04

Facial expression and mood
Unless our character is a very good actor, poker player (or has had lots of Botox injections that prevent the facial muscles from working), we will be able to tell his or her emotional state from the facial expression and the look in their eyes (image 04). Are the eyebrows raised or furrowed? Are the eyes wide open or droopy half-awake? Is the mouth relaxed? Smiling?

There is a great variety of emotions, positive and negative, and our facial features will display them accordingly: happiness, pleasure, interest, disgust, anger, contempt, fear, and surprise, just to name a few. However it will help a lot if you don't just stick to these basics; instead try to invent some sort of context for your character – a story, a

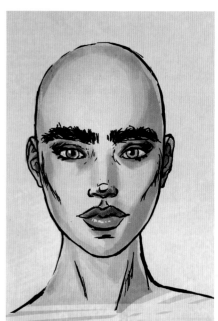

▲ Thick, bushy eyebrows for females will 　03b
create a masculine effect

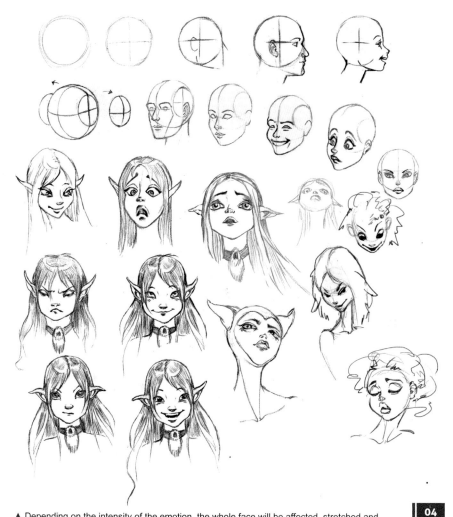

▲ Depending on the intensity of the emotion, the whole face will be affected, stretched and twisted, by the expression

04

special situation that he or she is confronted with – so that you can come up with better fitting expressions with finer nuances.

"A look can be challenging or inviting; it can signal interest, involvement and warmth, fear, sadness; or it can seem brutally cold and intimidating"

Step 05
Eye contact

How do you give your character that special "look", which really brings them to life? Just as in the old saying, "the eyes are the window to the soul", you can use the eyes of your character to communicate how they feel and what they are thinking. A look can be challenging or inviting; it can signal interest, involvement and warmth, fear, sadness; or it can seem brutally cold and intimidating.

If you take a look at images 05a and 05b below, you can also see that a portrait of a character that is directly looking into the camera can have an intense effect on the viewer because of the connection that will be established – it addresses and involves the viewer directly. This can be a useful trick so keep it in mind!

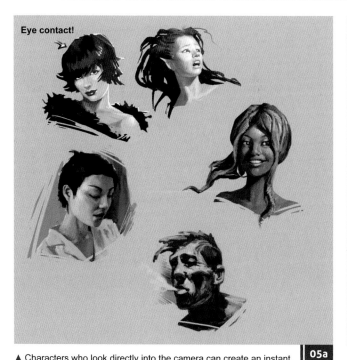

Eye contact!

▲ Characters who look directly into the camera can create an instant connection with the viewer. Use this little "trick" to engage the viewer

05a

▲ Hiding parts of the face behind a mask will obscure the expression of its owner, causing the viewer to guess what lies behind it

05b

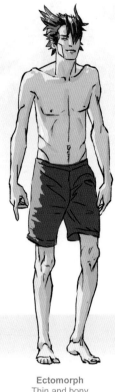

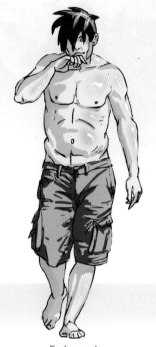

| **Ectomorph**
Thin and bony | **Mesomorph**
The energetic type | **Endomorph**
The fat type |

▲ Cultural stereotyping

Step 06

Body types (somatotyping)

Are body types related to special character traits? According to Dr. William Sheldon, a US psychologist who studied the variety of human bodies and temperaments, they are. In the late 1930s he created his "somatotype" system. Having taken pictures of thousands of people for analysis, he discovered three fundamental elements which, when combined together, make up all body types.

Sheldon calls his three somatotypes: ectomorphic, mesomorphic, and endomorphic. Of course we all (men and women) have these components in varying degrees; no one is simply a mesomorph without having the other elements present even a little.

But the easiest way to get an idea of the variety of human physiques is by looking at the three extremes (see also image 06):

- Ectomorphic: long, thin limbs and thin muscles with low fat storage. They don't build muscle easily.

- Mesomorphic: muscular, strong, with large bones, moderate fat levels, and a solid torso. Predisposed to build muscle easily.

- Endomorphic: wide hips, medium shoulders, with a medium bone structure. They gain weight and store fat easily.

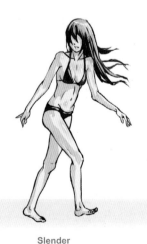

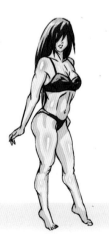

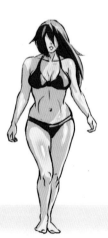

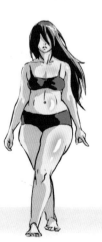

| **Slender** | **Athletic** | **Hourglass** | **Pear** | **Apple** |

▲ Some generic female body types

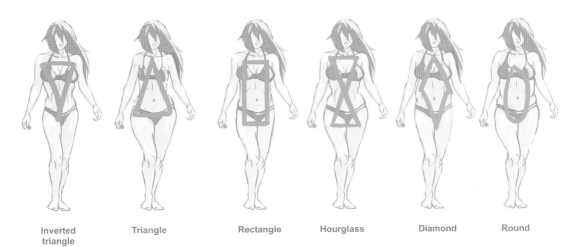

| Inverted triangle | Triangle | Rectangle | Hourglass | Diamond | Round |

▲ More categories for female body types

Certain physiques carry certain cultural stereotypes. For example, mesomorphs (muscular) are perceived as popular and hardworking, whereas endomorphs (fat) are seen as being lazy and slow. Ectomorphs (bony, thin) are stereotyped as being intelligent but fearful, with a strong love of long-distance sports, such as marathons.

Presumptions also include the idea that endomorphs are sociable and easy-going, mesomorphs are adventurous, bold, competitive, aggressive, and energetic, while ectomorphs are introverted, inhibited, and secretive. So the shape of your character can convey what type of person they are.

Step 07
Categories for body shapes
Study the differences in form and shape in our fellow human beings. By closely examining the people around us, we develop

a keen eye for the rich variety of proportions that exist. It is like building a visual reservoir to use for our character designs.

In general you will want your female characters to appear more delicate than their male counterparts. Think soft curves instead of hard angles. Females tend to have higher levels of fat to be stored in their body compared to males. This will also affect the body fat distribution: in females the buttocks, hips, and thighs will be more rounded than those of males; males will be more muscular.

Images 07a and 07b give some examples of different body shapes that can be used to categorize the female body. Obviously there is no fixed rule and there are wide ranges of actual sizes within each shape. With an idea of basic shapes and variations you can create pretty much any type of character you want. Don't draw all your women (and

men) the same though! It happens often, that we adapt to one way of doing things and then we get lazy and repeat what we have learned over and over again. Explore the differences and try some variations!

Step 08
Poses, balance, and movement
When drawing a character, it is important to understand that the human form, in essence, is a delicate balancing act. With every step, we set the masses of our body into motion. This can look graceful or not. The various ways in which people walk is a great source of inspiration for character design.

Depending on the energy a character puts into the movement, it can be a presentation of confidence, the head and body held upright, challenging the world, or if the energy is missing it can be a sloppy maneuver, with the character defeated and slouching along, with drooped shoulders and hanging arms. These qualities will show in their silhouettes (see image 08).

▲ Explore the effects of different poses by using silhouette drawings. The shape alone can communicate a lot about the inner state and mood of a character

08

★ PRO TIP
Silhouettes
Silhouettes are a great tool to explore the effect of a pose, to check if it really works. Also, they act as a quick way to focus on shapes and designs that make a strong impact on the viewer. A good character will be easily recognizable as a silhouette.

Step 09

Curves, rhythm, and motion

Since character design has a lot to do with producing an emotional response from the viewer, the more life-like a design, the easier it will be to connect with our audience. We need to capture the energy and attitude of an imagined, "living" being. In a drawing we can work with the lines and curves to tell our story and give a sense of movement and excitement to our creation.

In image 09, you can see the effect that symmetry has on a pose. It will look stiff, dead, and a little boring. But, if our model is presented in an asymmetric pose, as seen on the right side, the flowing curves will change that impression instantly.

Step 10

Body language and gesture drawings

Non-verbal communication plays an important role in human social interaction. Even if we don't speak, we still communicate via our body language. According to some studies about the communication of emotions by Professor Albert Mehrabian, if a person sits in front of us, talking about their feelings, we will react to 55% to body

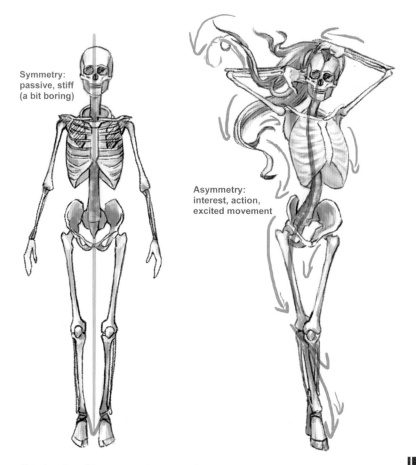

Symmetry: passive, stiff (a bit boring)

Asymmetry: interest, action, excited movement

▲ Note the effect of the asymmetric pose: the flowing curves give a sense of motion and balance to the pose. Our skeleton comes to life! **09**

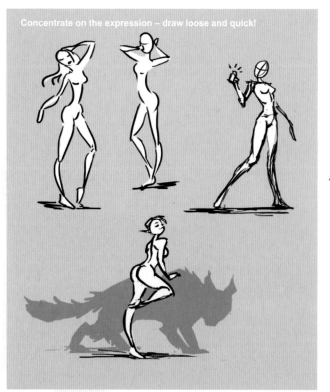

Concentrate on the expression – draw loose and quick!

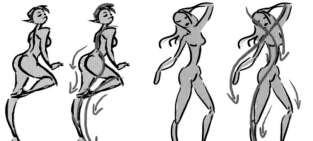

Flowing lines suggest balance, rhythm, and vivid movement

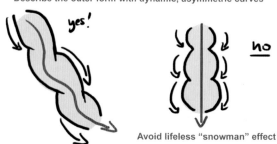

Describe the outer form with dynamic, asymmetric curves

yes!

no

Avoid lifeless "snowman" effect

▲ Initial gesture drawings. The red lines illustrate the rhythmic flow. Use asymmetric curves to indicate movement, direction, and balance! **10**

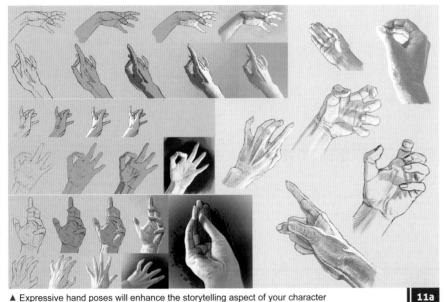

▲ Expressive hand poses will enhance the storytelling aspect of your character

"Capturing some spark of life in a drawing or painting is where the real magic appears"

language, 38% to tone of voice, and only 7% to spoken words. That means that while we are watching the person in front of us, we will subconsciously "read" his or her real feelings and attitudes, no matter what they say. As artists then, we can use the effects of body language to communicate our story.

To find a nice, lively pose for the character, it is helpful to start with some quick gesture drawings (image 10). These are simple drawings that capture the essence of a pose. Is the character happy or sad? Aggressive or passive? These basic qualities should be apparent in the initial lines, ready to be taken further in design.

Capturing some spark of life in a drawing or painting is where the real magic appears. The more we render and rework an artwork, the more we tend to kill this off. Make sure you keep the lines vivid and loose right from the beginning, so that there will be some energy left shimmering through in the final illustration.

Step 11

Expressive hand gestures

Another way to enhance the look of your character is to pay attention to the expression of the hands. We use our hands when communicating. Some of us do it more than others. There are subtle poses and wildly exaggerated ones. Hands can be used to point at things; they can be clawed in anger, or opened in friendship; they can be inviting, seducing, demanding, or defending.

Sometimes simply looking at a character's hand pose can offer sufficient information to understand what kind of character we have in front of us. There are so many cues we can get from analyzing the way people hold their hands: if someone is biting their nails, for example, the person appears anxious and unsettled. Hand poses can therefore be used with great effect to tell your story (see images 11a and 11b).

▲ The hand, holding the delicate scarf of the dress, adds to the seductive pose of the character

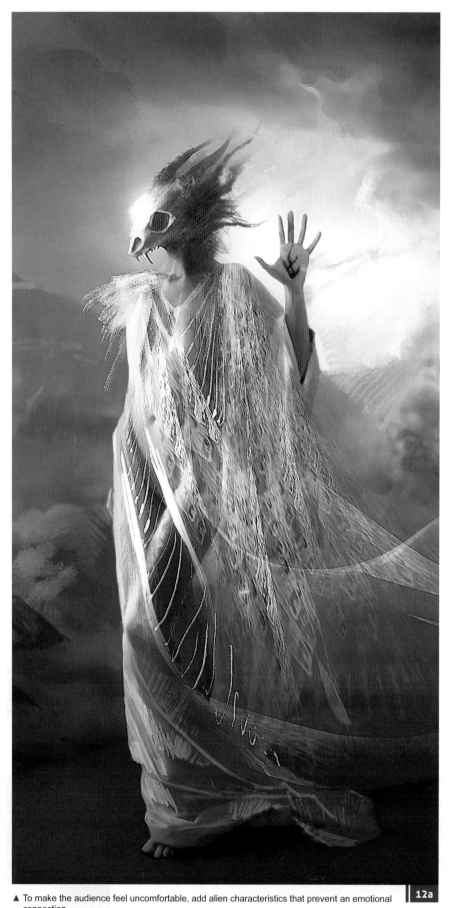

"As human beings we have the ability to be empathic and the more similar the other being is to us, the easier it will be"

Step 12
Thoughts on alien hybrids

Let's end this chapter with some thoughts on hybrids or alien characters. How far can we go with our creation? How many human characteristics can we replace without losing contact to our audience? As human beings we have the ability to be empathic and the more similar the other being is to us, the easier it will be.

The more alien our counterpart appears, the more suspicious we are (see image 12a), and so when it comes to an emotional contact, we need similarity to connect (see image 12b). We can relate to hybrids as they are fully capable of emoting as human beings do – take a look at the one in image 12c for example. Play around with this balance to see what you can achieve!

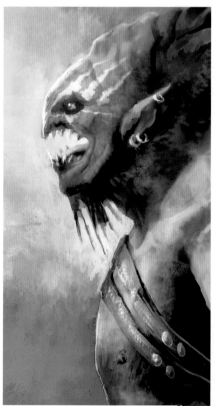

▲ To make the audience feel uncomfortable, add alien characteristics that prevent an emotional connection **12a**

▲ This guy seems to be rather unlikable, but has relatable human characteristics **12b**

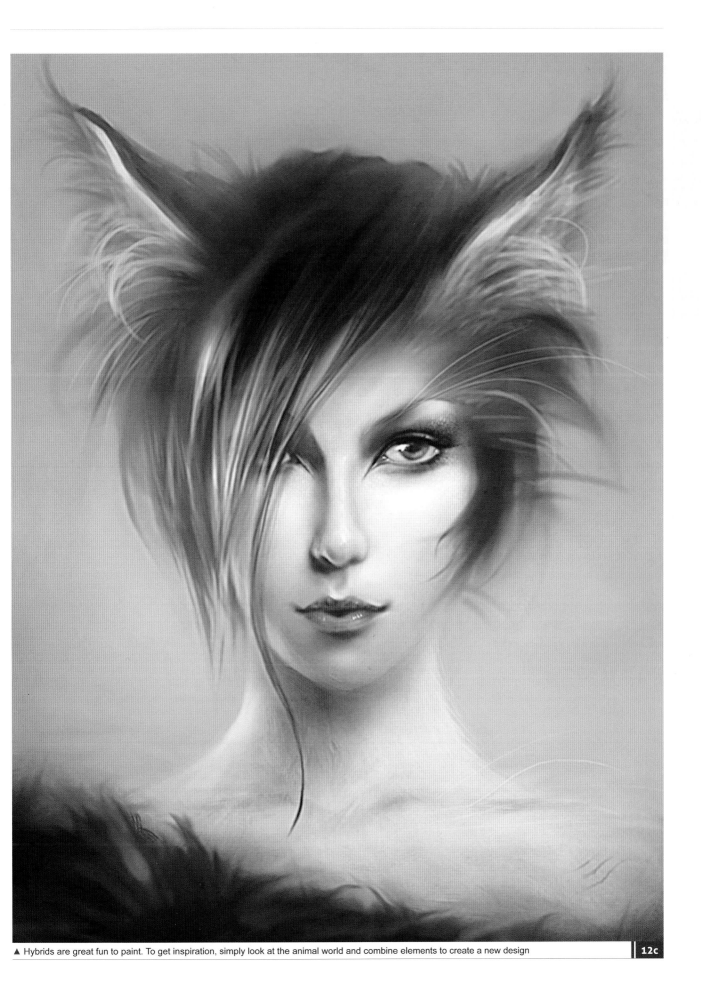
▲ Hybrids are great fun to paint. To get inspiration, simply look at the animal world and combine elements to create a new design

Character types

What makes different types of characters recognizable?

by Benita Winckler

We tend to perceive the world around us with a lot of biases; stereotypes do exist. If they are overdone in an artwork it can look kitsch and our reaction will be either boredom, or amusement if the presentation is really over the top and intelligently done so on purpose.

As character designers we need to be aware of known character types and the associations that go along with them. The big task here is to create interest and avoid generalization (where the result is boredom), while at the same time showing our audience something that they can relate to.

To do so, we need to open a door into the audience's past experience. We need to find something that will connect with them on a deeper level. If you are able to talk to your audience about something that is meaningful to them, which taps right into their feelings and their emotions, then and only then will you get a response for your artistic endeavors.

If you want to be understood, be original; but don't stray too far from a certain type. If the character is evil, make them look evil. Let's talk about the various character types and how we can use visual key elements to make sure that our character will be perceived as we want it.

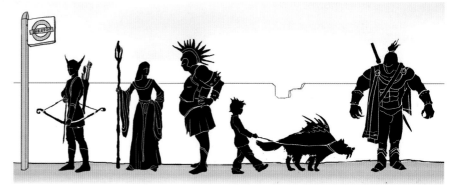

▲ Character line-up with some standard cliché character types amongst them

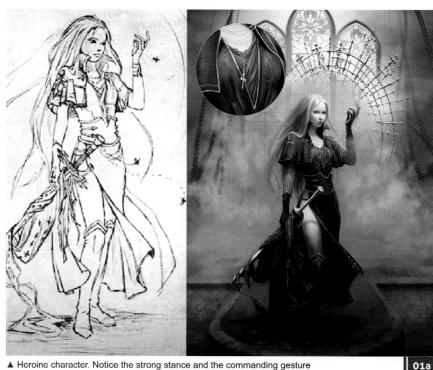

▲ Heroine character. Notice the strong stance and the commanding gesture

01a

Step 01

Heroes and heroines

The main character for most stories is the hero (or heroine), or the good guy (or girl). This doesn't have to be a mega-muscular superstar, eternal winner, half-god, or top model; but the character does has to have certain features and characteristics that will make them recognizable as a hero in any situation.

Let's analyze what makes a character appear to be a hero. In the previous chapter we talked briefly about the effect that shapes can have in character design: triangles for active, dangerous features; squares for reliability; and circles for friendliness. This is one way to communicate an idea. Another approach is to work with a mix of elements that when seen together will convey certain characteristics. Elements that can suggest a hero are a strong, upright stance, shoulders back, wide chest, and belly tucked in, with a commanding hand gesture. Weapons can also suggest strength (although be aware that a little unarmed boy can be a hero, too!).

In image 01a the jewelry and the insignia of the uniform suggest power and influence. Blond hair looks good on angelic characters but can be used on evil ones as well if accompanied with supporting elements. Red is a good color for strong characters as it demands attention. Here the effect is enhanced by adding golden tones overall to suggest wealth and energy. As a guideline, make your heroes look strong, with a strong expression on their face. Image 01b is another example of a heroine.

Step 02

Villains and evil characters

These are the fun ones! With evil characters there is nothing holding you

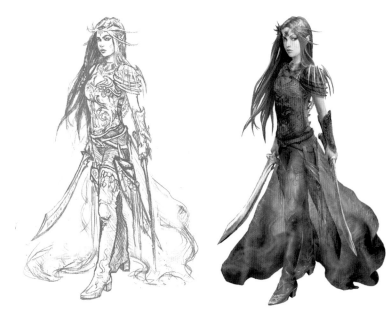

© S. Fischer Verlag GmbH, Frankfurt am Main, 2014 erstmals erschienen 2012 im Sauerländer Verlag

▲ Another example of a heroine character | 01b

back. Enjoy the dark side and go wild! In comparison to the good guys there is plenty of opportunity to add subtle humor and to happily overdo it. Image 02a shows an example of a villain Elvin warrior. I have enhanced the front part of his hairstyle to give his already pointy face an even pointier and sharp-edged look. Here the real attitude of the character is mainly shown in the expression of his face. The long hair

blowing over his shoulder gives a nice spiky outline with lots of splinter-like triangles, suggesting a certain dynamic and danger.

At this point you may wonder what it is with all this analysis of small details: it's important to remember the importance of the little things. If you look at image 02b, it shows the same character but with softer facial features – notice how the evil aspects are gone.

★ PRO TIP

Add some contrast

To make the character really stand out, always aim for contrast. Try combining the hard (or even nasty) features with something nice, charming, and beautiful.

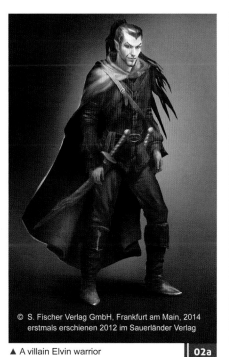

© S. Fischer Verlag GmbH, Frankfurt am Main, 2014 erstmals erschienen 2012 im Sauerländer Verlag

▲ A villain Elvin warrior | 02a

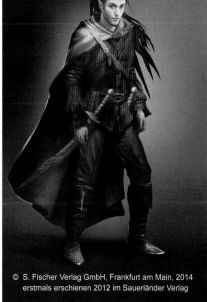

© S. Fischer Verlag GmbH, Frankfurt am Main, 2014 erstmals erschienen 2012 im Sauerländer Verlag

▲ Altered slightly and he looks friendly | 02b

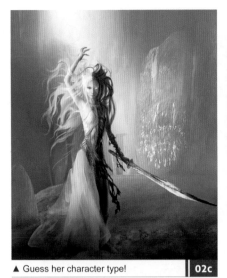

▲ Guess her character type! **02c**

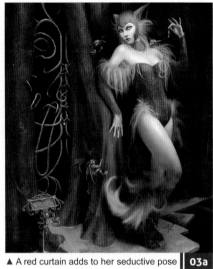

▲ A red curtain adds to her seductive pose **03a**

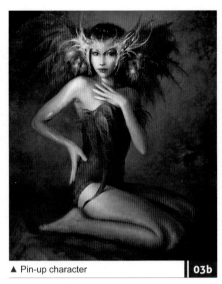

▲ Pin-up character **03b**

© Mosaic Mask Studio

▲ Some goofy/funny characters produced in a stylized comic style

04a

When creating a villain, try to imagine how a bad guy would behave. You could even act the part in your mind – imagine the gestures, facial expression, and personal interests of the character. Minor details such as a particular way to style the hair can really add a lot of depth to the impression of a villain (image 02c).

> "If you need to paint a powerful femme fatale for your project, first think about her story. What is your character's mission?"

Step 03

Femme fatale and pin-ups

The femme fatale: think of snake-dancers, spies, and double agents in James Bond movies; think mystery, seduction (image 03a), and deadly situations!

When analyzing this character type, we can say that the major ingredients are that they are attractive, erotic, strong-willed, and morally ambiguous. The femme fatale is dangerous. *Her beauty is a weapon and she knows how to use it...*

If you need to paint a powerful femme fatale for your project, first think about her story. What is your character's mission? In what time is she living in? This will dictate the choice of clothing. Select a suitable lascivious pose – self-assured and feminine. Keep the expression in her face strong. No weakness! To add a soft spot to her psyche, give her a luxurious addiction such as a love for diamonds, champagne, or cigarettes. Add these elements to her outfit to support your story.

Classic pin-ups, in comparison, generally look more innocent and playful. Here the task is simple: paint a sexy, playful female for decorative purposes. Show some skin, tease, and make sure you keep the atmosphere light and joyful (image 03b).

Step 04
The goofy/funny character

Thinking about the classic Disney cartoons, a number of characters will easily spring to mind when you think of this type of character.

Image 04a shows an example of two characters created in a comic style. The wonky guy on the right is our hero; the evil-looking lady on the left is the antagonist. Let's analyze the features that make the hero look particularly goofy.

First, note the pose. His stance is quite crooked and stooped. He is a good guy (smiling, open expression), but sloppy and clumsy: the open belt of his jacket suggests that he is slacking off, careless, and lazy. His hair isn't very tidy either.

In terms of the antagonist, since the requested style in this case wasn't realism but comic, exaggeration is the right tool. She is supposed to be a villainous principal/mistress so the headdress was a good

© Mosaic Mask Studio

▲ Comic characters placed in a scene
04b

element to focus on. The double-layered costume design is easily recognizable in this sense and, with its stiffness, communicates the inner state of the character. The white gloves add to the impression of her absolute correctness and idolized perfection. Her weapon of choice is the little red book in her hands (let's assume it is some sort of religious artifact, which is of great value to her, as her pose suggests).

The environment that the figures are placed in is also significant in establishing the characters (image 04b). The background helps to give the viewer an idea about the time and location in which the characters live – there is no electricity, instead a gas lantern and candles.

Look at the background in image 04a as well. Gnarly, leafless trees and cobwebs hint at the autumnal season. Through the fog in the far background we can see some sort of castle or what may be the roofs of a shabby old town. The overgrown steps add to the overall atmosphere.

"Feel free to overdo the physiques: strong fighting types can do with a bit of unnatural muscle mass"

Step 05
The dark warrior

The next character type on the list is the dark warrior, a character equipped with a sword and fully armored. When painting fighters in armor, it can be helpful to analyze the functionality of the equipment before starting with the design. Most people will probably never notice if a sword is made for two hands or for one hand, or if the grip is long enough or too short. For a warrior character, however, there is extra effort needed to make sure the armor and weaponry are recognizable (while still being functional). Also feel free to overdo the physiques: strong fighting types can do with a bit of unnatural muscle mass.

▲ Warriors need recognizable as well as functional weaponry
05

★ PRO TIP

Create a focus point

To pull the focus of your viewer to a certain area, make sure you give it the greatest contrast in your image. This is where you will want to put your lightest lights and darkest darks (see more about composition on pages 62–71).

Step 06

Magicians, spells, and light effects

Let's talk about magic. When dealing with magicians, a certain amount of visual fireworks have to be expected. After all, they have supernatural power and know how to bend and manipulate reality. We'll now stop the theory and open Photoshop to create some fireworks for ourselves.

Image 06a shows a magician character. As you can see, there is no pointed hat, flowing robe, or long wand. Instead I have played with a mixed effect of exotic costume, hand gesture, and light to suggest the magical act of spell-casting. To create light effects I usually use the following workflow:

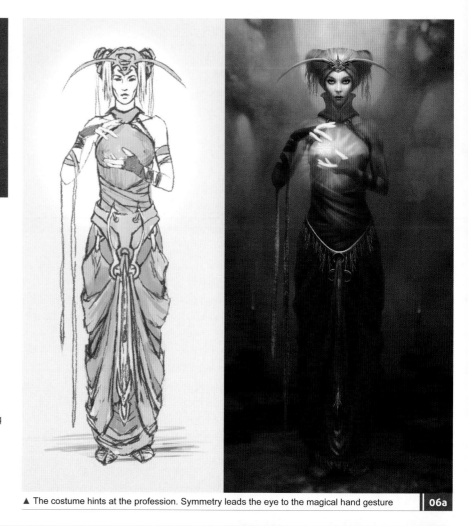

▲ The costume hints at the profession. Symmetry leads the eye to the magical hand gesture | 06a

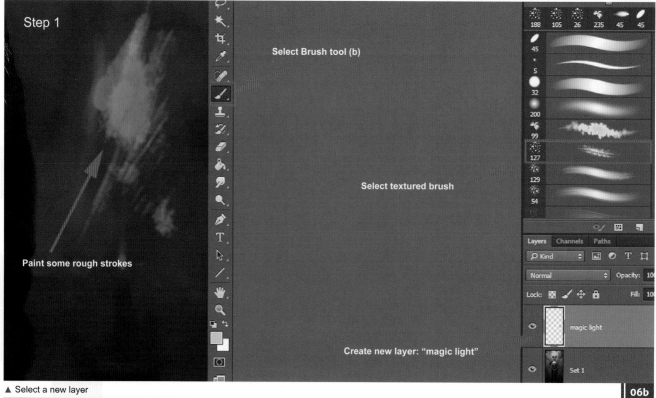

Step 1

Select Brush tool (b)

Select textured brush

Paint some rough strokes

Create new layer: "magic light"

▲ Select a new layer | 06b

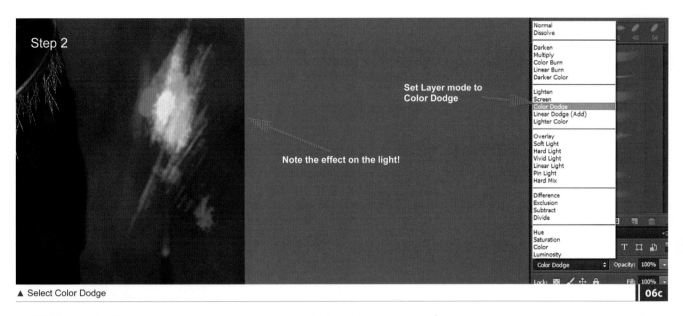

▲ Select Color Dodge **06c**

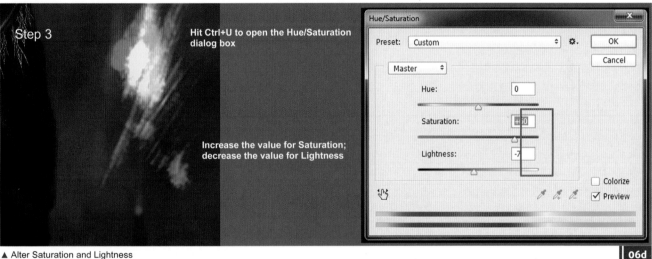

▲ Alter Saturation and Lightness **06d**

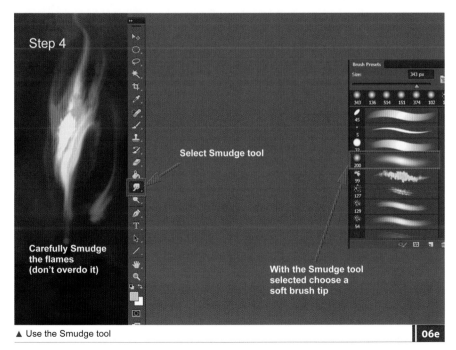

▲ Use the Smudge tool **06e**

1. Select a new layer to paint on and name
 it "magic light". With a textured brush,
 paint some rough strokes. Choose muddy
 colors for this – no extremes (image 06b).

2. From the Layer mode menu in
 the Layers palette, select Color
 Dodge. This mode can cause some
 interesting effects (image 06c)!

3. With the "magical light" layer still
 selected, hit Ctrl+U to open the Hue/
 Saturation dialog box. Alter Saturation
 and Lightness (see image 06d).

4. Carefully use the Smudge tool to
 soften your brushstrokes. Note: image
 06e shows extreme smudging, in
 order to better illustrate the effect.

▲ Elite paladin, marked from endless fights **07a**

▲ Paladins on their way into battle **07b**

Step 07
Knights and paladins

Another character type that is often needed is the knight or paladin character. There are similarities to the warrior character: what has been said about the weaponry and armor applies in this step as well. In fact, all these categorizations are quite flexible.

Maybe a paladin will take better care of his appearance than a warrior living out in the highlands. However, if a knight has spent the last few months on the road, sleeping in muddy tents, that image could look different. Again, think about how the story will have an influence on the look. Has the sword of your knight character been excessively used in battle? Is his armor marked from endless battles (image 07a)? Is he a spotless, shiny knight on a white horse, composing poems all day? Considerations such as these will enhance the believability of any artwork you create.

▲ Areas of interest are his face and sword **08a**

▲ The crown indicates her royalty **08b**

When painting a type of knight that will appear as a group or more than once on a battlefield, it can be helpful to give the group a visual element that is easily recognizable. Image 07b shows an example of a group of knights, all with red elements visible. The rounded design of the helmets also gives a visual clue that these are members of the same side/army.

Step 08
Skeleton kings and other royals

Skeletons don't offer that many possibilities for facial expressions, with a bit of artistic

freedom, however, we can still give one an intimidating look (image 08a). A throne adds a lot to the idea that we are dealing with a king here. The crown, in addition to the richly detailed armor, tells the audience about his status.

When painting people of royalty, one way to strengthen the impression is to use rich ornate clothing and shiny jewelry (image 08b). Think delicate structures, elaborate design, abundance in pattern, and variety. For a poor character you would expect a simpler look in comparison.

Step 09
Children and young characters

The perfect heroes for adventure stories! When painting young characters, look at the physique and anatomy (image 09a). The facial features will be softer and more rounded. A child's head is bigger in relation to his body than that of a fully grown adult. To paint a character that will be perceived as a child, use bigger eyes, a larger forehead, smaller shoulders, and small arms.

Pose is another way to create a character that will be perceived as young or youthful.

Children's movement and stances are natural and unrestricted since they haven't learned to follow all the rules of an adult world yet.

Image 09b shows the character of a young orphan during Victorian times. His trousers and jacket are torn and oversized. However the situation isn't hopeless, he is positioned on the roof-tops overlooking the city and there is a lot of light in the picture. We will talk more about composition and storytelling in the following chapters.

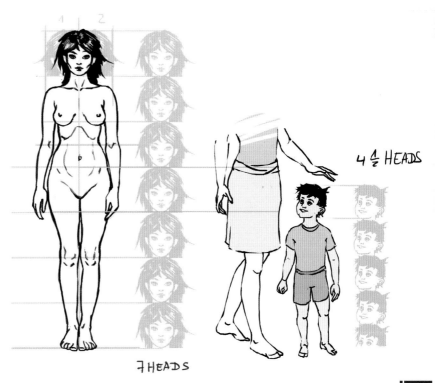

★ PRO TIP

Experiment with scale
To play around with the scale of your character design, select and copy your design, then use the Transform tool (Ctrl+T) to scale it up or down (hold down Shift at the same time to keep the ratio).

4 ½ HEADS

7 HEADS

▲ How can we tell if the character is a child? The secret lies in the relation of head size to body 09a

▲ A young orphan boy. His clothes don't fit and the huge hat further enhances his childlike appearance © Sauerländer audio/Argon Verlag 09b

Composition and positioning

Techniques and rules to enhance your designs

by Benita Winckler

If you want to enhance the visual impact of your design, you need to decide on a good position for your character within your composition. Certain compositions will work better for a given task than others.

In this chapter we will look at the different qualities of various compositions. We will look at rules, such as the golden ratio and the rule of thirds, and will discuss

how the application of them can improve the appearance of an image. We will also examine some of Photoshop's tools that make composing an image much easier.

Note that composition rules do apply for character portraits. We will therefore look at the subject of the framing of a portrait. We will explore possible pitfalls in composing portraits and learn how to avoid them.

Composition not only works on a macro level (big shapes) but on a micro level as well (inner coherence). To achieve a harmonious result, a composition needs to work on all levels. The trick is to not paint parts in isolation, but instead relate them to other parts. Playing with the macro and micro in your composition is a lot of fun; it will help lead the eye of the viewer around the image, ideally directing the speed and flow of their attention.

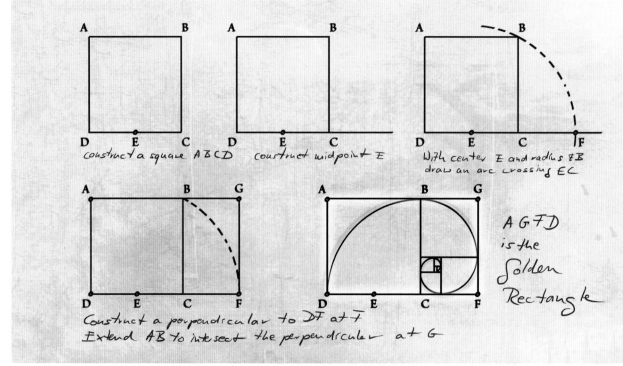

▲ An approximate of the golden spiral, a logarithmic spiral whose growth factor is the golden ratio or phi

01a

▲ An example of a design that can be described with the golden spiral

01b

Step 01

The golden ratio

"Without mathematics there is no art"

Fra Luca Pacioli (a contemporary of Leonardo da Vinci)

The human instinct for the detection and appreciation of beauty is one of life's great mysteries. Sure, beauty lies in the eye of the beholder, but there are proportions that are commonly accepted as beautiful and aesthetically pleasing. The first discovery of the golden ratio dates back as far as some hundred years BC. Since then numerous mathematicians and artists alike have studied and worked with the "divine proportion".

Examples of creatives who have worked with the golden ratio include the famous architect Le Corbusier, who proportioned his work approximately to this ratio. Another example is Leonardo da Vinci, who used the golden rectangle extensively in his paintings.

You can construct the golden proportion (which is the beautiful number of 1.6180339887, represented by the Greek letter Phi) by following image 01a. As you can see, the golden spiral is derived from the golden ratio and is an organic way to lead the eye of your viewer around your

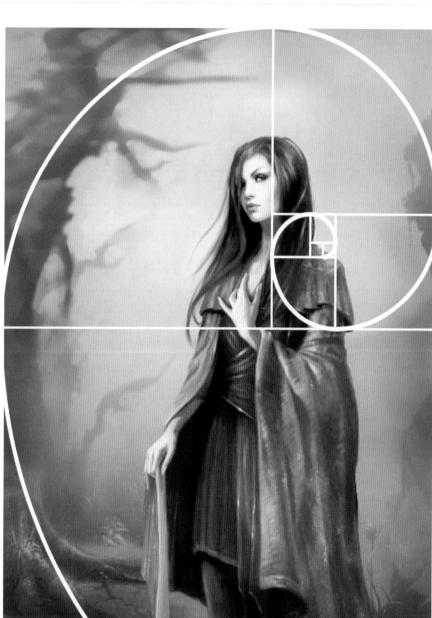

▲ Another example of the golden spiral. Here the background elements are framing the character in a spirally flow

01c

composition. It draws the eye to where you want it to focus. Your subject can sit in the intersection or, for great impact, in the center of the spiral (see images 01b and 01c).

Although numbers are a fascinating topic, let's not look further at the math here, but rather inspect the possibilities of its use in our character design compositions.

Step 02
Photoshop tools for composition

When starting a new creation we normally work instinctively, without measuring the relation of elements with a ruler. Often it is not until the image is done that we suddenly notice that we have followed an inner idea of a harmonious arrangement that can now be made visible by overlaying a diagram, such as the golden spiral. This is an important point: when laying out an initial design, don't restrict yourself to rigid guidelines, but instead trust your instincts. Still, it is good to know the theory behind composition so you can improve your paintings if necessary.

Before we practice how to generate fresh composition ideas, let's look at a useful Photoshop tool that will come in handy: the Crop tool. If you want to check if the framing works or if it can be optimized, simply use the Crop tool to shift the important elements to the sweet spots of your composition (for example, where the composition lines intersect and create a focal point).

Open a sketch. From the toolbar, select the Crop tool (shortcut C). The Crop menu has different options; select Golden Ratio for example (image 02a). With the Crop tool selected, click into the image. You will get an overlay dividing your image into golden proportions (image 02b). Note that intersections are a good place for your center of interest. Pull the anchor points (image 02c) to shift areas of your image to these intersections and improve the composition. Hit Enter to confirm; then you can continue the work on your design.

▲ Select the Crop tool to refine the composition and framing of the character **02a**

▲ The overlay grid shows whether the design is working **02b**

▲ Anchor points are pulled to re-frame the canvas **02c**

▲ Left: balanced; middle and right: tension because of the contrasting sizes **03a**

▲ Two ideas for dividing the canvas horizontally and vertically **03b**

▲ Add diagonal lines to divide the canvas into interesting sections **03c**

▲ This technique works the other way around as well! Use shapes to analyze a sketch and then play with the composition as discussed | 03d

Step 03

How to generate composition ideas

Breaking the spell and coming up with new ideas out of nowhere can be a challenge. Let's look at a way to discover possible new ways of placing our elements on the canvas.

Start with a blank canvas of any size you like, say 600-pixel × 900-pixel screen resolution (this is going to be a rough sketch for exploration, so there is no need for print resolution at this point). The example discussed in this step is in a landscape orientation.

With a hard-edged brush, paint two interacting abstract shapes on the canvas. Note the different impressions of the abstract shapes. To create tension, draw one shape bigger in relation to the other. If two shapes are seen as identical in size, they will tend to balance each other out, which will result in a calmer and less dynamic look (image 03a).

We're going to continue with the balanced version on the left, touching upon the rule of thirds. The rule of thirds involves applying a physical or mental grid over your image, usually made up of four horizontal and

vertical lines, and placing your focal point on the intersections or along the lines. Start by dividing (using brushstrokes) the canvas horizontally and vertically (image 03b). Then decide where to put the center of interest (see step 04); avoid putting it in the center.

Now add diagonal lines that further divide the canvas into interesting sections (image 03c). Later on you can refer to these "lines of action" when sketching. Shapes help to analyze a composition (image 03d) and can be a guideline for simplification. Image 03e shows the final composition.

▲ The final composition | 03e

Step 04

The center of interest

The center of interest is basically about fascination. One area of the picture is given the quality of creating a powerful attraction. If all goes well it works like a charm and the focus of our viewer is magically drawn to it.

For a successful center of interest, ensure that other elements of the picture do not create distraction; they should support the effect. If their appearance is too intense, elements will start to compete, diminishing the intensity of the area of interest.

Image 04 shows some interesting compositions. In the top-left the scribble shows a composition with a center of interest reduced and simplified for maximum effect as a dot in the middle of nowhere; by eliminating all other elements in the image, the viewer has no option but be drawn to the simple object in the composition. If we zoom in (top-right), we can detect a person. Interesting! Coming even closer (mid-left), we naturally focus in on the face and the gesture (the center of interest is placed at the top-left intersection) until we are close enough see the beauty spot on her skin (mid-right). By placing the center of interest along intersections we are following the rule of thirds, which helps to emphasize the focal point in the composition.

For mandalas (bottom-left), a centered focus area might be acceptable. Portraits of royals (bottom-right) or other awe-inspiring figures can benefit from a symmetrical composition, with the center of interest placed in the middle instead of somewhere to the left or to the right.

Give one part of the artwork special attention. Decide where the viewer should look and this spot will have to hold the greatest contrast, the richest colors, the blackest blacks, the whitest whites, and the loveliest details.

Step 05

How to create dynamic compositions

In the first chapter of this section on establishing your character, we briefly hinted at the effect of form in character design. It

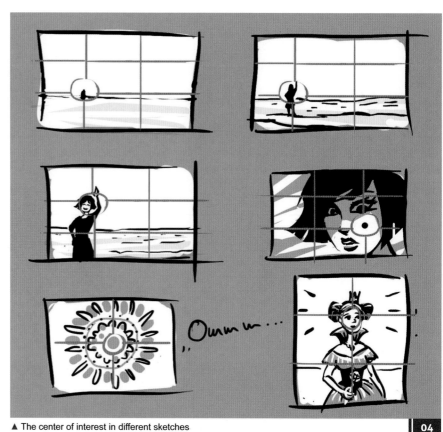

▲ The center of interest in different sketches 04

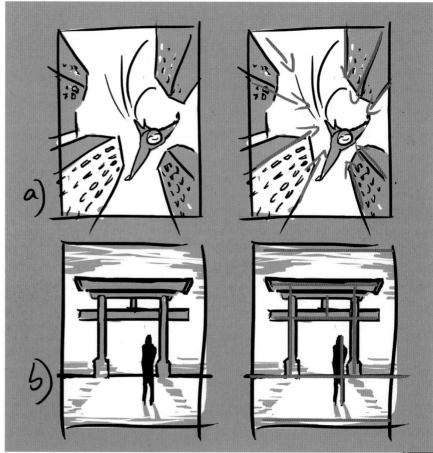

▲ A dynamic composition versus a static composition 05a

can be used in the shape of the character itself, but it will also work when applied to the composition. A composition can be calm and stable, or it can be wild and dramatic, with lots of energy and movement. Whatever you want to achieve, the use of line direction can assist you in your task. Image 05a shows an example of a dynamic composition versus a static composition.

For a dynamic composition, choose lots of diagonals. Guide the eye of the viewer in a rhythmic motion through your design. For the effect of calmness use a combination of straight horizontals and verticals instead of diagonals; the impression will be that of order, strength, and control. This is especially the case in artworks featuring a lot of symmetry. In example b) in image 05a, the character is placed a little closer to one side, resulting in a more interesting composition.

Image 05b shows an example of a triangular composition, which gives a dynamic impression. There is motion and energy in the pose of the two characters. The effect could be enhanced even further by breaking the symmetry: simply move the center of interest away from the middle line. Remember, diagonals are dynamic, creating the impression of motion. Triangular compositions enhance the effect of movement and flow; symmetry can dim it.

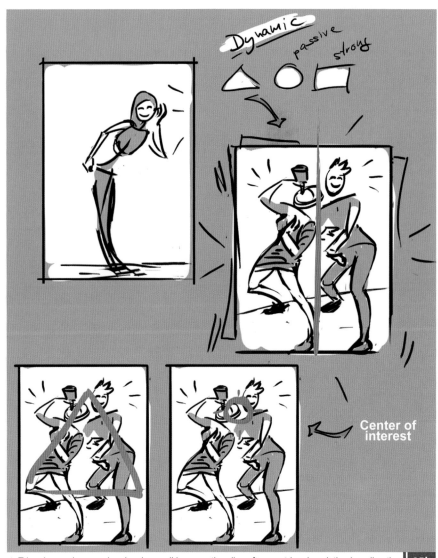

▲ Triangles work on a micro level as well here, as the elbow forms a triangle pointing in a direction | 05b

Step 06

Using perspective

The angle from which the character is seen will completely alter the effect on the viewer. The results can be subtle, but they will work nonetheless. In this step we will look at three ways to draw characters in perspective (refer to image 06):

1. Looking up to the character.

2. Looking down on the character.

3. Being on eye level with the character.

Looking up to the character, the figure is seen from a position lower than themselves. As viewers, we have the impression that he (or she) is towering high above us. This will give us the feeling of being small or less powerful in comparison. Use this position whenever portraying a powerful superhero figure or a mature adult. This is definitely a pose of dominance and ability. The character will be perceived as strong and capable.

Looking down on the character allows us to see the character from a position which is higher than them. This will have the effect of the character being small and innocent, weak, or a child. It could also be a defeated enemy. The character can look up to the viewer, or he can lower his chin to further enhance the look of submission.

At the same height, we are equal to the character. A connection seems effortless. The character seems approachable so we may associate with them more easily.

▲ Examples of different perspectives | 06

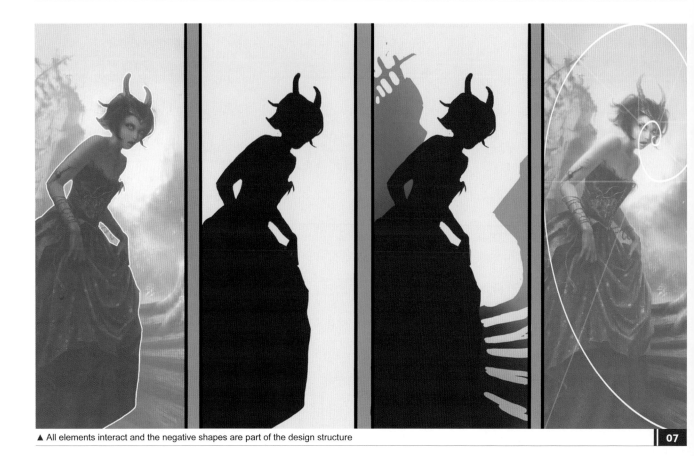

▲ All elements interact and the negative shapes are part of the design structure

07

Step 07
Positive shape and negative shape
When framing the character you have to deal with two types of space: positive and negative. The positive space is the actual main subject whereas the negative space is the area around the main subject. That means that every item you put on a canvas will immediately change the dynamic and perception of the whole. The more elements you add into an image, the more you reduce the negative space and how dynamic a character will look in a composition. Image 07 shows a character that has been cut out and pasted back into the file. The layer has been darkened, so you can see the effects of positive and negative space.

Note how the spiky horns of her crown are mirrored and repeated in the elements of the background. There is more repetition of this idea in the lines at the bottom on the right. The shapes of the steps continue the design idea of the spikes seen at the top, but bigger.

To test your composition for effectiveness as in image 07, you can follow this technique:

• Cut out your character with the Lasso tool (see page 215). Copy/paste it back into your document. If your character consists of many layers, select Copy Merged from the Edit menu to create a merged copy of the content of your selection (super useful!).

• The new layer then needs to be darkened. Open the Hue/Saturation dialog box (Ctrl+U) and lower the Lightness.

• Next create a new layer below it and fill it with a light color.

• Now improve your positive (and negative) shapes to enhance the visual impact. The negative space should give your positive space clarity.

Step 08
Dominant value
There are different ways to present a character. Sometimes it is enough to communicate the design elements in a clean way. Then sketches will do. However, as soon as we are painting a fully fledged illustration, showing our character in

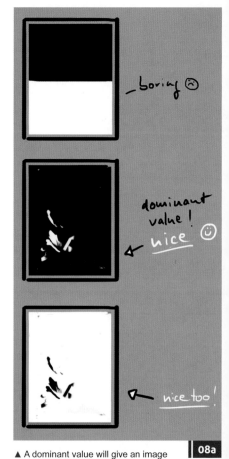

▲ A dominant value will give an image weight and interest

08a

action, or painting a portrait to fascinate our audience from an emotional point of view, then we need to know about the concept of the dominant value.

What is a dominant value? Image 08a shows us an example of the most boring painting ever, a composition that is exactly half black and half white. But what happens if we shift the relation of black to white? Now we have a weight in the image. Let's introduce a middle value and shift the relations even more for maximum effect.

What does this mean for our character composition? As an artist you need to be aware that it is a natural tendency to balance things out. However a design will be more interesting to look at if things are a bit more edgy – if there is an emphasis or imbalance in the distribution of values. An image can be enhanced a lot if it has a clear dominant value. This can be the middle value, the white, or the black, it's your choice! Always remember that the dominant value must be larger in area than the other two values combined.

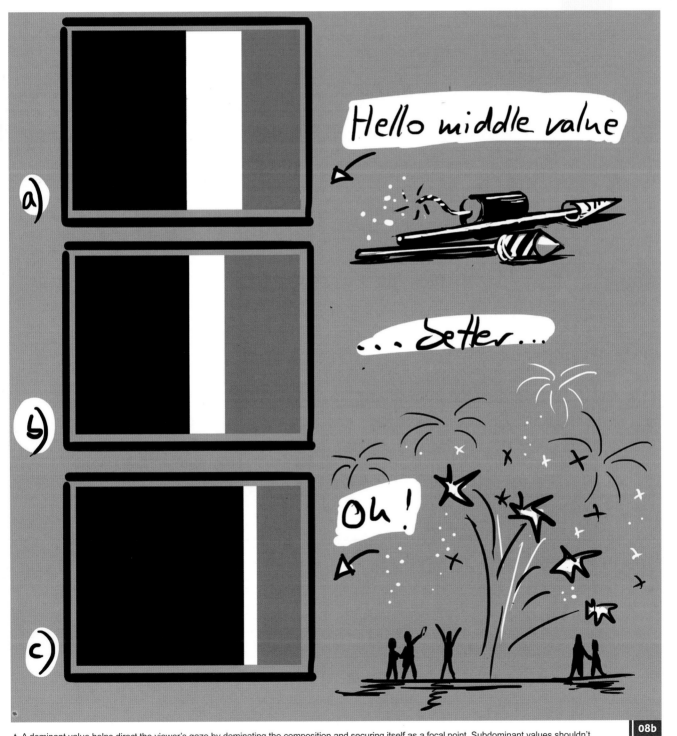

▲ A dominant value helps direct the viewer's gaze by dominating the composition and securing itself as a focal point. Subdominant values shouldn't be equal in area

Step 09
Treatment of edges

Let's conclude with some final thoughts on the treatment of edges. You can play with both the silhouettes and the lighting to tell the story. Not all parts of the body need to be in clear sight. If you are working on an illustration showing the character in some kind of setting, then you can opt for suspense and mood, hiding parts of the body in the dark for example (image 09a).

Alternatively, if the focus is more on illustrating possible outfit elements then the design should be well lit so that it is easy to read. Experiment to

▲ Example of using lighting

09a

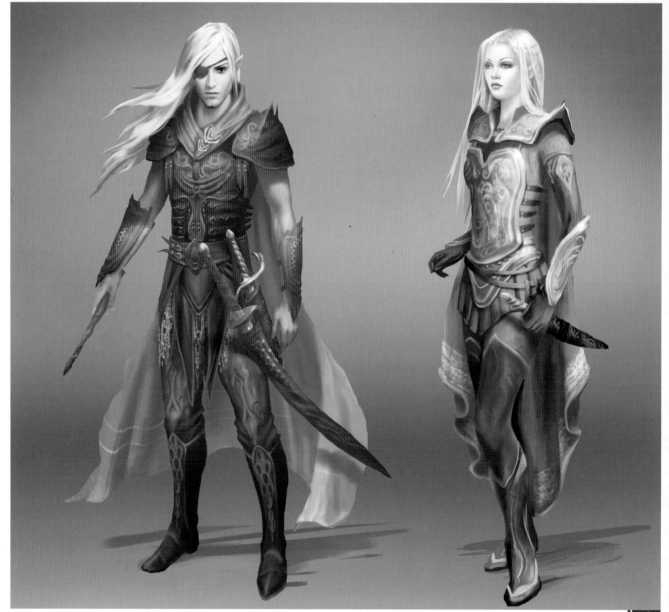

▲ If everything is dipped in shadows, it would be hard to read details of the costume, for example

09b

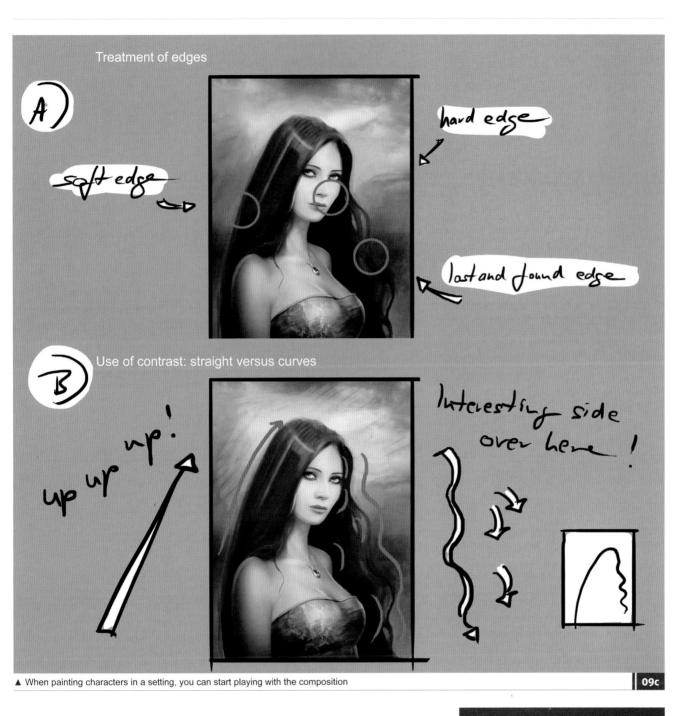

Treatment of edges

A)

soft edge

hard edge

lost and found edge

B) Use of contrast: straight versus curves

up up up!

Interesting side over here!

▲ When painting characters in a setting, you can start playing with the composition

09c

find a good mixture of atmosphere and technical clarity (image 09b).

"Playing with all of these qualities in a composition can give an artwork a more dramatic flow"

Now, back to the edges. There are soft edges, hard edges, and lost and found edges. A found line is sharp, whereas a lost line is soft or less defined; lost and found edges can help in creating more of a 3D effect of a subject on a

background because the character looks more part of a scene rather than being cut out and stuck into it. Playing with all of these qualities in a composition can give an artwork a more dramatic flow.

Image 09c shows a quick portrait as an example of contrast between straight and curved edges and how this also results in contrast in the composition. The left side is kept simple, while the right side contains lots of curves and visual interest. Use contrast like this to control the speed of perception in your viewer.

★ PRO TIP

Flip your canvas

To check the composition, use the flipping command. When working on an image for a long time, we become blind to it in a way, accepting how it looks without noticing the errors. Flip the canvas and rotate it around to get a fresh look (use Edit > Transform to bring up the menu).

Storytelling and moods
Discover narrative arcs and visual clues

by Benita Winckler

Let's begin with a question: what exactly is a "story"? One answer is that a story has a beginning, a middle, and an end.

If we are looking at the narrative arcs of fictional stories for example, we will find that in the beginning a character will be introduced. We will get to know the surrounding environment and the people the character is involved with. The middle part will feature the adventure, the difficulties, the twists and turns, the ups and downs, before finally, the story reaches its climax. After that the curve goes smoothly downwards again and the story ends.

Although the medium of a visual image is a bit different to that of text, we still have a person in front of us (the viewer) who likes to be led on a journey, just like a reader does.

Step 01
The problem of a single frame

What needs to be done to map a similar curve of excitement for our illustration? Here comes the first challenge: we only have one frame. If you are working in animation or film, you have several frames available and you can take your time to introduce the character and so on (images 01a and 01b). But how do you build up tension with just a single image? Our composition needs to

▲ A narrative arc for fictional stories

be carefully crafted. Then a timeline effect will happen in the mind of the viewer, as they follow our direction and decipher the visual clues we have laid out for them.

Step 02
Directing the view

A powerful method to direct the view of your audience is to have other figures looking in that particular direction. Think about those everyday situations where people form a crowd and gaze at something – our reaction is to think that it must be exciting if so many people stop to look at it. Most times we at least get curious.

In image 02a, for example, the viewer's eye follows the supporting characters' direction of sight. All the boys focus on the center figure, where the candle is shining, so the viewer will look there as well.

When it comes to light sources, humans are not so different to moths; we like a nice light source. Light attracts interest and also directs the view (image 02b). A character in the spotlight will demand our attention naturally. You can either have the light source visible or you can omit it, showing only the lit character.

Another thing that demands our attention is movement. Our characters are supposed to be life-like and believable, so if something attracts attention in the image, they will look as well. Movement can be difficult to pull off in an image; however, we can show our characters focusing on an object.

Step 03
Location and time

Who? What? Where? When? These are all important questions in storytelling. To visually indicate the location and the time

▲ Several frames are used in animation **01a**

▲ What will happen next? A comic strip can show the "before" and "after" states of a situation **01b**

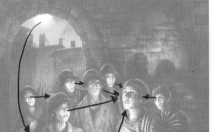

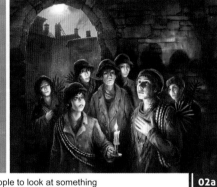

© Sauerländer audio / Argon Verlag

▲ The viewing direction is a powerful tool to get people to look at something **02a**

© Sauerländer audio / Argon Verlag

▲ Using light to direct the view. Note the characters' attention to the movement of the owl **02b**

▲ The location plays an important role **03a**

▲ The bagpipes suggest the location **03b**

we need to place some visual clues into the image, because they have the power to trigger an emotional response or bring up certain ideas in the viewer's mind. The effect might be subtle on first sight but it will work.

Have you ever looked at a nice beach with white sand and turquoise water? Imagine it: sunlit patches between the palm trees, bright blue sky. Thoughts of holiday and good times arise. If location elements such as these are put in an image (and if it is done well), these clues will help to set a certain mood. They can also trigger thoughts of adventure; adding a treasure chest can bring up connotations of pirates (image 03a).

To indicate the era/age in which the character is shown, simply add elements from that period to the image. How will the houses look? What's the style of the clothes? Pick elements that are most convincing for an era and place them in the background. Certain key elements will also help to indicate in which country we are located and will evoke associations in the mind of the viewer (image 03b).

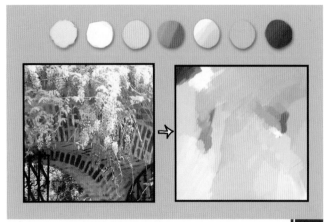

▲ Define a number of swatches or paint your palette into a new image **04a**

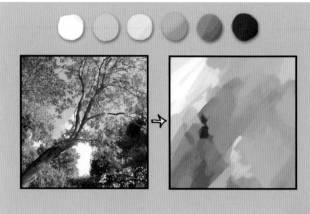

▲ Play with the dominating color using a textured brush **04b**

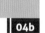

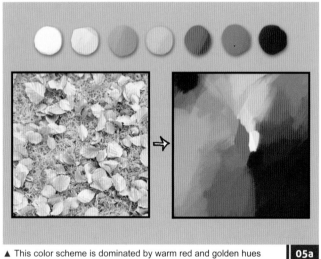

▲ This color scheme is dominated by warm red and golden hues **05a**

▲ A muted palette with plenty of opportunity to paint blue shadows **05b**

"You can greatly enhance an image by giving it a clear dominant value. This can be the middle value, the light, or the dark"

Step 04
Spring and summer colors
When making design decisions for a character, an effect that is often overlooked is the use of seasons. Let's first look at springtime: nature is back and it's time for colors! Subtle cool hues can serve as contrast for the pinks, reds, and fresh greens. The mood is joyful! Place your character in a spring scene to convey positive feelings. Show blooming trees and clear blue skies.

Summer conveys the feeling of perfect days outside, with deep blue skies and warm air. Everything looks bright, rich, and vibrant. The colors are brilliant and intense,

and the shadows are strong. If you look around during midday, notice that the light is almost overpowering, washing out the highlights and casting harsh shadows.

You can either select colors intuitively from Photoshop's Color Picker (or color wheel) or you can collect color inspirations from photographs and paint your palette from there (images 04a and 04b). You can greatly enhance an image by giving it a clear dominant value. This can be the middle value, the light, or the dark.

Step 05
Autumn colors and winter colors
Autumn features the most wonderful hues of gold and russet colors, but on bad days autumn can offer ideal conditions to portray gloom: foggy streets, heavy rain, wind pulling at umbrellas and hair. You could have the character grab the collar of his coat to

keep off the cold or, if you are aiming for a playful mood, positively surround him with whirls of golden leaves. Adjust the outfits accordingly; add scarves or earmuffs.

A winter palette basically consists of black-and-white, bluish gray tones. With most of the colors missing you can only play with the effect of warm light against cold. Dominating cool areas are perfect to be set off by red glowing spots of fire or the warm light of interior places. Explore the possibilities of outside/inside scenarios. The mood caused by winter, if analyzed further, will show an association with an archetypal danger, but also mystery and wonder. Think starry nights and virgin snow.

Step 06
Archetypes and symbolic elements
Since our image is lacking a timeline to tell our story, we have to find another

way to communicate our ideas: we can use symbols and archetypes.

A symbol is something that represents something else. For example an owl is often associated with wisdom; a red rose can be a symbol of love. When using symbols you need to be cautious that the audience has the same cultural background, otherwise the idea might not be understood, or worse – misunderstood.

An archetype is a universal symbol that has a meaning for people across time and culture, almost like a motif. Examples of archetypal characters include superheroes, mother figures, and villains. If we want to convey a certain emotion, we can make use of archetypal imagery. That way a whole story can be touched upon in a single frame alone.

Image 06a plays with symbols and archetypes. Staircases are often used to suggest a journey. An ascending staircase can be seen as positive and hopeful; one that descends may be negative or dangerous. Horns are often associated with evil and the occult, reinforcing the caption that the character is fleeing the underworld.

Image 06b shows a character carrying an opium poppy, a symbol of Morpheus, God of Dreams. The forest, path, and water are archetypes that often appear in dreams.

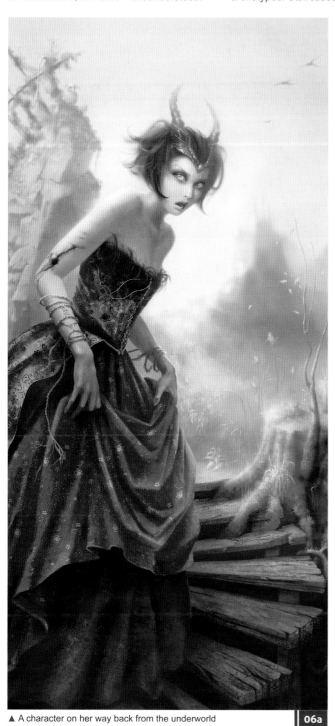

▲ A character on her way back from the underworld | 06a

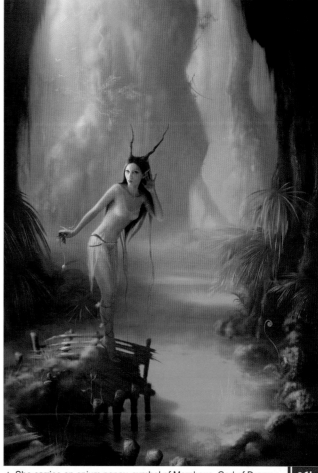

▲ She carries an opium poppy, symbol of Morpheus, God of Dreams | 06b

★ PRO TIP

Working in an non-destructive way

Often you will work on a project and then at some point you will need to make changes to your design. What if you have merged your layers, deleted your reference, or saved over an old version because you thought you won't need that one again? The solution: work in an organized fashion. Keep old versions. Save numbered iterations. And use layers, masks, layer modes, copies of layers, and so on. It might save you time further down the road.

Step 07

Using color palettes to create mood

Now let's focus on mood by taking a look at color palettes for dark characters. First thoughts are to use lots of black and blue, and to stay within a monochromatic color scheme instead of using plenty of colors. Analyzing the distribution of dark and light areas, you will notice the portrait in image 07c is predominantly light, in comparison to the portrait in image 07a, which has the dark values dominating. Additionally, a blue color scheme is used in 07a: a classic combination to get the desired effect.

Instead of painting everything black, however, you can play with the concept of darkness itself. In image 07c a warm color scheme is used, but by enhancing the shadows close to her face, a dark area is introduced that will draw attention there. The angelic elements, such as the silver hair and porcelain skin, are harshly offset by the dark red shadows. Her eyes are alien-black, another element that tells us that there is something out of the ordinary going on.

Interestingly enough, you can get a dismal atmosphere by using colors which would normally be perceived as being mild and friendly, such as pastels, pinks, gold, and warm reds (image 07d). Furthermore, the image doesn't need to be all dark to convey the atmosphere successfully. Composition plays an important role, as well as the facial expression of course, which is naturally a key element to set the mood instantly.

Step 08

Light and color

Lighting has significant power over mood and perception. Using a single source shadow on the face in high-contrast can signify mystery; if highlighted with red, it can signify evil. Color also affects our emotions, making this a great storytelling tool as well. As you saw in step 04, colors can trigger emotional responses and connotations (see also "Setting up your color swatches", page 36).

Let's quickly discuss nature's rules, so that we know our subject. Image 08a shows an example of a snowball hit by the warm

▲ Dominating color here is blue, a classic decision for a, dark look. A cold red is used for contrast 07a

▲ As expected, a bluish color scheme will result in the effect of a cold atmosphere in the image 07b

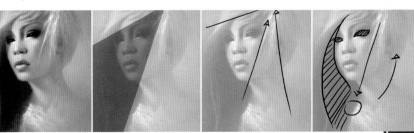

▲ Use dark shadows with angelic white to get the an enigmatic effect, without using blue 07c

▲ This friendly color scheme plays with warm hues, but stays within a monochromatic look, 07d

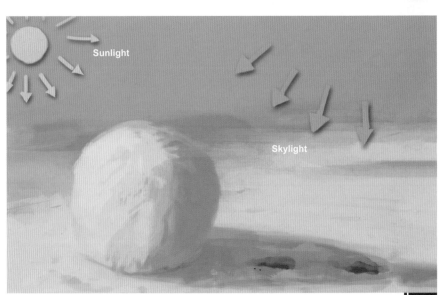

▲ Main light source is the sun; secondary is the sky, causing the color in the shadows to look blue 08a

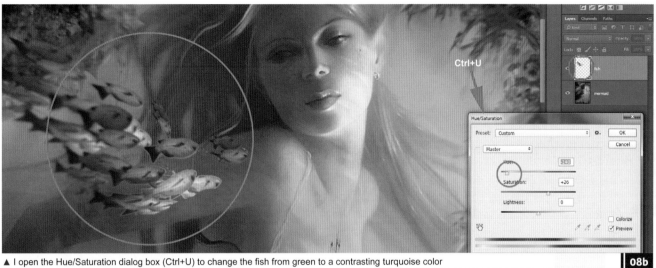

▲ I open the Hue/Saturation dialog box (Ctrl+U) to change the fish from green to a contrasting turquoise color **08b**

▲ With the new cold color, the fish stand in a nice contrast **08c**

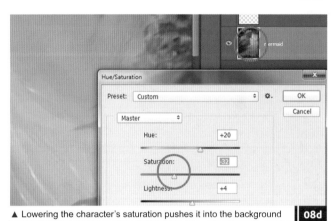

▲ Lowering the character's saturation pushes it into the background **08d**

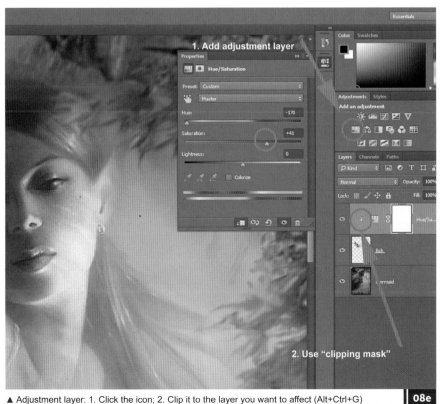

▲ Adjustment layer: 1. Click the icon; 2. Clip it to the layer you want to affect (Alt+Ctrl+G) **08e**

orange light of the evening sun. Note the cool tint of blue in the shadows? That's actually light bouncing from our secondary light source, the blue sky. The holes in the snow are areas that receive very little light, neither direct light from the sun nor indirect light from the sky; as a result, they appear very dark.

Before picking a palette we have to consider where the light is coming from. Is it natural or artificial? Is it morning or afternoon? What are the colors of the environment? Once we know the light source, we will have an idea about the colors and their temperature.

However, natural light isn't the end of the story. If we want maximum effect, we can bend the physics a bit. Images 08b and 08c show the use of color temperature as a contrasting element in a design. The golden light illuminating the character is not to be found on the fish and rocks in the foreground in image 08c, adding a slightly

ethereal feel to the character. Contrasting a warm shade against a cool one can also add a lot of visual interest to a design.

Image 08d (previous page) shows how instead of changing the foreground color, you can also lower the saturation of the character in the background to push it further back. To find a nice color combination, use the Hue/Saturation dialog box or use an adjustment layer (image 08e). Subtle changes in the hue and saturation of elements in your image can change the mood of your image, for example from warm and inviting to cold and eerie.

Step 09
Using masks for final effects (part 1)
By creating selections and masks you can isolate or modify sections of your image, allowing you to easily alter mood without having to repaint areas. If you need a dreamlike backdrop for your character, try the blur effect. This can be overdone, but if used sparingly, gives a subtle ethereal quality.

Set the workspace to Essentials as I have done, so we can see the same panels. We want two copies of the same layer holding our image. One layer will be blurred and then masked, to let the original version show through. First, make a copy of your layer. If your file has several layers use Edit > Copy Merged to get a merged layer of your image. Put that layer on top of the layer stack (image 09a), or create a new document with it.

▲ Copy your character image layer to get two exact copies
09a

With the top layer selected, hit the Mask icon (the Mask thumbnail will appear in the layer stack next to your image thumbnail; image 09b). Pick any brush and roughly paint the area you don't want to be affected by the blur (since we haven't applied the blur yet, it will look the same). The Mask thumbnail shows the painted area in black. You can only paint or erase; black creates holes in the mask or white closes holes (image 09c). Grays will work too, indicating areas of transparency.

Step 10
Using masks for final effects (part 2)
Let's quickly check the extent of our masked area to check the coverage of the mask is as we wanted. Select the bottom layer; hit Ctrl+I (Image > Adjustments > Invert) (image 10a). This will invert the layer, making it look like a negative. See the area covered by the mask? Repeat the command to invert it back.

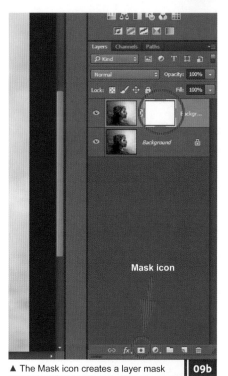

Mask icon

▲ The Mask icon creates a layer mask
09b

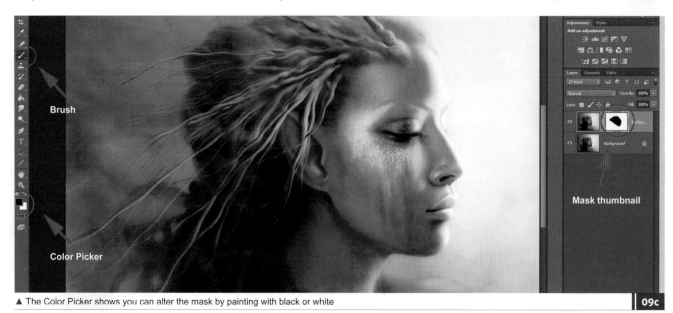

Brush

Color Picker

Mask thumbnail

▲ The Color Picker shows you can alter the mask by painting with black or white
09c

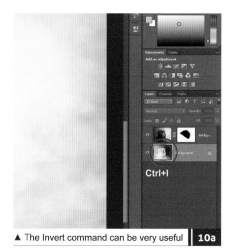

▲ The Invert command can be very useful | 10a

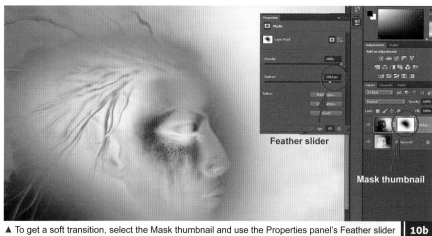

▲ To get a soft transition, select the Mask thumbnail and use the Properties panel's Feather slider | 10b

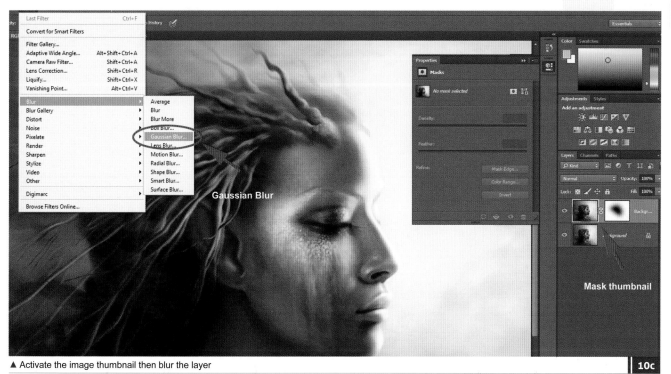

▲ Activate the image thumbnail then blur the layer | 10c

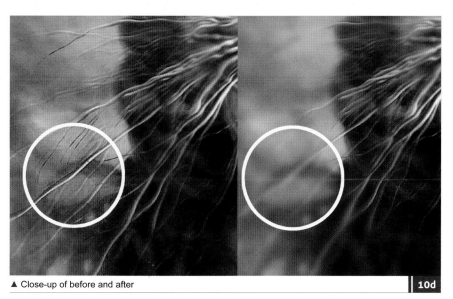

▲ Close-up of before and after | 10d

Next we'll soften the transition. Click the Mask thumbnail. In the Properties panel, pull the slider to feather the mask (image 10b). To apply blur to the image, first click the image thumbnail of the Mask layer. From the menu bar, select Filter > Blur > Gaussian Blur, decide on a value, and confirm (image 10c). To lower the effect of the blur, simply reduce the opacity of the layer altogether, by using the Opacity slider in the Layers panel, or (this is the more controlled way) use a soft brush and paint on the mask to make more holes. Make sure you activate the Mask thumbnail when trying to alter the mask, otherwise you will paint on your image; it can easily happen! You can see the effect in image 10d.

Character generation

Find out how to use Photoshop tools to create a character.

Now that you have discovered the key tools and theories
behind character creation, it is time to put them into practice.
Bram "Boco" Sels will guide you through a complete character
generation process. Using his own character creation, Bram
will break down the workflow, explaining each setting, tool, and
technique he uses to develop his design. From using masks to
paint skin and custom brushes to paint hair, to adding background
texture to ground your character in a scene, you will learn a
variety of methods you can then apply to your own paintings.

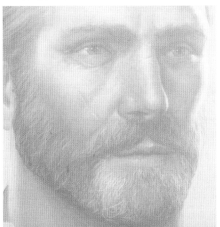

Body type and skin

Figure drawing and painting realistic skin textures

by Bram "Boco" Sels

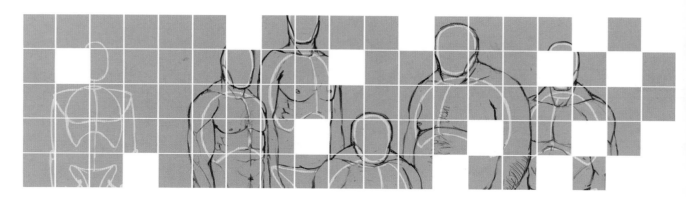

In this section we'll look in-depth at how to create a heroic 19th-century character for a video game. It's tailored to concept artists who are just starting out, as well as more experienced concept artists who are looking to hone their skills. The approach is simple: each chapter starts with some insightful theory, followed by an explanation on how to create part of the character, all leading up to the polished hero pose in the final chapter. Need to design just the portrait or the costume? No problem, just skip ahead to their respective chapters (pages 88 and 104) and start from there.

By following this step-by-step tutorial your designs will become more flexible and you'll be able to quickly do thousands of iterations of the same subject without effort. Don't like the head of your character? Just unscrew and replace it with a new one. Not sure about his mustache? We have a few others in stock for you! We'll go over all the basics you'll need to paint a flexible easy-to-adapt character ready for the production pipeline of the AAA-studio of your dreams.

And to top it all off, this section is filled to the brim with quick tips such as how to use the Pen Pressure toggle to your benefit, how to create your own

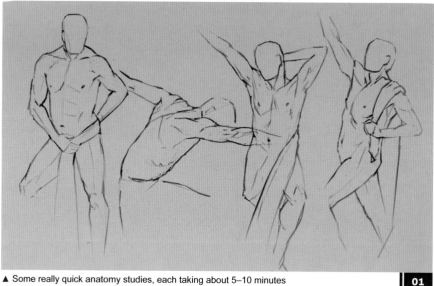

▲ Some really quick anatomy studies, each taking about 5–10 minutes 01

textured brushes, how to use the free PaintersWheel palette, how make your character feel gritty by applying the Noise filter, and how to conjure mood with custom fog and particle layers. My fingers are tingling to get cracking!

> "Your painting techniques quickly improve if you do some studies every day"

Step 01
Warm-up 1.0
When I start on a new piece I almost always do a warm-up first. This is a step that a lot of beginner artists are tempted to skip.

Mainly because they feel it's a waste of time and working on an epic environment or character is so much cooler than doing small anatomy sketches or perspective studies. It is, however, a step that I feel is absolutely necessary for two important reasons.

First and foremost, your painting techniques quickly improve if you do some studies every day, and it broadens your horizon a lot, too. It forces you to paint different subjects in rapid succession, learning something new with every session. Second, though warming up seems like a waste of time when you have a deadline coming up, a good warm-up makes you paint faster and

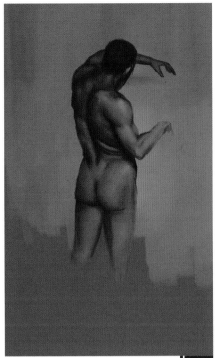

▲ A longer study of around 30 minutes **02**

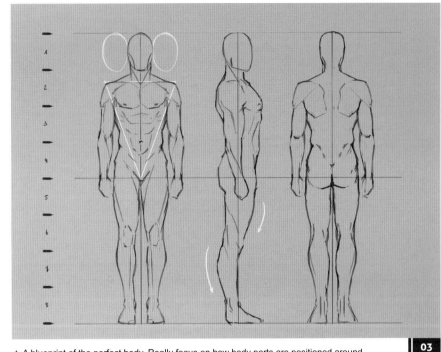

▲ A blueprint of the perfect body. Really focus on how body parts are positioned around the center line **03**

more fluently, so you'll regain that time (and even more) throughout the rest of the day.

Step 02
Figure studies

Every art-school student goes through figure-study classes. The reason for this is that the human body is often the main focal point of an illustration and is very hard to master. We are constantly looking and interacting with other humans, so our eyes are trained to quickly detect inaccuracies when we see a human body in a painting. The good news is that it's just a matter of practice.

When you do figure studies (and you can't do enough!), you start to notice how light impacts the body, how muscles connect, and how perspective and foreshortening change what we see of the body. Practice every day and you'll get better in no time. Image 02 took me around 30 minutes.

Step 03
The human machine

Of course, the human body is different for every person, but a reigning theory in art is that it all starts from a perfect base – an ideal body that can be modified to create different body types. So following that theory you start

out by learning how that perfect body works. There are different approaches to doing that, but one of the more famous ones is that of Andrew Loomis, an influential American illustrator, art instructor, and author.

Part of this approach involves measuring body parts against each other in order to get proportions correct. For instance, the

ideal body is made up of 7–8 heads, so when you draw the head you can quickly measure where the feet should be. The crotch is exactly in the middle of the body and the bottom of the breasts and knees are in the middle of their respective halves. The body is also three heads wide and the shoulders and crotch should create an imaginary triangle that goes between them.

★ PRO TIP

Pen Pressure

Photoshop CS6 and upwards comes with some cool new brushes that are perfect for digital artists. These brushes mimic how an actual brush works and come with a small pop-up window that shows how Photoshop is registering your brush on the canvas.

Tilt your stylus and you'll get a flat line; push hard and you'll get a fat line. Nifty and great to do line art with, it prevents you from getting monotonous line work.

Another new gimmick is the Pen Pressure toggle next to the Opacity slider on

Opacity slider Pen Pressure toggle

top. When you have it on the harder setting, you press on your stylus and the more opaque "ink" will flow out of it, which is a bit more intuitive than working with the Opacity slider itself.

▲ Using the Pen Pressure toggle for opacity gives you more control over your brushes

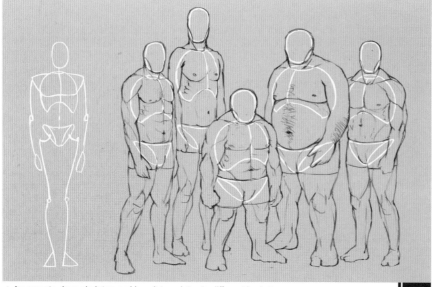

▲ An easy-to-draw skeleton and how it translates to different body types | 04

▲ The ideal body, leaning on his right leg | 05

Step 04
Imaginary heroes
Up until now the only thing we have done is study the perfect human form and how it's translated to a drawing, but what if you don't have an exact reference for what you want to draw? As an illustrator or concept artist you should be free to draw whatever you can imagine, so copying a reference 1:1 will get you nowhere. (Unless you have a bearded dwarf or an alien locked up in your basement, that is.)

Artists often have to draw bodies for which they don't have a reference, so an easy alternative is to start with a shell that looks like a human and for which you do find a reference. That "skeleton" is easy to draw, can be moved around and posed without much work, and afterwards you can draw whatever you want on top using your (human) reference as a guide. Drawing a small muscled dwarf for example? Just broaden the head, ribcage, and hip, and move them closer together.

Step 05
An ancient Greek hero
Around 500 BC the Greek sculptors became masters of anatomy by studying the ideal body and creating millions of sculptures to its likeness. They almost always placed the weight of the body on one leg, making the sculpture a lot more dynamic. Compare this body to the blueprint of the body in image 03 and notice how the entire body language changes, even though it's based on the same blueprint. Closely study how the muscles group and how the center of gravity slightly moves towards the left.

"A body with correct values but wrong color still looks okay, but a body with wrong values quickly looks anatomically incorrect"

Step 06
Key light/back light
Trying to figure out how to light a body might feel difficult and overwhelming at first, but it

★ PRO TIP
Lock transparent pixels
When you're working on a character, masking is always one of the first things you should do. Basically it means you paint the silhouette of the character you're working on and use it as a stencil.

Create a layer below the line art to act as a mask and in the top of the Layers palette you can lock transparent pixels, which blocks off all pixels in that layer that are empty (in other words, everything outside the silhouette). Now when you're painting you don't have to mind the size of the brush you're using, since all paint will stay neatly inside the mask.

Lock transparent pixels

▲ Masking out the silhouette of a character can really speed up your workflow

▲ Defining the light scheme on a little ball helps to organize things 06

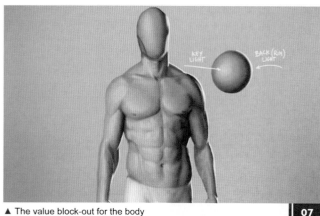

▲ The value block-out for the body 07

becomes a lot less daunting when you go at it one step at a time. A great tip is to start out in black and white. That way you can focus on the values without being distracted by the color and temperature of the skin. A body with correct values but wrong color still looks okay, but a body with wrong values quickly looks anatomically incorrect.

Another great trick is to define the lighting scheme on a ball before starting on the body. A common lighting scheme in concept art is with a key light (the main light) from the front and a rim light (back light) from behind. Note in image 06 how the muscles react almost the same to the light as the ball.

Step 07
The body as a whole
Keep in mind that the body remains a volume in itself. See it as a giant cylinder and think about how that giant cylinder would react to the lighting scheme you defined in step 06. It's not enough to define every muscle according to the lighting scheme; you should also keep in mind where those muscles are on the body. If they are on the light side of the "cylinder", they will of course be lighter than the other side. This is most clear in the biceps of both arms. The right bicep is on the light side of the body and is almost entirely lit, while the left bicep hides in the shadows of the chest that sticks out and blocks the light.

Step 08
Highlights, midtones, and shadows
After adding in the basic values, try to define a color scheme. Different lighting conditions have a different impact on the body, but for

this study we're keeping the light neutral so the skin tones will be fairly neutral as well. Caucasian skin tones often range from purple to deep red, to yellow and even green.

When you look closely at a person's skin, you'll see that there's a lot more information

there than you might expect. Still, it's best to define some common skin colors at first and start from there. I usually change the painting mode of my brush (you can find that in the Options bar at the top of Photoshop) to Color, and give the entire body a color wash; in this case a warm, orangey tan.

▲ Defining the skin colors; the arrow points towards the main wash 08

Step 09
Color zones

Often skin tends to have areas where a certain color dominates over all other colors. Once you're familiar with these zones it becomes easier to notice them and eventually predict how the skin there will react to the light.

When you move lower down the body, skin tones will gradually become more reddish and purple than they are around the chest area, where they'll be more yellow and orange. You can especially see this in the hands, knees, and feet. This has its effect on the shadows as well, resulting in dark purple shadows in those areas and warm shadows around the chest. Look for some references when painting these areas – they will really help out a lot to get your figure correct and realistic!

Step 10
Refining the body

The last step in this chapter consists of refining and detailing. Although you already defined the values a few steps back, you should still keep working on them – nothing is set in stone at this point. Push the highlights as much as you can and try to create lively shadows by introducing vibrant colors to the darker parts and areas. Take a step back from it once in a while, so you can come back to it with a fresh eye later on. It often makes you notice the mistakes and gives you a fresh perspective.

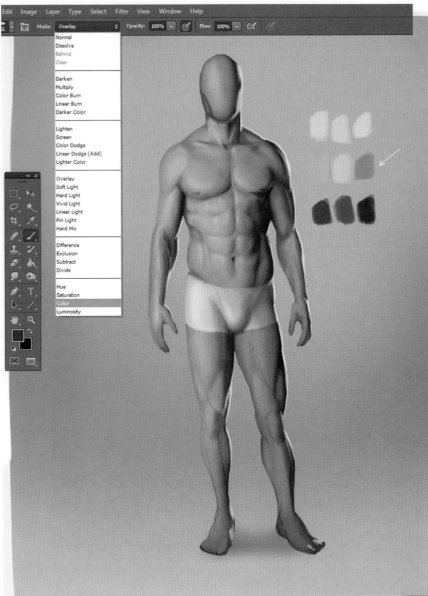

▲ The body gradually becomes more reddish near the bottom

09

★ PRO TIP
Noise

A great way to give skin some extra texture is with Photoshop's built-in Noise filter. Create a new layer and fill it with a neutral gray (use the following RGB levels as shown in the image on the right here: R: 125, G: 125, B: 125). Click on Filter > Noise > Add Noise, and use it to whip up a 100% monochromatic noise. Now use Edit > Transform > Scale and then drag to double the layer in size; this will give you nice big chunks of noise.

Click on Filter > Filter Gallery > Brush Strokes > Spatter; then click OK and select a Spray Radius of 10 and a Smoothness of 5. Now click on Filter > Blur > Blur More and you'll get a nice gritty skin texture. Put the layer's blending mode to Soft Light and it's opacity to 12% – your skin will suddenly have a lot more texture.

▲ Creating a noise layer to blend over your skin will often give it that extra edge

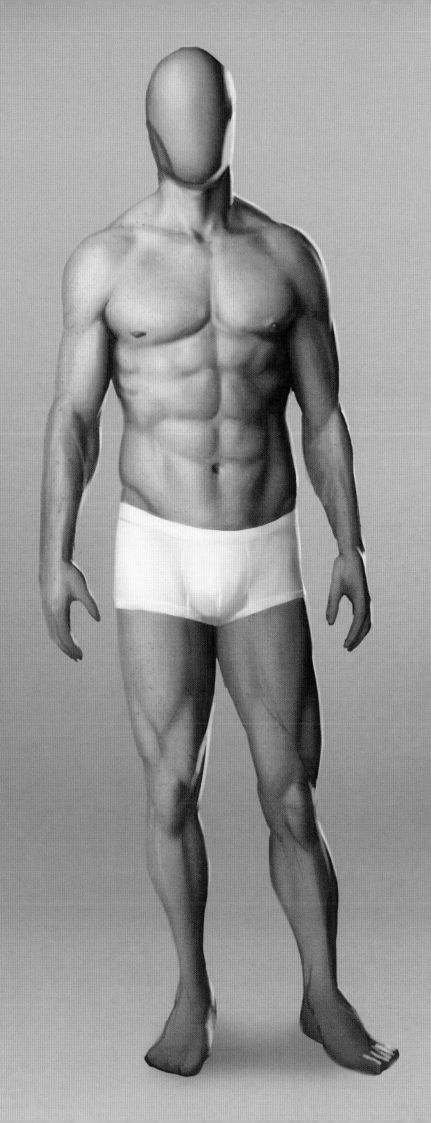

Designing and painting the face

Mastering the techniques to create a life-like portrait

by Bram "Boco" Sels

Portrait painting has been around for centuries. Before the invention of cameras people mainly used it as a means to immortalize themselves, but with the rise of photography it lost a lot of its popularity. The reason for that was that photography could achieve the same effect a lot quicker and thus cheaper.

With the development of concept art, however, methods from portrait painting have become a lot more popular again – be it as a way to put existing actors in imaginative environments or to create characters that don't exist in real life but look so convincing that they could do.

To create such a character it's important to master the techniques needed to create a life-like portrait. In this chapter you'll learn, among other things, how the skull is the foundation of the head and how it changes the distribution of light on the face; you'll see how the direction of the light can dramatically change how a person looks and how the face is made up of different color zones. You'll learn everything you need to know to paint realistic, imaginative faces from scratch.

Step 01
Warm-up 2.0 (the classy one)

Just like in the previous chapter, it's important to warm up when starting on a new

▲ Five head studies from Wiki Commons, taking around 10 minutes each 01

▲ Studying the skull that's on my desk. On the right you can see how it can be reduced to basic, primitive shapes 02

piece. This time I opened up Wiki Commons and browsed through their enormous library. It's a fun thing to do and browsing through different eras and different subjects expands your internal reference library each time.

Eventually I stumbled on a set of early 20th-century gentlemen and decided to do a study of a few of them. Something to think about while doing studies like these is how the eyes can really define the character of a person. Got to love that facial hair, too – I wish I could get away with a mustache like that!

Step 02
Skulls are awesome!
Write this down: you should do at least one skull study each year. Not only is it a cool subject, it really makes you understand how the human head works – how the jaw connects to the rest of the skull for instance, and how the brow and the cheekbones define the form of the head. It's a good idea to get yourself an anatomically accurate skull to refer to while painting.

When drawing the skull you'll start to notice that it basically consists of a few simple shapes: a ball with the sides cut off and the chin as a rounded square protruding from it. Understanding these simple shapes is half the battle when painting the head.

Step 03
Lighting the face
Starting out with the simple shapes from the previous step, you can construct the rest of the facial features on top of them. Keep the facial features simple at first; it will be a lot easier to light them that way. Notice in image 03 how the nose protrudes from the face and how the eyes are (obviously) round and should be lit that way.

The two lighting schemes on the right of image 03 are pretty basic but very common in concept art. The first has light coming from the top, the other from below. Depending on where the light comes from, some planes will be lit while others will hide in the shadows. Always keep in mind how the planes are oriented towards the light; planes directly facing the light should always be lightest.

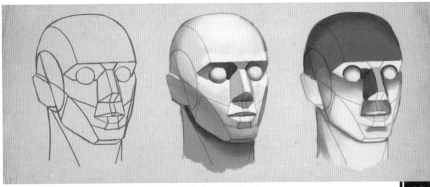
▲ Different lighting conditions have different effects on the head ▐ 03

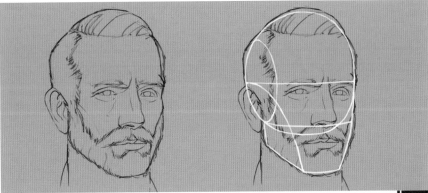
▲ The line art for the head, trying to create character with the facial features ▐ 04

Step 04
Creating your own character
Inspired by the warm-up in step 01, I wanted to create a face that looked both worn and rugged, but still appeared stylish and 19th-century-like. I wanted to create the main character for a fictional video game, and chose to go with a Caucasian, bearded, hero type.

I started out with the basic shapes from the previous step and once they were correct I placed a layer on top for the details, systematically erasing the under drawing as I went. In this step it's important to really look at how facial features are constructed. Look at how the eyes have eyelids and how they work. Note how the nose as well as the mouth is divided into planes that flow over into each other.

Step 05
Masking the face
As with the body, I created a layer below the line art to function as a mask. The idea is to keep all paint within the mask and still have the lines on top of it

▲ Creating a mask, while simultaneously checking the silhouette ▐ 05

unharmed. Eventually these lines will be erased and blended with what's below.

Creating a one-color mask will also give you a clear view of the silhouette of the head. There's a lot of character in there as well: the hair, for instance, is slick and thin and cuts into the silhouette above the ears and on both sides of the forehead. The same goes for the beard and his left eye socket (see image 05).

"Because the face is often the focal point of an image, it is important to get the facial features just right"

Step 06
Blocking out the main planes

Keeping the same lighting scheme as for the body in the previous chapter, I started blocking out the biggest parts of the face. I've put the hair on a separate layer so that I can focus on it later on. As with the body, I started out in black and white to really concentrate on getting the values right.

This is the step where knowing how the face is divided into planes really comes in handy. The planes that face the light directly catch most of it and will be the lightest. You'll also notice that some transitions will be sharp (like the front of the nose), while others will be a lot smoother (like the forehead).

Step 07
Refining the face

Because the face is often the focal point of an image, it is important to get the facial features just right. If something is a little off it will skew the entire character. Get into the habit of flipping your image once in a while (Image > Image Rotation > Flip Canvas Horizontal); it gives you a fresh view so you'll notice mistakes in a heartbeat (image 07a).

While you're refining, it's also very important to gather the right reference. Look at how eyes reflect the light source, how the tip of the nose often catches a highlight, and how age lines turn with the shape of the skull. Note that here the head will have a lighter side and a darker side. Depending on the side it will differ how the facial features should be lit.

When rendering, I basically stick to the same basic round brush and a textured brush. Using the Opacity Pen Pressure toggle helps me to achieve some interesting complexities. I often use a seamless texture that I use as a texture in my brushes as well. It has a convincing grain in it that works really well to give the impression of pores and details on the skin (image 07b).

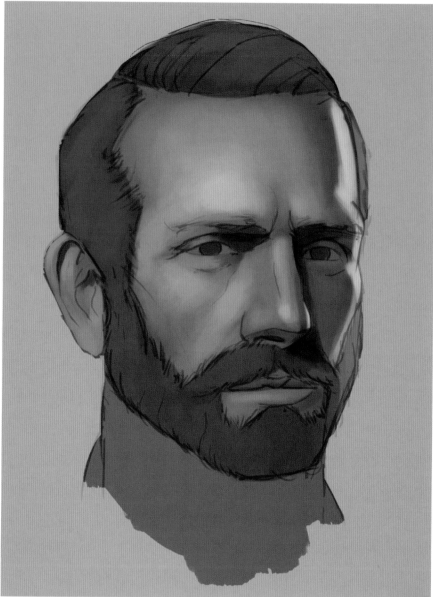

▲ Quickly laying in values for the face, keeping the lighting scheme in mind

06

★ PRO TIP

PaintersWheel

PaintersWheel is a free plug-in for Photoshop, created by Len White (http://lenwhite.com/PaintersWheel/). It doesn't do anything you can't directly do in Photoshop, but it's a lot more accessible than the standard color picker and it arranges your hues in a circle which is somewhat more logical. When you're painting skin it's a helpful tool to quickly micro-manage your hues if you feel your skin is becoming too dull.

▲ Len White's PaintersWheel, a free and very accessible plug-in for Photoshop

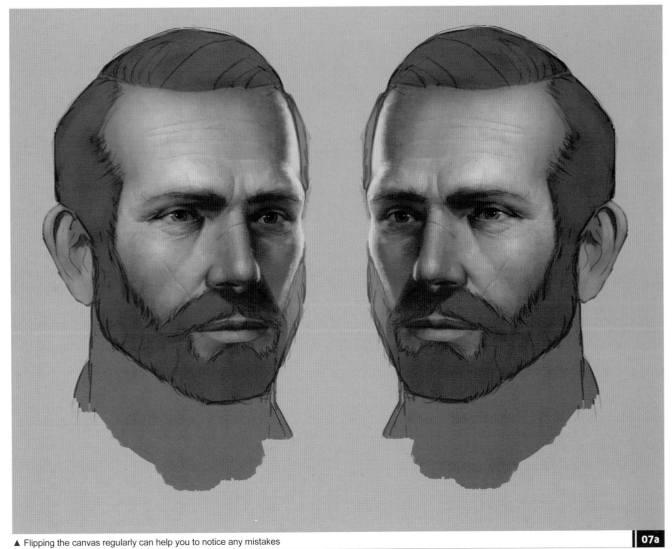

▲ Flipping the canvas regularly can help you to notice any mistakes

07a

▲ Refining the facial features using settings like these can really give the head a lot more character

07b

Step 08

The color zones of the face

When thinking about color, the face can be divided into different color zones. It all depends on the color of the light of course, but for Caucasian skin for example, when the light is neutral, the top part of the head tends to be more yellow, the middle part more red, and the bottom part more blue/gray.

This is especially true with male faces due to the facial hair they tend to have around the chin, which has a very distinct blue/gray tone. This should be subtle of course and should not be exaggerated, but knowing those colors are there makes it easier to see them when looking at reference photos.

★ PRO TIP

Soft Light and Overlay

The Soft Light and Overlay modes are traditionally ways to increase the contrast of what's below. The two most common ways they are used are by creating a new layer on top and changing its blending mode, or alternatively to directly change the blending mode of your brush in the toolbar at the top of the Photoshop window. The latter avoids having to create a new layer, but is admittedly a little less flexible.

The difference between Soft Light and Overlay, is that Soft Light uses a combination of Screen and Multiply blending, and Overlay uses as combination of Linear Dodge and Linear Burn. Both are valid ways to boost contrast (see step 10), but Overlay is the more intense of the two and thus a lot less subtle.

▲ The face is roughly divided into these three color zones

08

▲ Mask the area of skin you plan to paint color over

09a

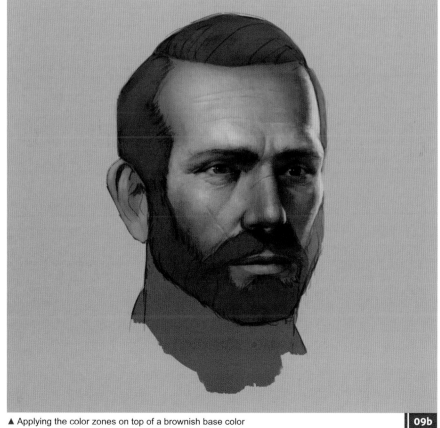

▲ Applying the color zones on top of a brownish base color

09b

"You'll find the most intense reds around the tip of the nose and on the top of the cheekbones"

Step 09
Toning the face

To tone the face, I created a mask over the area of skin I wanted to paint (see image 09a). I then started out with a wash in the same color that I used for the body in the previous chapter. After that I kept the painting mode of my brush on Color, but changed the opacity to 25%.

One by one, I color-picked the colors from the last step and went over their respective zones (see image 09b). Again, look for some references online and make a mental note of where the most saturated colors should be on the face. You'll find the most intense reds around the tip of the nose and on the top of the cheekbones for instance. Don't overdo it though, or your character will quickly look unrealistic or like a drunk.

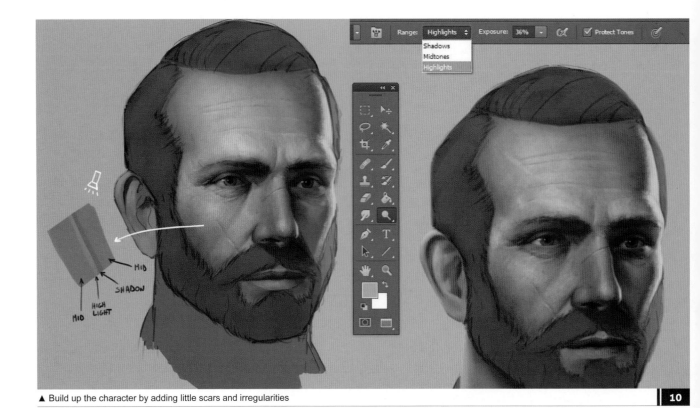

▲ Build up the character by adding little scars and irregularities

Step 10
The head is not a cue ball

That's right, the head is not glossy and smooth like a cue ball. It's covered with little holes, pimples, and pores; especially in the case of my character who I want to be a bit more worn than the average Joe.

I put some scars on his cheek and nose and used a textured brush to get some extra noise in the skin (see pro tip on the right). I took the time to make the age lines pop and to polish up the eyes, making them appear more lively. I also noticed that the forehead should be a little lighter and that the overall contrast could be boosted, so I tweaked those two things, too.

To boost the contrast on the forehead use the Dodge tool, set to Highlights. It's a great way to build up values and to get vibrant colors in skin. The scars and irregularities are subtle changes in the midtones that have a shadow side and a highlight side. Using the textured brush means they fit in nicely with the rest of the skin. It's important to keep it subtle here – the strongest highlights and shadows should be preserved for the bigger shapes like the forehead, eye sockets, nose, and chin.

★ PRO TIP

Brush texture

Another way to get some extra texture in your skin is to work with textured brushes. If you open up the Brush palette you'll see an option for Texture. In this case I used a texture I created from a watercolor painting. I felt that the rough texture of the wet paper had some really organic bumps which could fit well on human skin.

There is, however, a lot of great and usable presets already present in Photoshop, so you'll quickly find something that fits. It's a technique that's usable with every brush and on every subject, so when you feel your painting is lacking an edge, this might help you out.

▲ Using the texture option in the Brush palette to get some extra bumps in the skin

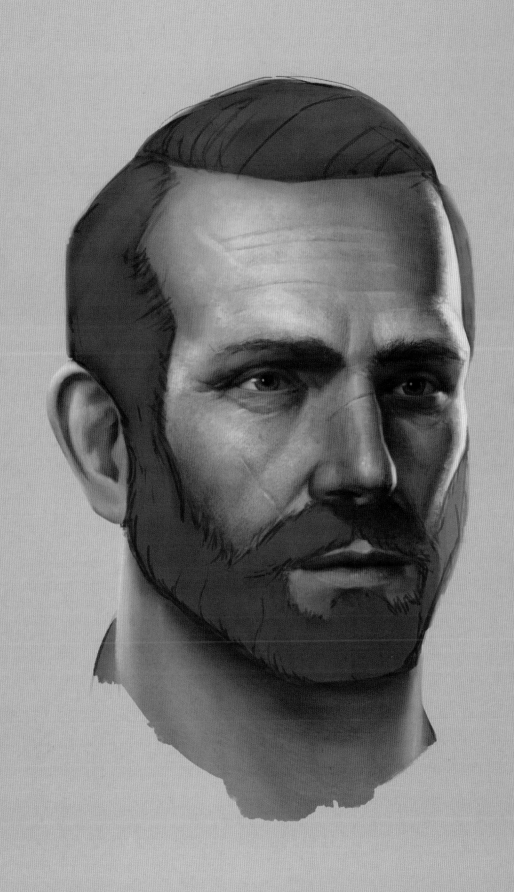

Painting hair

Techniques for painting hair and creating a brush to speed up the process

by Bram "Boco" Sels

Painting hair might seem very different to painting a face, but you'll soon discover there are more similarities than you might expect. There is one big difference though, and that is that hair is anything but static, so it's harder to predict where and how it will move. There's no anatomy involved either so you can't really measure it against something. The only thing you do know is that it follows rules of gravity and is therefore likely to fall in a certain way.

I used to struggle a lot with painting hair. I just couldn't get a handle on it until I started learning about sculpture. It was a real eye-opener to see how classical sculptors were able to

render realistic-looking haircuts by chiseling hair from marble. It drastically changed my approach to painting it.

Instead of looking at hairstyles as a combination of individual hairs, I began to see them as solid forms weaved through each other. This not only made hair easier to understand, it suddenly became clear how hair should be lit as well.

Here you'll discover how to light those solid forms, as well as how by adding little specks and hairs you can create the illusion of the haircut consisting of thousands of hairs. You'll also learn how to create a simple brush that can save you an huge amount of time.

"The haircut alone can really help define the back story of a character"

Step 01
Warm-up 3.0 (the stylish one)
During this warm-up I copied the line drawing from the previous chapter and tried some new haircuts on it, just to broaden my horizon. None of these haircuts made the final cut (pun intended), but I don't think it hurts to try experimenting anyway.

For the sake of this tutorial, I quickly masked out the hairstyles in image 01; you'll immediately notice how much the shape of the hair can affect the way your character looks. The sharp point on

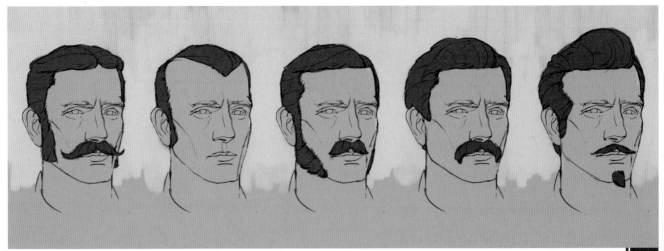

▲ Five different hairstyles, each generating a different back story

01

HIGHLIGHT

MIDTONE SHADOW

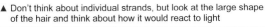

▲ Don't think about individual strands, but look at the large shape
of the hair and think about how it would react to light

02

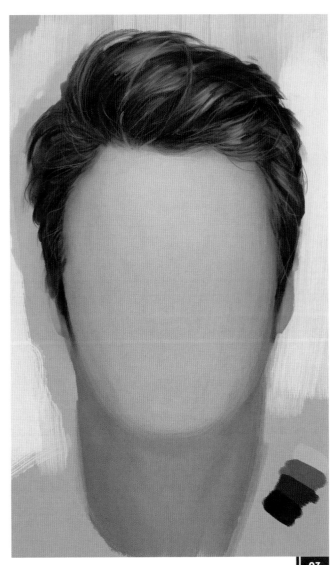

▲ Coloring the hair is a lot less difficult if you make sure your
values are correct

03

the second portrait makes you wonder
if he's an evil mastermind, while the
voluminous hair and slick mustache
of the last one make you think he's a
Casanova. The haircut alone can really
help define the back story of a character.

"Think about how you would chisel hair out of marble and try to mimic that in your painting"

Step 02
The shape of the hair
Beginner artists often make the mistake of
thinking about hair as individual strands. By
thinking about it like this you are tempted
to meticulously paint each one, hoping it

will result in a convincing haircut. Nothing is
further from the truth. Hair has the tendency
to group into locks and those locks are
larger shapes that react in the same way
to light as every other shape would.

Think about how you would chisel hair
out of marble and try to mimic that in your
painting. Afterwards, you can always paint
in some individual strands on top to give
the solid shape the illusion that it consists
of thousands of individual strands of hair.

Step 03
The color of the hair
Painting hair does not differ from painting
anything else, in the sense that values
are still more important than color. If

your haircut looks believable in black
and white, it will look believable in color
as well. Heck, you can color your hair
purple if you like and claim it's part of
your design if your values are correct; but
you can't get away with bad values.

In this study I went for a golden
brown hairstyle and after looking at
some references, I defined the color
swatches in the bottom corner to refer
to and to help me out (image 03).

As a quick tip, I would advise that you
never use pure black in the areas of
shadow or pure white in the highlighted
areas; even black, gray, or white hair
contains some subtle color in it.

★ PRO TIP

How to brush your hair

After you've suggested the bigger volumes of the haircut you can start by adding the texture it needs. Rather than doing it with a single brush a thousand times, an easier way is to open a new rectangular document and put some more-or-less evenly spaced dots in it. They should be black and white, differ in size, and have different values.

Now click on Edit > Define Brush Preset. Then give your brush a name and click OK. This will now appear as a usable brush in your brush library. Open up the Brush (Window > Brush) palette and in it you can select your brand new brush. In the Brush Tip Shape menu, change the Spacing to 1% and you'll have a fast and convincing hair brush. Don't use it too much though; it's better to switch back to single brushes during the final stages because they lead to a more spontaneous result.

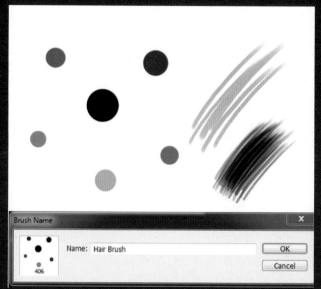

Brush Name

Name: Hair Brush OK Cancel

406

▲ Creating a new brush is a quick and easy way to fill up those big volumes of hair

Step 04

A mask of hair

Keeping the haircut on a separate layer is a good idea when you start laying in the big volumes. By selecting Lock Transparent Pixels in the Layers tab, you can use a big, soft brush on the sides to manually create some gradients. Using this technique also forces you to see the haircut as a solid shape rather than a combination of lots of single hairs, so it will be easier to shade it as a whole as well.

Look, for instance, at the shadow under the nose and behind the ear. By painting it roughly now, I'll remember to avoid strong highlights in those parts later on. There is a pitfall in working like this, however: we're creating haircuts and not hairpieces, so we need to remember to work on the transition between the head and the hair, too.

You can change the settings of your custom-made "hair" brush (see pro tip above) by going into the Brush Palette to achieve

Make sure you are in Brush Tip shape

Set spacing to 1%

Turn Size Jitter off

▲ Masking the hair is great to get some gradients going, but keep in mind that you're not creating a hairpiece!

04

▲ Hair is grouped in locks that are draped around the head in different directions | **05**

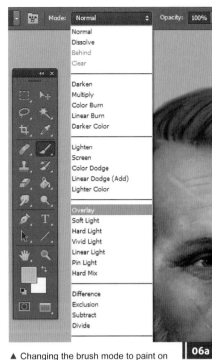

▲ Changing the brush mode to paint on Overlay in the current layer | **06a**

the desired effect. The most important things here are to change the Spacing to 1% and to turn on Shape Dynamics to get Pen Pressure opacity. Turn off the Size Jitter though in order to keep your hairs straight and consistent (image 04). Scattering, Texture, and Dual Brush mode shouldn't be used here because they will make your hair feel messy and cluttered.

Step 05
Twist and turn

A haircut is mainly defined by how the bigger locks of hair are cut and draped around the head. When designing a haircut it's a good idea to think about which way the hair is turning. In this case, the slick hair on top of the head will be neatly combed to the side, flowing over into the beard which will be more rugged and chaotically weaved (image 05). Mustaches can be the exception and will often be neatly combed and modeled as well.

Use your brushstrokes to suggest the direction of the locks; try to use large brushes to avoid the individual-strands-of-hair trap.

Step 06
Color as a statement

The color of a haircut can be a statement in and of itself. In this case, I wanted my character to look a little wiser but still not too old, so I decided to give him dark hair that started to turn gray. For the beard, I wanted to give him a salt-and-pepper kind of look: warm dark browns combined with bright gray and saturated browns around the mouth.

You can change the mode of the brush itself to paint in Overlay in your current layer, without creating new overlay layers (see image 06a). You can use this technique instead of the Dodge tool to boost the highlights and to sneak in some new colors. As touched upon earlier, even when painting gray hair, you should always avoid using neutral grays. It's better to go for either a warm gray or a cooler variation (image 06b).

Using different colors helps prevent the haircut looking dull and unoriginal, and slightly builds up the character by giving him another edge.

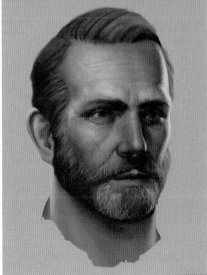

▲ Coloring the beard with a salt-and-pepper tone | **06b**

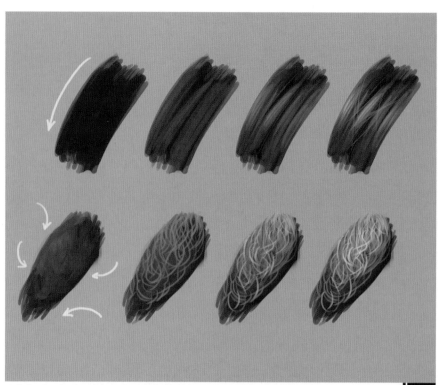

▲ A step-by-step breakdown for painting hair 07

"It's important to work from dark to light. Start with the dark undertones and build your locks on top of that"

Step 07

Dark to light

When painting hair it's important to work from dark to light. Start with the dark undertones and build your locks on top of that (see pro tip above). Use big brushes to lay in the shapes and rough values, and see how it already starts to group in locks (image 07). It's a bit different for the beard since it's so chaotic, but the idea behind it is the same.

Lastly, put a few hairs every which way to avoid getting a sterile and unrealistic haircut. And if you really want to make it pop, set the painting mode of your brush to Overlay, pick a bright color, and paint in some extra shiny highlights.

Step 08

Controlling the light

Every now and then it's important to step back and see the bigger picture. When the first thing you notice is individual strands of hair, you're probably doing something wrong.

▲ Using Lighten and Darken as painting modes to pull it all together 08

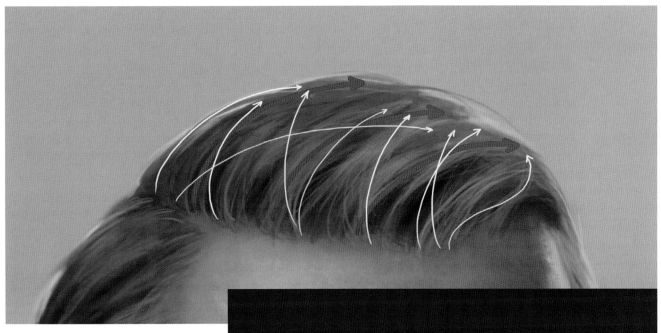

"No haircut is perfect, there will always be a few hairs running against the stream"

A trick to help avoid this is to select a big, soft brush, put its painting mode on Lighten, pick a light color, and sweep it over the parts of the locks that are turned towards the light. Then put the painting mode on Darken and do the same with a darker color on the darker parts. This can really help to pull it all together. Don't go overboard with this technique though; keep your values in check.

Step 09
There's perfection in imperfection

No haircut is perfect, there will always be a few hairs running against the stream. And that's a good thing; by recreating those little rebel hairs in a layer on top of the haircut, you'll make it look alive and convincing.

Look at the arrows in the top part of image 09 and see how the red arrows show the general direction of the hair, while the white arrows take different roads. These little hairs still get shaded the same as the others, but because they move in other directions they stand out and make the hair more interesting to look at. In some cases, it's even a good idea to group some of them together to create one or two big, rebel hair locks.

▲ A haircut becomes a lot more convincing if a few hairs stray away from the path　09

★ PRO TIP

Use reference!

The age-old discussion of whether or not a "real" artist needs references is a redundant one. Millions of artists throughout history have used references, and to great result at that. It's not a question of whether or not you should use it (you should); it's a question of *how* you should use it.

Basically there are two different ways. The first is to look for a reference (be it photographs or *en plein air*) and make an exact copy of it. It's a great way to learn and it's a whole art form in and of itself.

The second way, which is used by concept artists all over the world, is to create something from scratch but get the right information from the right resources. In this case, I browsed through **freetextures.3dtotal.com** for a hair reference (first image on the right here).

Notice that the reference is completely different from what I was painting, but there's still a lot of valuable information to

collect in it: the way hair flows, how tiny hairs get highlighted and stick out, the way the hair shapes around the head, and so on. While painting I go through tons of these photographs, getting exactly what I need out of each of them.

▲ Use reference photos to your benefit when painting – there's a lot of valuable information to be found in them

Step 10

Moving the hairline

At this point I felt the hairline of my character was a bit off. I wanted him to look just a tiny bit younger so I decided to move his hairline forward and introduced a bit more brown into it. I move the hair line forward by selecting it with the Lasso tool and then pressing Ctrl+Shift+C (to copy merged), and Ctrl+V (to paste). Now the entire hair line is in a new layer, which I then nudge forward with the arrow keys. Afterwards I only need to erase the edges with a soft brush and paint in some new hairs here and there to make it fit with the rest of the head.

I used the Overlay mode on my brush to push the volume and to make the beard fuller. I also lightened the left side of the face and painted some extra tiny rugged hairs on the transition line between the skin and beard.

It's a matter of going with your gut, letting the image rest for a while, and picking it back up again later on. Keep at it and soon your character will be ready to hit the town.

▲ I move the hairline forward and introduce more brown to make the character feel a bit younger **10**

Designing a costume

Painting different materials to create a 3D feel for your character

by Bram "Boco" Sels

Generations upon generations have expressed themselves through fashion and that's precisely why concept artists can greatly use it to their benefit. When you look at someone's clothing, you immediately (and perhaps even subconsciously) picture what type of person it must be. It is a form of prejudice that can be wrong and hurtful in real life, but often spot-on in movies and games.

There's a good reason for that: because of the fast pace of most movies and games you should be able to take one look at a person and judge what his or her role is in the story. The concept artists behind the scenes are expertly trained at communicating this; their job is to create characters and environments that speak for themselves, show history, and are rich with a back story. In the previous chapter you learned that the shape of the hair can be helpful in doing that. The same holds true for the clothing you give your character.

It is important to remember that every decision that you make as a concept artist should contribute to what you are trying to communicate through your designs. If your character is a villain for instance, giving him sharp, dark clothing will help to reinforce the idea that he is bad and make him seem more evil.

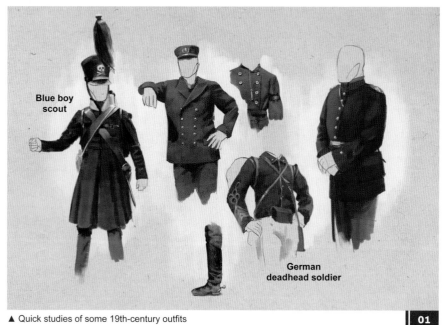

Blue boy scout

German deadhead soldier

▲ Quick studies of some 19th-century outfits

01

This chapter will take you through everything you need to know to give your character an interesting costume, from how to paint different materials to how to translate that knowledge into painting onto volumes, to achieve a lively and 3D character.

Step 01
Warm-up 4.0 (the historical one)

A different kind of warm-up this time! I had decided to move forward with the 19th-century theme I had going in the previous chapters so I opened up Wiki Commons again, this time researching costumes from that period. I wanted to create a hero, so I looked a lot at military uniforms and did some little studies of the outfits that really spoke to me (image 01).

I particularly liked the German deadhead soldier's roped jacket, the officer's jacket buttons, and the blue boy scout's crossed leather bands. I looked at paintings contemporary to the time as well. You can't have too many references, so I created a new folder in my reference library for everything I could find from the 19th century.

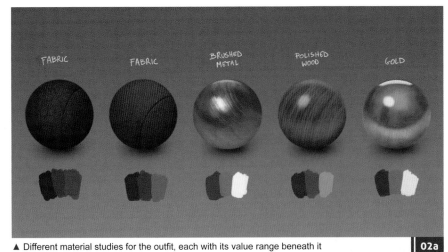

▲ Different material studies for the outfit, each with its value range beneath it 02a

▲ An example of one of the patterns and brush texture settings I used 02b

▲ Three mannequins, ready to be dressed 03

Step 02
Different materials

When painting outfits you'll come across a lot of different materials. Each material has a different color and texture, and reacts differently to light. While warming up I noted which materials were going to return in the outfit and did a separate study of those.

In image 02a you'll notice that there's a big difference in values for each material. I've put the value range in black and white below each, and you'll quickly notice that materials like metal and gold reflect a lot more light than fabric does. Their highlights are stronger and they reflect their surroundings a lot more clearly than the fabric, which has almost no highlights but does have very dark shadows. The texture is also different in each material: some are rough, some smooth.

To paint the different materials I used exactly the same brushes as I did for painting the face. I did change the pattern in the texture mode from time to time though (see image 02b). You can find great textures on sites such as **www.cgtextures.com**. To create a new pattern, download the image and open it in Photoshop. Then click Edit > Define Pattern. To get that sleek lighting look for the glossy-looking areas on the edge of the balls in image 02a, I used the Dodge and Burn tools around the edges of the ball masks. The highlights were painted manually.

Step 03
Mannequins

Just like a fashion designer, start out with an anatomically correct mannequin. Picture it as a dummy which you dress up the way you like. It shouldn't be too detailed since it'll be covered with clothes, but it's important to get the big volumes right. If the base is incorrect it will be very difficult to rectify it later on, so really make sure the foundation is right.

Eventually, I duplicated it so I have three figures and can therefore create three entirely different outfits. This way you keep your mind open and, especially in a production pipeline, it gives you a few options to show to your client, which is always safer than coming up with just one suggestion.

Step 04
Dress to kill

Dressing up a character is such a fun thing to do. It brings your character to life and gives it background and history. At first I started with a rough, no nonsense kind of soldier with a roped jacket and dirt covers over his pants, but I quickly felt that he needed a long coat to raise his status and to make him more heroic. In the second character I kept the roped jacket and introduced boots with spurs to suggest he'd have a horse somewhere.

The last character I drafted had a different type of coat. I gave him a ceremonial sword to push his status further (see image 04).

Step 05
Assigning values

Designing costumes is a bit different when it comes to values. Each element will have its own value range depending on its color and what it's made from (see step 02).

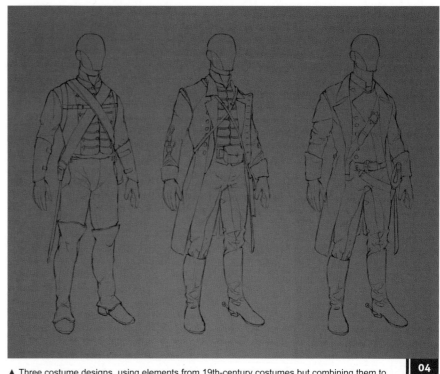

▲ Three costume designs, using elements from 19th-century costumes but combining them to create something new and unique

04

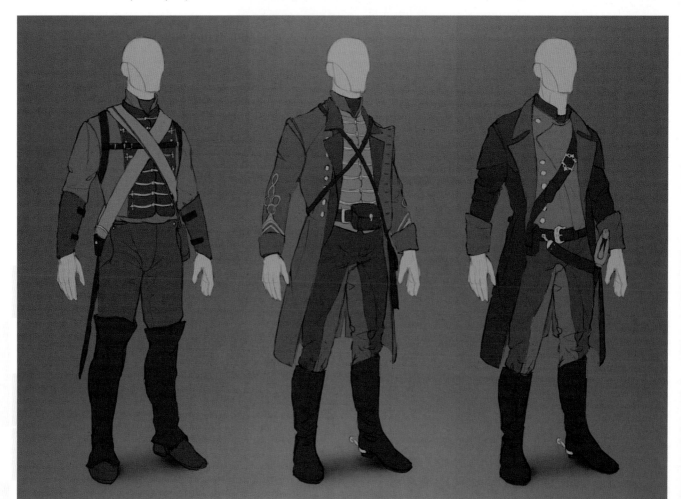

▲ Thinking about the big values is important if you want to create a character that's readable

05

Still, all these elements will have to work together and support the character.

It's important to keep this in mind and think about what you want to emphasize and what you don't. For instance, note that in image 05 there's a difference between the roped jacket in the first character and in the second. In the first I chose to use light ropes against a dark jacket; in the second I used light ropes against a mid-range jacket.

As a result, you can see that the ropes in the second jacket become a lot more subtle and the emphasis moves towards the buttons on the coat.

Step 06
Making it 3D

Once you've settled on the basic values you can start thinking about volumes again. The process is basically the same as in the chapter on painting the body

(page 82), but the difference here is that instead of painting muscles you're painting different materials and wrinkles.

The way you approach it, however, is almost the same. Think about the body as a cylinder; think about what side of the cylinder you're painting on and let common sense take it from there. It also doesn't hurt to keep some references open in a separate window; I almost never paint without them.

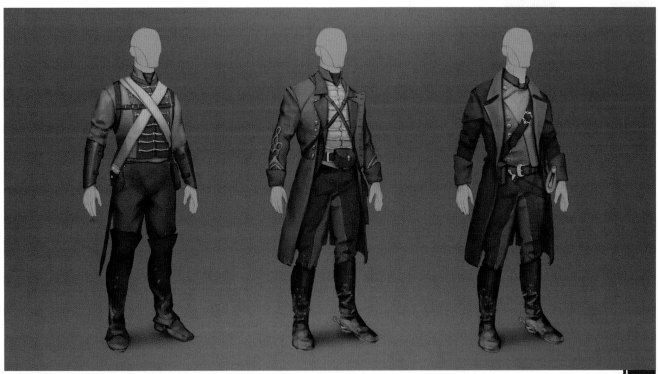

▲ Pushing the values, thinking about the direction of the light and which planes are facing it

06

★ PRO TIP

Using the Histogram

The Histogram is a great way to keep track of your values. You can consult it by pressing Ctrl+L, which opens up the Levels pop-up window for the layer you've got selected. Alternatively you can also open the Histogram palette through Window > Histogram, which shows you the Histogram for the entire image.

What the Histogram does is show you how many pixels of each value there are in your painting. In the image here you can clearly see that for my costume layer the curve leans towards the left, which means I've got a lot more darks in it than lights. Note that no pixels are entirely black (0) and no pixels are entirely white (255). This is an important thing to keep an eye on since pure black and white can quickly make an image feel flat and dull.

▲ Checking the Histogram once in a while keeps your values balanced and alive

> "Depending on the material you're painting, those highlights and shadows can differ"

Step 07
Picture it!

As an artist, an important skill to master is to be able to visualize what you're painting in front of you. Think about it as a 3D object you can turn around in your head and envision how light falls on it. In this case, the key light still comes from the front left, so in my mind I try to visualize a cutout of what I'm painting in front of me.

In image 07 I've highlighted the parts that are directly facing the light, which should be lightest; the black parts can't be reached by the light, so naturally they'll be darker.

Depending on the material you're painting, those highlights and shadows can differ. For example, the white jacket will have a lighter value range than the dark coat.

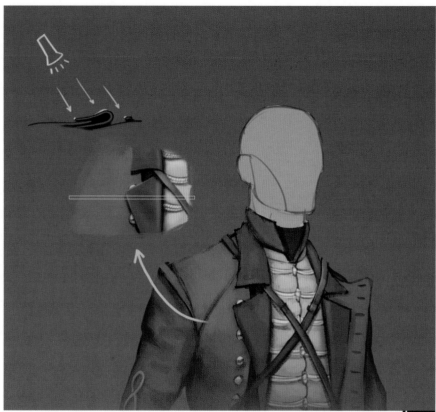

▲ A cutout for part of the costume. Note where light hits hardest and which areas hardly receive light at all

07

★ PRO TIP

Photographic textures

Freetextures.3dtotal.com has a great and free collection of textures that you can use in your paintings. These photographic textures can help you get your materials just right. Simply look for the right texture, paste it into your layer, and use your mask to select the part you need (Ctrl+click on the thumbnail of the layer in the Layers palette).

If you change the blending mode of your texture layer to Soft Light or Overlay and reduce the opacity, your materials will suddenly become a lot livelier. This is one of those occasions where subtlety is key, though. Textures should boost your painting, not be a substitute for it or an easy way out.

▲ Photographic textures can really liven up your clothing

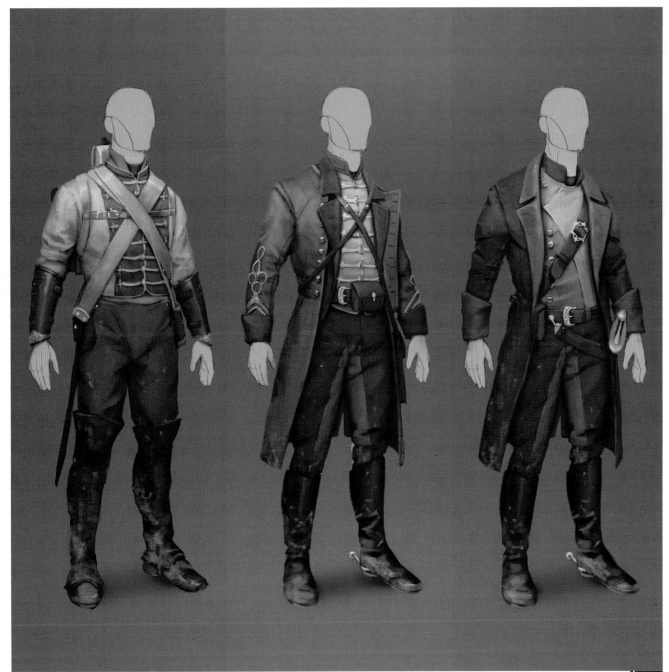

▲ Pushing the values with the Burn and Dodge tools

"When working in black and white you don't have to worry about oversaturating the colors, so burning and dodging areas is a quick and easy way to push the values"

Step 08
Pushing the values

A great way to push the values further (that is, push your darks darker and your lights brighter) is by using the Burn and Dodge tools to create a clear separation of values. When working in black and white you don't have to worry about oversaturating the colors, so burning and dodging areas is a quick and easy way to push the values that little bit further.

You can use the Burn tool (see the glossary on page 211) with a soft brush to go over every overlapping part of the outfit to create convincing occlusion shadows, and you can use the Dodge tool to really push the highlights to where you really want them to stand out and shine. For more information on occlusion shadows, please refer to the glossary (page 216).

Keep in mind that these are dangerous tools to go overboard with. You can quickly distort your values with them, which will result in an unrealistic and flat image. Subtlety is key here; remember that every material has its value range!

Step 09
Color through history

The color of clothing has changed a lot over the course of history, so researching the right colors for your designs can really make your character believable. Think about what people dressed like in the 90s and try to picture a medieval warlord in those colors. Doesn't work that well, huh?

In the case of my 19th-century hero, I noticed the recurring colors from that period were navy blue, ocher, and burgundy. So with those colors in mind and a brush with the painting mode on Color, I quickly went over the bigger elements to try out some different combinations. After that I gave them one more round of detailing with a regular brush.

Step 10
We have a winner

After a while I settled down on the second of the three figures. I felt his double coat and roped jacket were the better combination of the three and I liked the double-colored pants combined with the dirty boots. I wasn't too sure about the belt, which I felt was better in the third design, so I copied that part and pasted it on my new champion. Lastly I gave the costume another round of detailing and polishing until I felt it was ready (image 10).

★ PRO TIP
Color noise

If you look at most photographs up close you'll see they tend to have subtle color discrepancies all over them. Using roughly the same technique to create the noise for the skin in the first chapter of this tutorial, you can create that great photographic noise yourself.

These color smudges will unify the picture and make the underlying colors feel vibrant. Follow the pro tip steps on page 86, but ensure you uncheck the Monochromatic checkbox in the Noise pop-up; use Filter > Blur > Gaussian Blur at 92 pixels instead of Blur More. This way you'll get nice blurry chunks of color that you can blend over your painting. In this case, opacity at 6% should do the trick – you don't want to overdo it.

▲ Blurred color noise unifies the picture and makes the underlying colors feel more vibrant

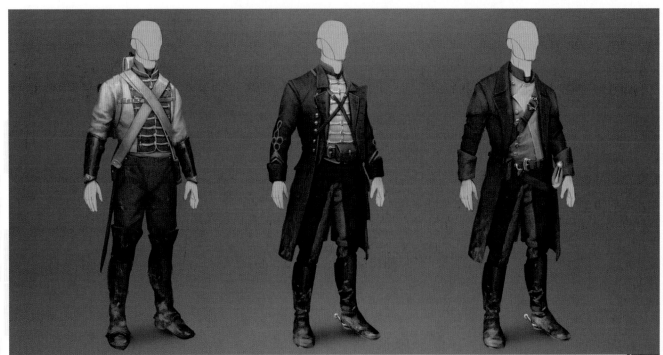

▲ Using navy blue, ocher, and burgundy as the main colors for the costume

09

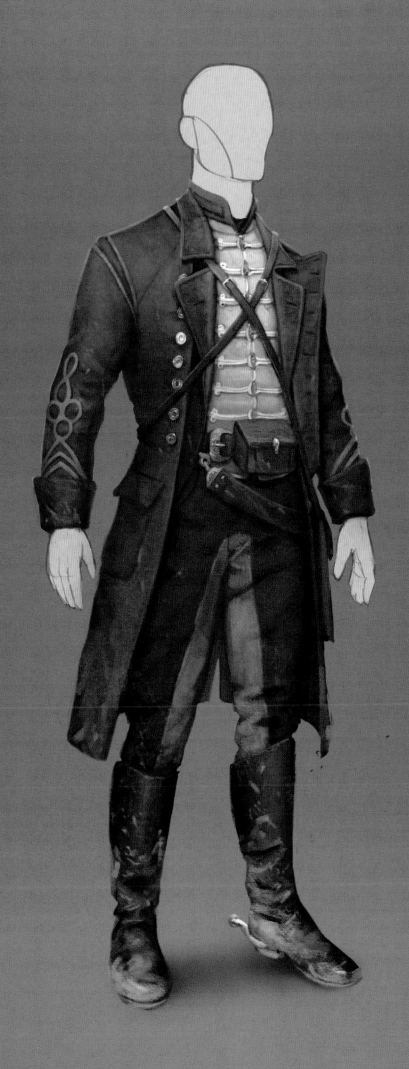

Pose and background

Learn to pose your character and add post–production effects

by Bram "Boco" Sels

The final pose is often just for presentation purposes. You've already decided what your character looks like and you've got the green light for the outfit. In other words, everything is ready to go into production and will eventually start its new life in the game world. A lot of studios do, however, still prefer to have a nicely shaded mood painting of the character as well. It combines all the elements and gives them a nice image to use for promotion. Preliminary sketches and designs like the ones from the previous chapters are great and helpful for a 3D artist to move forward with, but can't be used in marketing. Hence the last step: the polished hero pose.

The main difference here is that the focus lies more on how you light the scene and which mood you wish to convey. In other words, your character should almost be swallowed by the environment around him. This chapter will teach you how to create fog and particle effects to do just that. By smartly using light and color you'll quickly learn how to create the illusion that your character is really standing somewhere.

Step 01
Warm-up 5.0 (the quick one)
A good exercise to warm up with is to do some gesture studies. Look at some

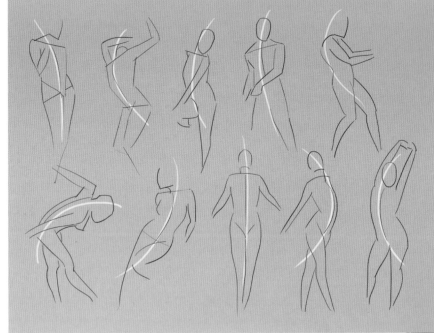

▲ Quick gesture studies with the line of action going through the middle

| 01 |

reference photos and try to lock down the poses as quickly and with as few lines as possible. These gesture lines are the bare minimum you need to get a readable pose. And if you decide to take them further, everything you add from then on should be submissive to these simple but dynamic guidelines.

Also notice that one line in particular is the absolute king of lines, that's the line of action. It goes right through the torso and is

what makes the pose dynamic (image 01). A good thing to remember here is that if you're looking to create something dynamic, the line of action should always be a curve. A curve indicates movement and force while straight lines quickly look stationary and boring.

Step 02
Mannequin action
As in the previous chapter, every character painting I begin starts with a basic mannequin which I then detail. When I first

▲ Building the foundations for my character:
knees slightly bent, hands ready to hold a musket

"You can't build a house on crooked foundations. If your mannequin is off, your end result will be too"

started out I often made the mistake of being quick and sloppy at this stage which resulted in a lot of blood, sweat, tears, and abandoned illustrations (they're still haunting my hard drive as we speak, it's horrible). You can't build a house on crooked foundations. If your mannequin is off, your end result will be too. It sounds obvious, but it's still one of the most common mistakes I see and one I still make myself if I'm in a hurry. There's no excuse for sloppy preparations.

Step 03
Translating the design

Once the mannequin is ready you can start dressing it up. There's little designing left to be done since you already decided on the portrait, haircut, and costume in the previous chapters, so it's just a matter of translating it accurately onto your posed character. Look for references that can help you out in the difficult parts, for example where there are wrinkles, weapons, and hands.

Look at how clothes fold around the knees and shoulders and try to mimic those folds in your own drawing. Once you're satisfied, duplicate the layer and hide the original. It never hurts to have a backup.

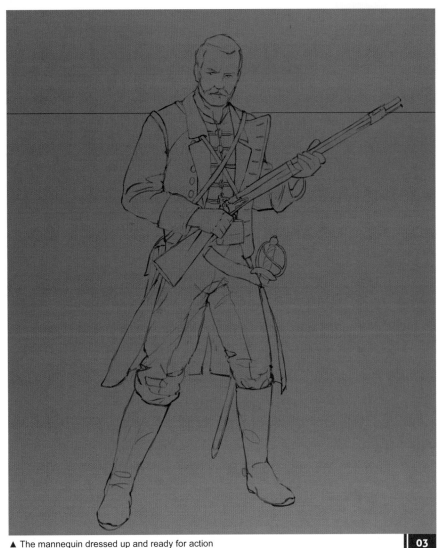

▲ The mannequin dressed up and ready for action

★ PRO TIP
Painting fog

Volumetric fog is a natural phenomenon that's used by a lot of concept artists to create depth in a painting. By placing something both in front of and behind a character you make him or her part of the environment. You can create custom cloud and fog brushes to use.

Keep in mind that fog is so organic that it's impossible for two parts of it to look alike and by using pre-made brushes you're bound to end up with such copies. You can counter that problem by quickly blocking the fog out with cloud brushes, but then heading back in with a regular soft, round brush and erasing and smudging the repetitive edges.

▲ Volumetric fog makes the environment swallow the character

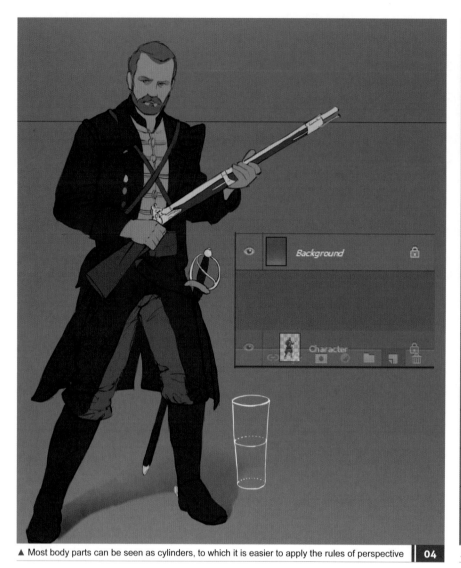

▲ Most body parts can be seen as cylinders, to which it is easier to apply the rules of perspective **04**

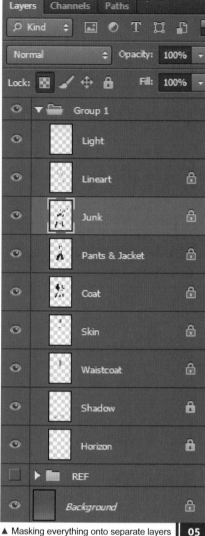

▲ Masking everything onto separate layers **05**

Step 04
Perspective

Something that is often forgotten by beginner artists is that even characters have to abide by the rules of perspective. Even though you might not see the obvious straight lines moving towards a vanishing point, it doesn't mean that perspective doesn't apply.

Think about every body part as a cylinder and try to figure out how it's oriented. It's a good idea to draw a horizon line on a separate layer as it helps you put your shapes into the context of perspective. In our case, the most obvious cylinders are in the boots; look at how they are below the horizon line (image 04) which means we see the top of them. Knowing this will help you to visually calculate how the boots should appear around the leg.

Dragging and dropping a layer on the Create New Layer button at the bottom of the Layers palette quickly generates duplicate layers and keeps a backup hidden underneath your new one. It's a good idea to keep backup layers so you can always go back a few steps if needed.

Step 05
The final mask

For the final image I decide to mask every element of the outfit on a separate layer: "Waistcoat", "Skin", "Coat", "Pants & Jacket", and "Junk" for things like the musket and boots (see image 05). Keeping elements on separate layers gives you freedom to fluently paint on the layers below, and you can quickly use the Burn tool to darken the transitions between different pieces of clothing without affecting what's on top.

I had decided I wanted to create a dramatically backlit scene, so as a first step towards this, the Light layer above the layer stack is an Overlay layer that brightens the top of the image.

Step 06
Detailing the face

A trap I've fallen into a lot before is detailing the face just as much as the rest of the body, marking the place of the eyes, the tip of the nose, and the line of the mouth without worrying about the rest of it. That way a lot of subtle information goes out the window and these gaps need to be made up later on. I feel it's much better to zoom in a bit and really plan the portrait out in advance. It's more manageable when you have a very specific face in mind, and it will save you a lot of time later on.

★ PRO TIP

Color adjustments

Adjustments can be made directly into a layer through Image > Adjustments, but can also be made via an adjustment layer, which you can find directly above the Layers palette. Working with an adjustment layer does create another layer, which will clutter up your file, but on the positive side you can toggle it on or off later on. This means you can always change the settings later on. Color adjustment layers allow you to experiment with color and tonal adjustments without permanently modifying/changing the pixels in the image. In this case I used a Color Balance layer to make the entire image coherent. The color options you can see in the image here map an existing range of pixel values to a new range of values, which helps keep the color changes unified. Color Balance can also be a great way to get some extra color in the shadows and highlights.

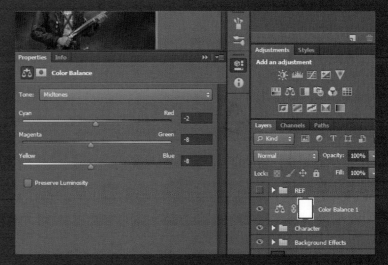

▲ The Color Balance adjustment layer, an easy way to unify the colors in your painting

▲ Planning out the facial features for the portrait

06

Step 07
Changing the lighting

I wanted to create a more dramatic and foreboding environment, so I had to change the lighting scheme somewhat. To get that dramatic vibe I increased the back light and moved in some fog to disconnect him from the background.

To paint fog, I create a brush from a cloud photo/texture. Do this by opening a cloud photo (it can be one you have taken yourself or from a free texture site), and, using the Lasso Tool, select an area of the image from which you want to make the brush. Right-click the selection and select Feather to about 20 pixels. This blurs the edges. Then copy and paste onto a new document.

We now want to desaturate the cloud: go to Adjustments > Desaturate (Shift+Ctrl+U). Add a Levels adjustment layer and move the sliders until you end up with a blacked-out background. Next add an Invert adjustment layer (Layer > New Adjustment Layer > Invert). You should be left with a nicely defined cloud, so choose Edit > Define Brush and you now have a ready-to-use brush.

Returning to the figure, I blocked in the values, looking closely at the images from the previous chapters to make the final illustration as consistent as possible. You might be tempted to copy parts directly from your previous designs, but I feel it's better to just paint them again from scratch. It'll be more correct and you'll have more control over what you're doing.

Step 08
Cue the dramatic music

If you're creating a mood piece like this it's important to think about the color scheme. I knew that I wanted it to be cool and dark to get that tense vibe across, so one of the first things I did was darken the background and tone it blue. I also started toning each part of the character in its local color (the color it has under neutral light). It's important to note that color changes when under a colored light, but I wanted to get the local colors as close to the original designs as possible before worrying about the color of the light.

▲ After increasing the intensity of the back light, the values of the character also changed 07

★ PRO TIP
Particles

Adding particles is another fantastic way to liven up an environment. Be it snow, rain, fire embers, or in this case dust, it makes you "taste" the atmosphere. I used a grainy photo of a moldy brick wall and placed it on top of the layer stack with its blend mode on Color Dodge. I reduced the opacity and erased the particles that I felt got in the way of more important elements. I think that after erasing, only about 20 percent of the particles remained, which was just the right amount to keep it subtle.

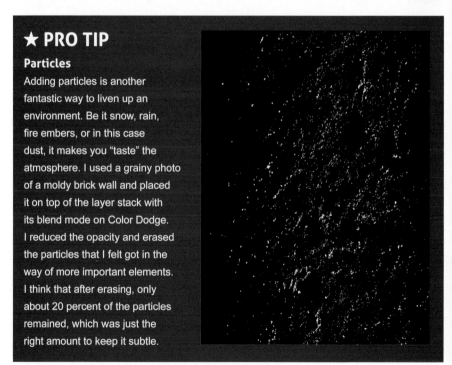

▲ The dust texture I created from a photo of a moldy brick wall

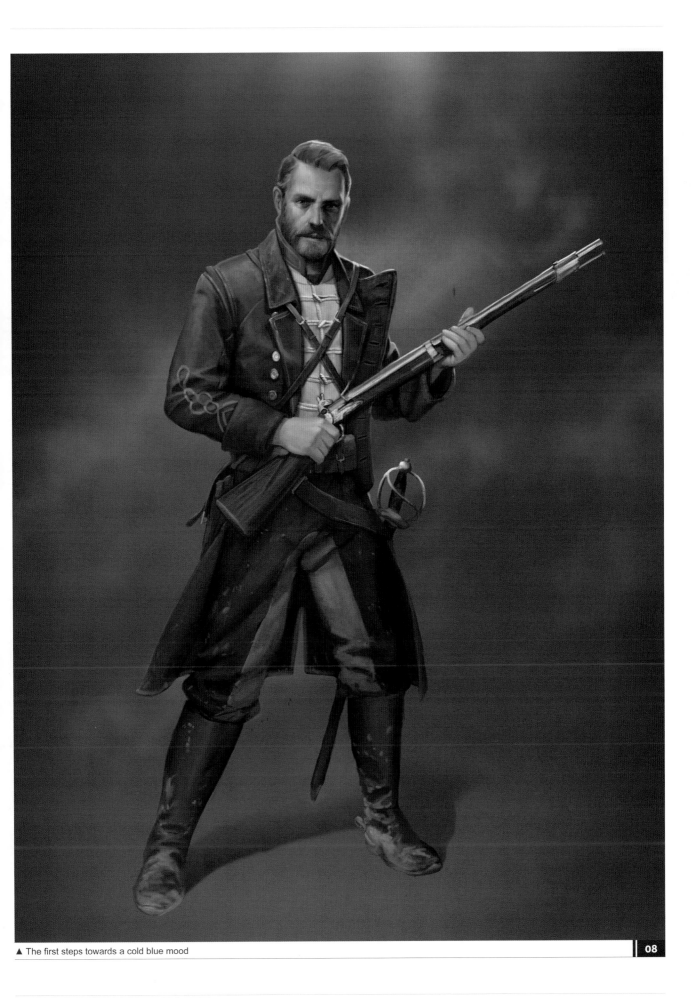

▲ The first steps towards a cold blue mood

"Some artists just starting out may be tempted to throw over an adjustment layer at this point and call it a day, but that should only be the starting point. Your lighting becomes a lot more accurate if you take the time to go back in and touch up your new colors by hand"

Step 09
Grounding the character

To make your character feel real and believable, it's important to suggest that he's actually standing somewhere. A great way to do that is by creating a platform and giving him a cast shadow. For the platform I used a free texture of a cobblestone road and used Edit > Transform > Perspective to warp it towards the horizon.

The shadow was created with a Multiply layer (see page 23) on top of that. Finally I added some fog in front of the character to really create the illusion that he's not just a cutout but an actual person standing amidst the fog.

Step 10
Pushing the mood

At this point the character still feels unhinged because of the local colors. It feels as though the mood and lighting have no impact on him whatsoever and that he is lit with a different type of light entirely, which makes him feel disconnected from his environment. So what needs to be done is to look at the different local colors and calculate what they will look like under a blue light source.

The blue coat will become more vibrant, the red of the undercoat will mix with the blue light and turn purple, and the yellows and whites will become a lot colder. Some artists just starting out may be tempted to throw over an adjustment layer at this point and call it a day, but that should only be the starting point. Your lighting becomes a lot more accurate if you take the time to go back in and touch up your new colors by hand. As you can see on the right, image 10 shows the final version.

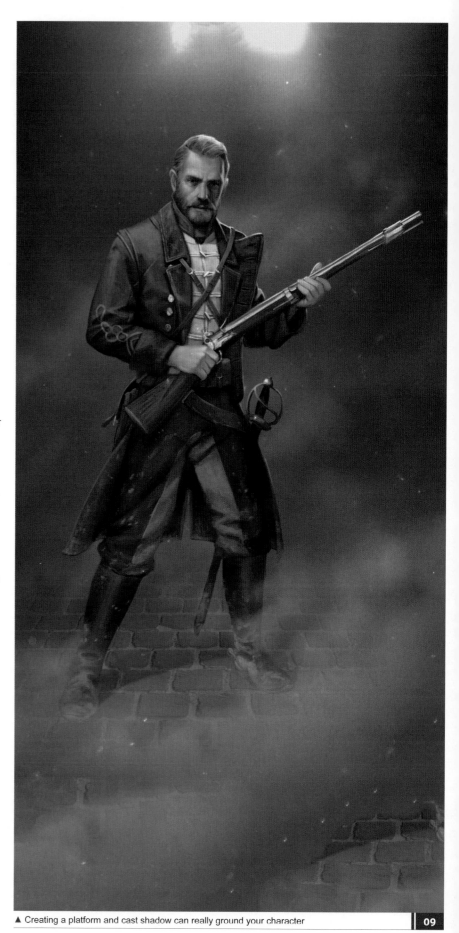

▲ Creating a platform and cast shadow can really ground your character

09

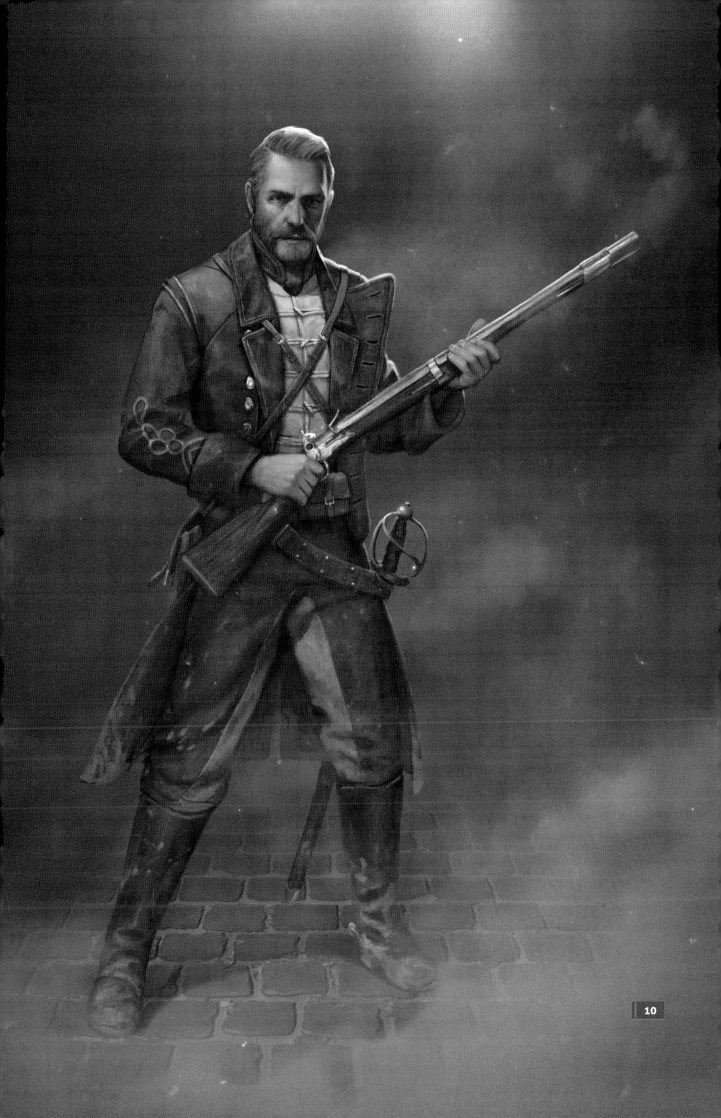

Creative workflows

Learn how to create different styles of characters in Photoshop by discovering the processes of top artists.

With the many different approaches and techniques accessible in a program as powerful and versatile as Photoshop, many artists have adopted signature and unique styles. Part of growing as a digital artist is crafting a style of your own and over time you will soon refine your own techniques. To help you on the path to developing your own style, a selection of talented artists, with a plethora of knowledge to share when it comes to digitally painting characters, are on hand to guide you through their creative workflow. Each artist will talk you through their complete creation – from initial ideas to the technical process – sharing their tools, methods, tips, and tricks, which will encourage you to find your own style.

Desert man

Create an evolved human designed for living in the desert

by Derek Stenning

In this chapter we'll go though the steps I usually take to create a character design for a client.

The assignment for this design is to create a character that has adapted, or evolved, to live in a desert environment. The design brief is pretty strict, in that even though the character has evolved, the character must remain human, with two arms, two legs, and so on. This means the evolutionary changes won't be too drastic, but they will (along with equipment and costume elements) help the character cope with the desert environment.

To warrant the need for these evolutionary changes, we won't be using any high-technology solutions to the challenges posed by the desert environment; we'll keep it fairly low-tech.

An important thing to look out for in a brief is a scenario or story. When design assignments don't have a scenario aspect to them I usually make one up myself, as it is a huge factor in making design decisions – what is this character doing in the desert anyway?

My process for this assignment will be no different, so I'm going to imagine that the character is some sort of scout; maybe he is tasked with patrolling the vast desert boarder areas of the society or group that he belongs to. This task will require him to spend extended periods of time out in the desert alone. Even though his people have evolved to be better able to cope with this environment, the scout will have to be equipped to carry out his mission.

Step 01

Character and environment research

I always start my designs with a little look into the subject matter. I'm no expert in evolution, or in desert environments, so a little time spent learning about those major elements for this assignment could go a long way in informing my design choices for this character.

I look into the challenges of living in, or adapting to, a desert environment. The major issues are the extremes of temperature

Challenges of a desert environment

Evolution:
• Ability to close nostrils
• Smaller mouth, no lips

Unseen:
Evolved kidneys that concentrate urine

Retaining water

Acquiring water

Lack of water

Moisture trap
• On staff and/or body?
Ground water pump
• On staff?
Stores carried on body

Aestivation — Not going to use this

Extremes of temperature
Hot during the day
Cold at night

Staying warm at night

Covered clothing/ Shelter to stay warm

Avoiding heat

Dissipating heat

Covered clothing:
• Block out heat and sun
• Robes, capes, layers
• Light in color to reflect heat/rays

Nocturnal/crepuscular:
• Burrowed, inactive in day
• Shelter

Increased mobility:
• Aids for traveling in sand, loose dry ground
• Large feet
• Walking stick/cane/staff

Covered clothing:
• Light in color to reflect heat/rays

Evolution:
• A move to darker skin
• Longer limbs/body to allow more heat loss
• Increased shoulder width to allow more airflow and heat loss between arms and body. Same for hips?
• Larger ears to allow heat to escape

▲ Collecting the various design problems in this assignment and thoughts on how to address them | **01**

▲ References are a great way to inspire | **02**

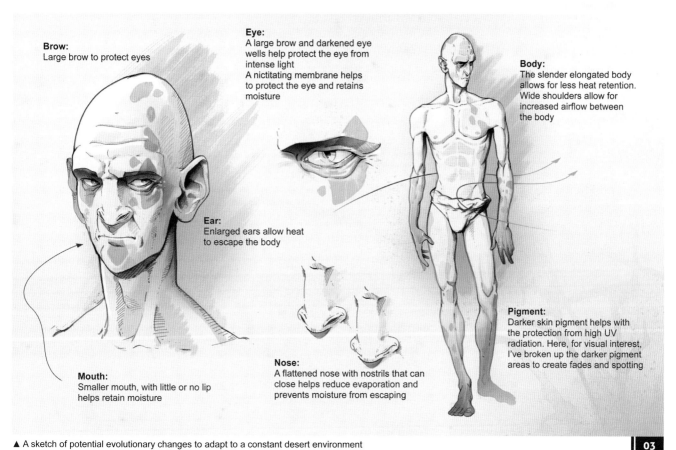

Brow:
Large brow to protect eyes

Eye:
A large brow and darkened eye
wells help protect the eye from
intense light
A nictitating membrane helps
to protect the eye and retains
moisture

Body:
The slender elongated body
allows for less heat retention.
Wide shoulders allow for
increased airflow between
the body

Ear:
Enlarged ears allow heat
to escape the body

Pigment:
Darker skin pigment helps with
the protection from high UV
radiation. Here, for visual interest,
I've broken up the darker pigment
areas to create fades and spotting

Mouth:
Smaller mouth, with little or no lip
helps retain moisture

Nose:
A flattened nose with nostrils that can
close helps reduce evaporation and
prevents moisture from escaping

▲ A sketch of potential evolutionary changes to adapt to a constant desert environment

03

(hot in the day, cold at night), and a lack of water. To address the temperature issues, I'll have to find ways for the character to avoid and dissipate heat in the design. I'll also have to find a way this character can retain or acquire water. The desert can be a hostile environment, so that will have to be reflected in the design. I take all my notes and collect them on an idea map for quick reference (image 01).

Step 02
Image reference gathering
After taking time to think about the design, I spend more time gathering images that I think can inspire me or introduce me to new ideas. References help to expand your thoughts on a particular idea, so I search for what I think are topics related to the assignment at hand. I collect images that strike me, or contain something that seems to address a part of the design concept, and put them on a reference sheet (image 02).

I limit my time doing this as I could search for reference images forever; I'm only looking

for little bits or elements that contribute to the design, not for the perfect image.

> "I'm keeping the body long and lean, as this will allow for less heat retention and increased heat dissipation"

Step 03
Evolution study
The brief states that the character has to remain human, so the first step in this design is to figure out the evolutionary changes to the body that have occurred for it to live in this desert environment.

I sketch these ideas out, as I find that it moves things a little faster than painting. In Photoshop I use a simple round brush with pressure sensitivity set to around 10–15% and opacity set to 50%. I lightly sketch out a few of the ideas that came to mind after putting together the idea map. I sketch these ideas out loosely on a layer, and once I'm happy with them, I then tighten them up a bit on a new layer,

adding a bit of quick shading to help define them and to give them a little "pop".

As it is early in the design phase and since this material is mainly going to be used to create another design, these sketches don't have to be too final or polished – they just need to communicate the ideas.

I'm keeping the body long and lean, as this will allow for less heat retention and increased heat dissipation. Wider shoulders set the arms away from the body and allow for increased airflow and more heat to escape. Darker skin pigment, in image 03 broken up into spots and fades for visual interest, aids in protection from UV radiation.

On the face, a heavy brow, darker eye wells, and the re-introduction of a translucent nictitating membrane protect the eyes from UV radiation and airborne debris. Larger ears facilitate more heat loss and a smaller mouth decreases the loss of moisture. The nostrils have gained the ability to be open and shut when breathing to conserve moisture.

Step 04

Silhouettes round 1

I love using silhouettes when designing characters. It is a quick and easy way to rifle through various design options. Here is a quick rundown of how I create the silhouettes for this very purpose.

First, I sketch out a quick pose over my body sketch from the evolution study I did earlier (under the pose on its own layer set to 15% opacity), so I'll know I'm keeping within my original proportions (see image 04a).

Then I rough out some loose costume elements and ideas over the pose sketch (see image 04b). Then with an angled brush set to 100% opacity, I fill in the main body forms (see image 04c).

Once the body is filled in, I fill in the interior of the cloak and the hood on a layer beneath the body fill (image 04d). I do this so I can lighten up these areas to give the silhouette more form and depth. To lighten these areas I just use the Radial Gradient tool, lightening the areas furthest away (see image 04e). Then I darken up the elements closer to us: the front side of the body belt and the right hand (see image 04f).

The next element I get to work on is a staff/rifle that our scout uses for protection and for aid in traveling. This is a more complex piece so I'll paint it in profile, as you can see in image 04g. I use the Free Transform tool to move this element into place (see image 04h). The final silhouette can be seen in image 04i.

Now I repeat these steps several more times, playing around with different design options. The options feature various elements to address the temperature issues, such as layered loose robes, cloaks, and shade-providing hoods. These elements are meant to double as shelters at night. Water-saving devices such as moisture traps and filters combine with water storage elements.

Protective footwear and armor combine with staffs to aid in traversing loose, rough, and hostile terrain. Signal reflectors, flags, and silks aid in communication across the vast desert expanse. I've noted these features on the silhouette page as points of interest/discussion as if I would be going over these design options with an art director (image 04j).

▲ A quick pose sketch **04a**

▲ Roughing out costume elements **04b**

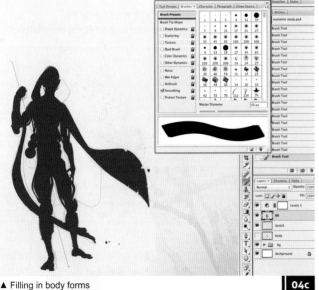

▲ Filling in body forms **04c**

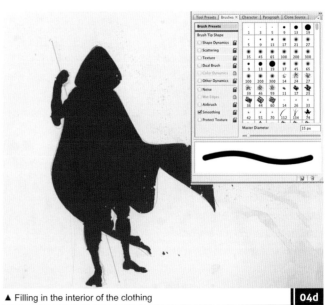

▲ Filling in the interior of the clothing **04d**

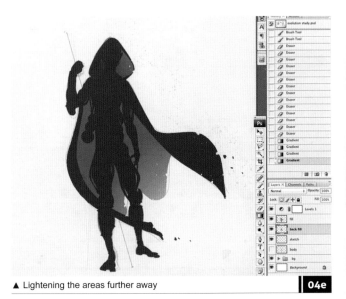

▲ Lightening the areas further away 　　**04e**

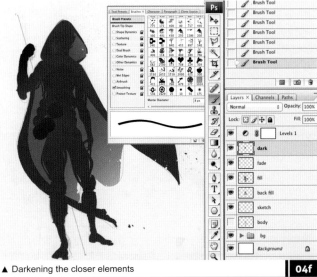

▲ Darkening the closer elements 　　**04f**

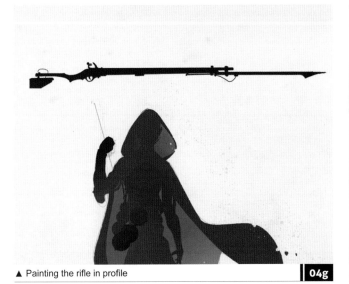

▲ Painting the rifle in profile 　　**04g**

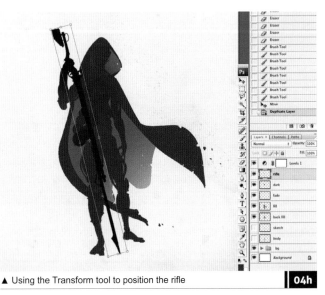

▲ Using the Transform tool to position the rifle 　　**04h**

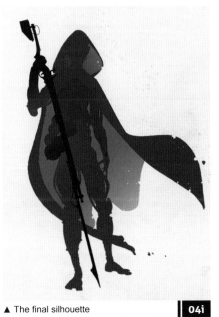

▲ The final silhouette 　　**04i**

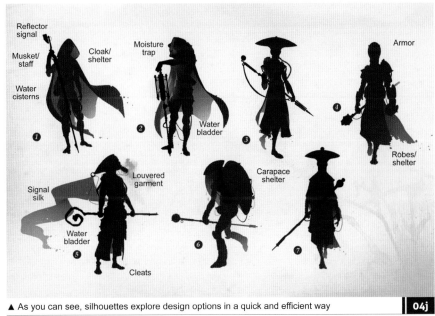

▲ As you can see, silhouettes explore design options in a quick and efficient way 　　**04j**

Step 05
Silhouettes round 2

We'll now narrow our options down by choosing our favorite designs and modifying them, with the addition of new ideas or elements from other options presented in the first round. In a production environment this would be done using feedback from the art director, but here I let my own thoughts and preferences guide the process.

To put these together you can cut up the silhouettes using a selection tool, such as the Lasso, and mash elements together. Alternatively you can paint elements over the silhouettes from the other existing silhouette options or new ideas that come to mind.

My first selection is option 7 from the silhouettes in image 04j as I really like the simplicity of it and it seems to communicate the desert scout theme to me. But I really like the signal silk from option 5, so I paint in a similar version and also add the signal reflector to his staff to aid in his scout role. I also paint in water collection bladders from option 5 along his sides to give him some more water retaining/creation ability.

My second choice for further study is option 1, as it also seems to sum up the character. The only additions I make to him are extending the armor elements and adding some armor to his right arm as in option 4, but in a much more restrained fashion.

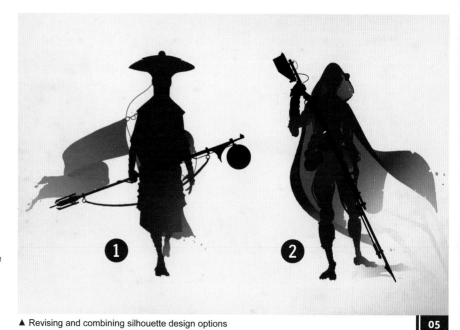
▲ Revising and combining silhouette design options

05

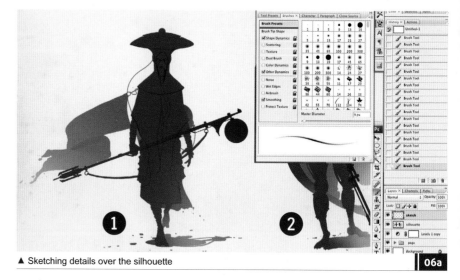
▲ Sketching details over the silhouette

06a

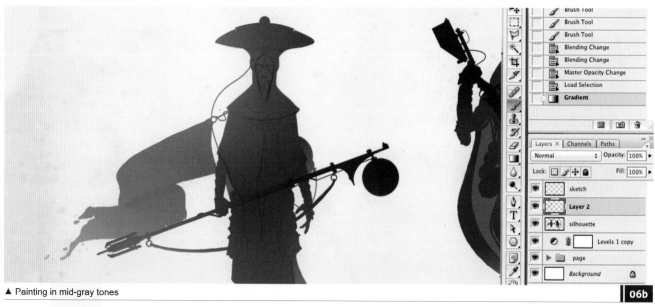
▲ Painting in mid-gray tones

06b

Step 06
Grayscale rendering

The next step is to take these two designs further – to block out the interior costume design elements to see how they work. This is done in grayscale as this can be a faster way to render up a character as you don't have to worry about color – you can just focus on the costume/body elements and values.

To get started on the grayscale rendering I first sketch out some interior elements on a layer over the silhouette to guide the painting (image 06a).

The lighting will be coming down from the upper left. To help indicate this and to get the rendering started I take a mid-gray and use the Radial Gradient tool across the upper left side of the character (image 06b).

Then using an angled brush, set to 50% opacity and with pressure sensitivity on, I do a quick rendering pass over the whole character, defining the major forms and keeping lighting and materials in mind (image 06c). I also use a cloud-like brush, and on a separate layer, fill in behind the character. This will aid later in rendering.

I now start rendering up individual elements (image 06d). The headdress is a major piece, so I start with that. An important thing to keep in mind while rendering is the material of the object you're painting. This will affect how the light is absorbed, reflected, or plays across the surface. The outer shell is a worn metal, so it will be well used but it will also reflect more light than the dark wrapping around the character's arms. I start by giving it a little texture to indicate wear by painting in some variance and marking with a couple of abstract shape brushes.

Then with the round brush I paint in the panel cut lines (image 06e on next page). I keep these on a new layer above the main painting layer, so I continue to paint in the lighting and texture information without obscuring these cut lines. As I said, while this is older, more worn metal, it should still be reflective, so I decide to paint in more

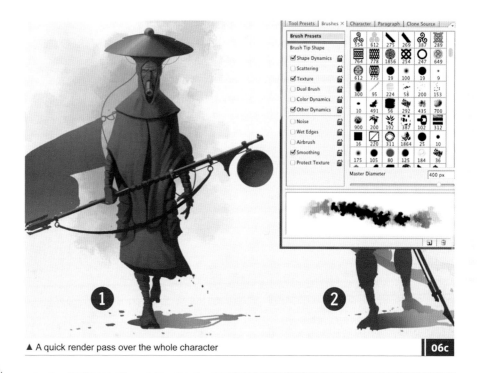

▲ A quick render pass over the whole character

06c

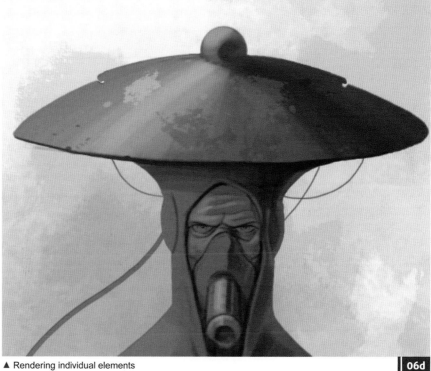

▲ Rendering individual elements

06d

★ PRO TIP

Presentation

Remember that concepts are about communicating ideas, and you can communicate your ideas better by adding a level of presentation to your work. Of course, a good design that is executed with a high degree of skill is the most important part of creating a good presentation, but you can make your concepts stronger by clearly labeling them, following naming conventions, and including additional thoughts and information.

contrast, punch up the highlights, and add some panel detail (image 06f). I carry out a final detail pass adding more highlights to the cut lines, a few more tertiary elements, and a bit of reflected light from the environment to give the headdress more form (image 06g).

I then repeat this process across the rest of the character, keeping my mind on points of interest and materials. These aren't final designs, so only spend time on areas that communicate unique aspects, like the headdress, staff, moisture trap, and signal silk on this character. The rest can be addressed later if this option is selected.

Image 06i shows the two options at the end of this process. The first design focuses more on softer materials like layered loose robes, the wraps, and the signal silk. He seems like a traveler, and is somewhat mysterious, with his headdress and his face obscured by the moisture trap.

The second option explores my idea of louvered clothing. These garments can open up to allow the passage of air and to allow more heat to escape, and can then be closed up for warmth. This character also seems more aggressive because of his armor and how the musket has been incorporated into his staff.

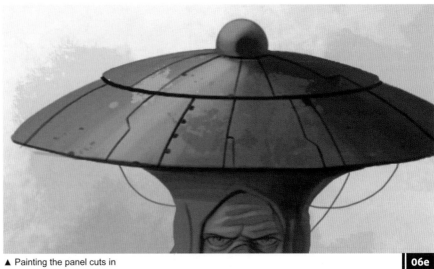
▲ Painting the panel cuts in 06e

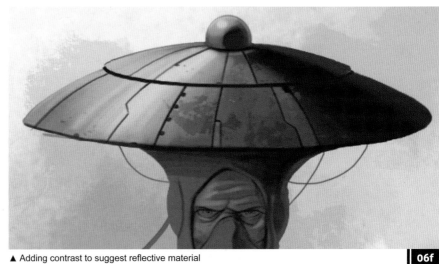
▲ Adding contrast to suggest reflective material 06f

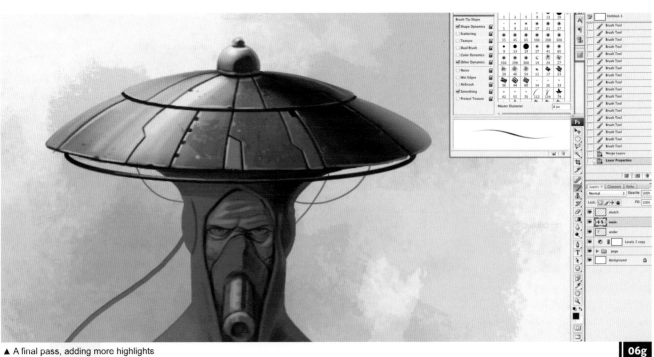
▲ A final pass, adding more highlights 06g

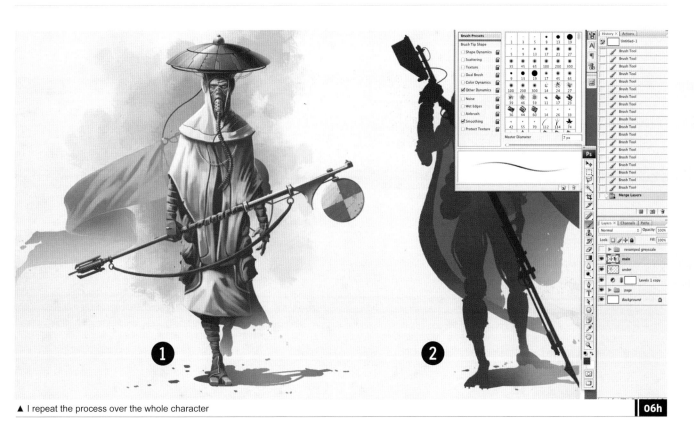

▲ I repeat the process over the whole character

06h

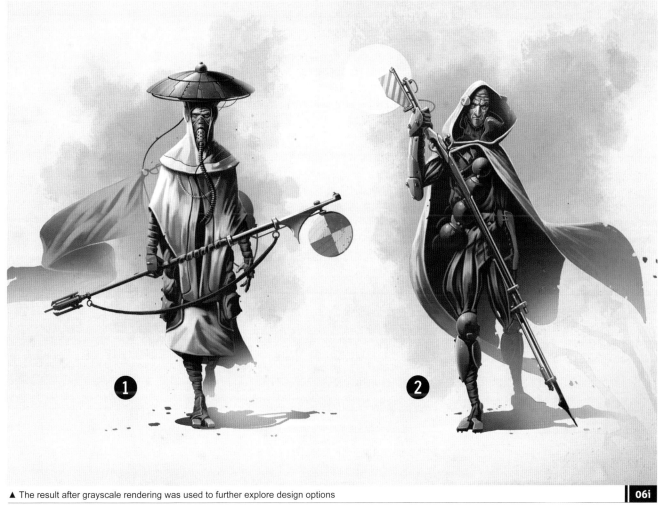

▲ The result after grayscale rendering was used to further explore design options

06i

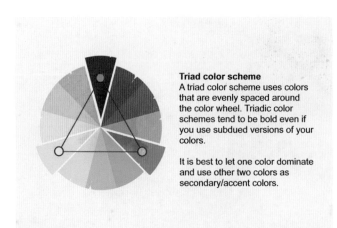

Triad color scheme
A triad color scheme uses colors that are evenly spaced around the color wheel. Triadic color schemes tend to be bold even if you use subdued versions of your colors.

It is best to let one color dominate and use other two colors as secondary/accent colors.

▲ The triad color scheme **07a**

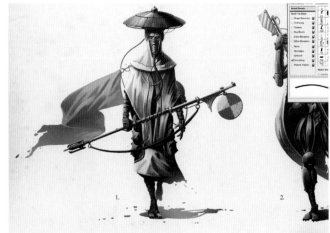

▲ Set the blending mode to Overlay and fill the layer with red **07b**

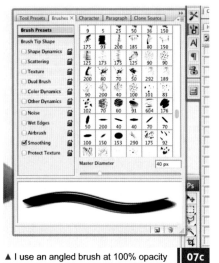

▲ I use an angled brush at 100% opacity **07c**

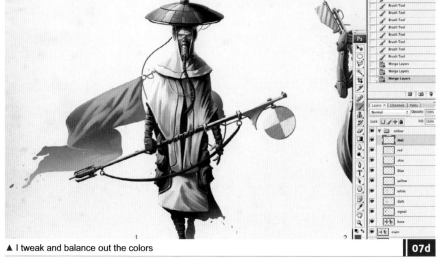

▲ I tweak and balance out the colors **07d**

Step 07
Rough color compositions

After the characters have been blocked out in grayscale, the next step in this exploration is to add some color to help us evaluate the designs. Color is important, and using an Overlay layer in Photoshop is a great way to quickly add color to your rough work. I'll explore a couple of different color schemes across the two designs and judge the results.

On the first character, I'm going to use a primary triad scheme. Triad schemes use three colors that are evenly spaced around the color wheel (image 07a). This method creates color schemes that are quite bold, even when using subdued hues, as I tend to do. As I want the heat to come through on these characters, I'm going to use red as my anchor color, with yellow and blue backing it up.

Once we have our color scheme sorted, I create a new layer set and change the blending mode of the set to Overlay (image 07b). This will allow me to use, sort, and change multiple layers for different colors over the grayscale image. I want the hot temperature to come through on these,

so on a new layer within the layer set I fill in a red color over the entire character.

I then go over the character, painting in the different colors for the different elements. I create new layers as needed for the different elements. This just makes it easier

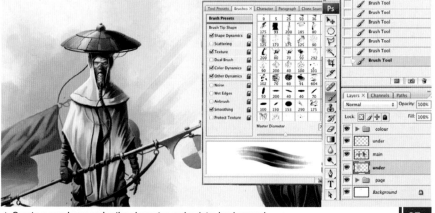

▲ Create a new layer under the character and paint a background **07e**

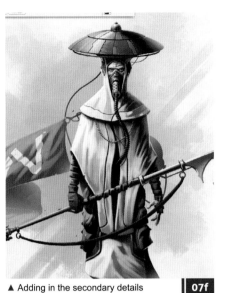

▲ Adding in the secondary details **07f**

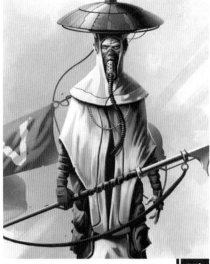

▲ Levels adjustment layer to alter contrast **07g**

▲ Wash the character with a warm orange **07h**

to modify and change the colors as you go. For the painting I'm just using an angled brush at 100% opacity (image 07c).

When the major elements are all filled in I spend some time tweaking and balancing the colors (image 07d). For this I often pick a new color and paint over the specific layer, but I also sometimes use the Hue/Saturation or Levels adjustment panel and tweak the existing color until I find something that works.

After the colors are where I want them, I create a new layer under the character and paint in a simple background for the character to rest on (image 07e). This was painted with a cloud-like brush and a texture brush to give it an abstract random feel. This background helps the "pop" of the page and will aid in the detail pass.

I now do a quick detail pass on the character. On a new layer on the top of the layer stack, using an angled brush with pressure sensitivity on and set to 50% opacity, I go over the character adding secondary details (image 07f). I also paint in some reflected lighting using the colors from the background to give the character more volume and depth. As this isn't a final design, you don't have to go too far with this detail pass, just get the image to a point at which the elements are reading and you are comfortable presenting it.

I then select the character and create a Levels adjustment layer. I tweak the levels, punching up the contrast by increasing the lights and darks (image 07g).

Finally, in order to warm it up a little, I select the character, and then on a separate layer I fill my selection with a warm, lighter-toned orange I grab off the character's shadow (image 07h). I then set the blending mode of the layer to Soft Light. As the fill color is lighter than 50% gray, this will lighten up the whole image

and wash it in the subtle warmth of the fill color. I pull the opacity back to around 40%, so we are left with a warm, hazy feel... kind of like you would expect in a desert!

I repeat this process on the second character, this time using an analogous color scheme (a color scheme that uses colors that are next to each other on the color wheel; see the right-hand figure in image 07i). I start with the same red base, but move into violets and indigo as my secondary colors, and add a bit of orange for an accent.

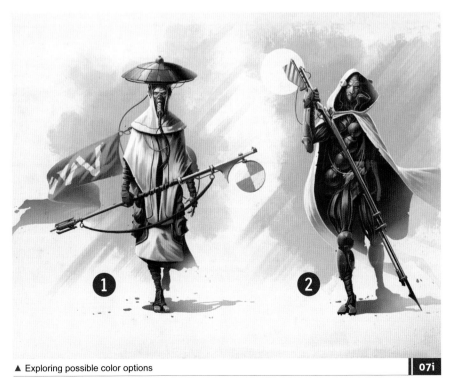

▲ Exploring possible color options **07i**

Step 08

Creating the final design

After weighing-up the two designs, I decide to move forward with the first character option. This version seems to hit more of the design criteria: the loose, layered robes and the large headdress (which I'm imagining will fold out into a shelter) help to block out heat radiation; the moisture trap, that collects moisture in the water bladders, helps with water retention; the footwear increases the sole surface area; and the staff will aid in traversing the loose, rough terrain. The signal staff and the signal silk (one of several carried) help this scout communicate across the desert expanse as well.

I'm also moving forward with this design because it has more emotional impact, and hits on the solitary, somewhat mysterious nature of the desert scout.

Now that I've made my choice, I refine the character a little more to bring it up to a presentation level. I start by taking the color composition and merging it all together, except for the background. Then I make a few larger changes.

First I adjust the position of the signal staff, bringing the heavier front end down. This looks more natural given the weight of the signal end of the staff. Using the Polygonal Lasso, I grab the staff and free transform it into a downward facing position.

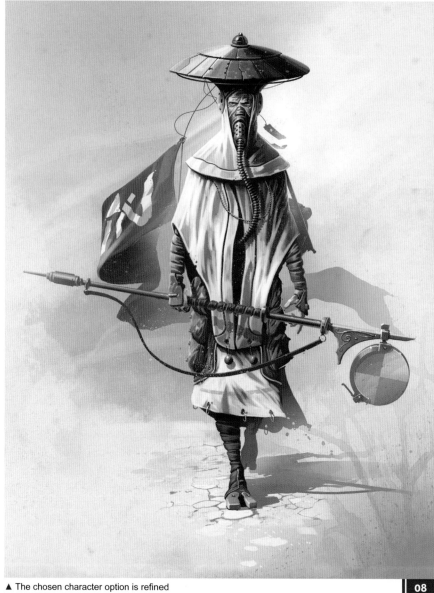

▲ The chosen character option is refined

08

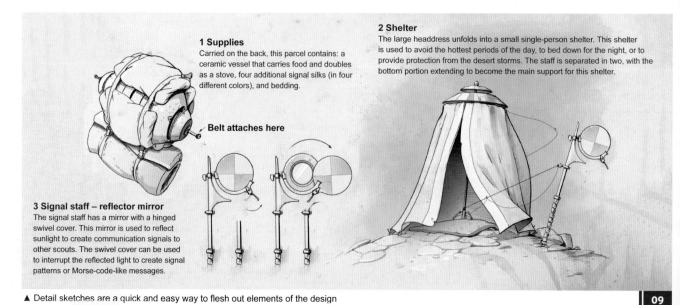

1 Supplies
Carried on the back, this parcel contains: a ceramic vessel that carries food and doubles as a stove, four additional signal silks (in four different colors), and bedding.

Belt attaches here

2 Shelter
The large headdress unfolds into a small single-person shelter. This shelter is used to avoid the hottest periods of the day, to bed down for the night, or to provide protection from the desert storms. The staff is separated in two, with the bottom portion extending to become the main support for this shelter.

3 Signal staff – reflector mirror
The signal staff has a mirror with a hinged swivel cover. This mirror is used to reflect sunlight to create communication signals to other scouts. The swivel cover can be used to interrupt the reflected light to create signal patterns or Morse-code-like messages.

▲ Detail sketches are a quick and easy way to flesh out elements of the design

09

Second, I erase the large signal silk to the left of the character. I want to give the image more depth, so on a new layer under the character I paint in a new a new signal silk that extends back into the background.

Now I'll work on tightening things up. I'll create a new layer on top of the layer stack and using the angled brush (again set to 50% opacity) I'll paint in more lighting information and add secondary details such as the little weights that keep the robes in place and the staff details. During this process I also rework the background with the addition of a patch of dry, cracked ground.

Step 09
Additional design details
Now that the final design is done, I'll create a few sketches of additional design details. These quick sketches will help flesh out elements of the character design that don't come through in the image from the previous step and communicate additional design ideas.

If you look at image 09, these include a detail of the supply pack carried by our scout, a detail showing how the large headdress folds out into a shelter to protect the character

from the environment (whether from the heat of day, the cold of night, or a desert storm), and finally a detail of the signal reflector mirror that is encased on the end of the staff.

Step 10
Compiling the design sheet
The last thing to do is to compile the design materials onto a single page. This will serve as our design sheet that would be used to present the final design to the client. I take the final design render, the additional design details, and since the facial area is half covered by the mask of the moisture trap, I include the head elements from the evolution study as well, and I arrange all the images on a page with the relevant notes (image 10).

At this point, if there are no revisions needed, the design is finished. If this design were to be approved, we would then move forward with creating a turn-around and potentially more detailed images so other artists could start to implement the design into the final product.

1. **Body:** the slender elongated body allows for less heat retention. Wide shoulders allow for increased airflow around the body.

2. **Eye:** a large brow and darkened eyewell help protect the eye from intense light.

3. **Moisture trap:** captures moisture from breath, funnels this down to the water bladder (worn around back of tights).

4. **Signal silk:** used to convey messages to other scouts.

5. **Bladders:** water bladders are slung around the back of the lower robes. Filled before missions and can be refilled at supply stations.

6. **Head:** numerous other features on the head contribute to desert adaptation: ear – enlarged ears allow heat to escape; mouth – the small mouth helps retain moisture; nose – nostrils that open and shut when breathing prevent moisture from escaping.

7. **Supplies:** carried on the back.

8. **Shelter:** the large headdress unfolds into a small single-person shelter.

9. **Signal staff – reflector mirror:** this mirror is used to create communication signals to other scouts.

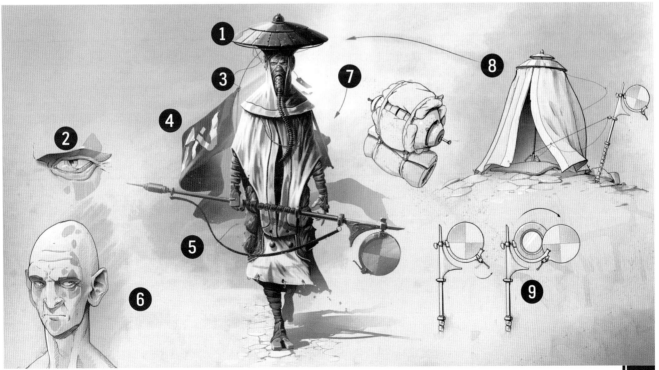

▲ The final design sheet is created to communicate the design to the client

10

Sci–fi female

Design and paint a character surviving in a low–gravity environment

by Charlie Bowater

My starting point for this character is the theme of "low gravity"; the idea that the character must have adapted to survive in that particular aspect of her environment. My first priority is to find out what the effects of low gravity on the human body actually are. Although there's no way to know what the effects would be long term, common side effects for astronauts are loss of body mass and bone density, nasal congestion, muscle atrophy, motion sickness, sleep disturbance, and bloating due to blood pooling in the center of the body. Sounds great!

Those are just a few starting points that could spark an idea for character design. Next I want to think about what I actually want to paint. What kind of colors and designs do I have in mind? I really like the idea of taking some color inspiration from space itself: a very deep, dark background and some vibrant splashes of pink and blue to highlight the character. I also really like the idea of a bit of white armor, à la storm trooper, to add a nice contrast to the dark background.

It helps to throw together a mood board or collection of references to get the ball rolling! None of them have to be anything that you have to stick to, but they can really help with inspiration and remind you of what you originally had in mind.

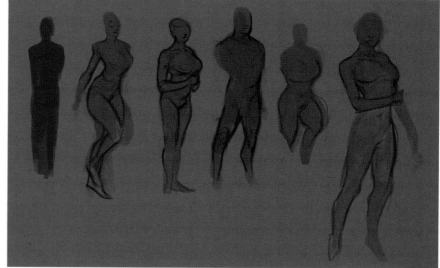

▲ I'm really just focusing on the general shape of the character at this point **01**

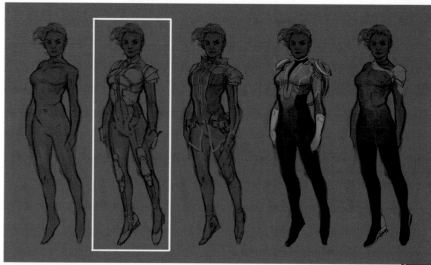

▲ I have a few ideas in mind in relation to low gravity; I'm having fun and seeing what works **02**

▲ Copy and paste from your other designs | 03

▲ I'm opting for a blue monochromatic color palette but then contrasting it with a vivid pop of pink | 04

Step 01
Starting with a sketch

To get started with my sketches I open up a new canvas, usually around 3500 × 4900 pixels. I like to work on fairly high-resolution canvases, as they're large enough to accommodate all of the detail I'll add later on; my canvas also needs to be large enough to be printed eventually.

On a new layer, I start to block out some very rough silhouettes of different character designs. I like working in silhouettes and rough sketches to start with – I can be very detail focused, so it's good for me to try to not worry about details too much at the start and just focus on the overall shape of the character. I still try to include character traits related to the effects of low gravity on the human body, though: a larger torso due to blood in the body pooling around the core, in particular.

Step 02
Iteration, iteration, iteration

Once you've decided on a particular character shape that you like the most, you can move forward and experiment with some variations on the design.

The reason I chose to move forward with the silhouette highlighted in image 02 is that it's the one that I personally liked the best; it has a simple and very readable pose so you can understand the shape and design of the character. It also included the low-gravity character trait of a larger core. At this stage we can experiment with the finer details of the design (such as costumes, armor, hairstyles, and so on) until we reach a design we're happy with.

Step 03
Deciding on the initial design

As you can see we have my initial chosen design in image 03. I like the look of this outfit and it hits on some of the elements I want to include; it's form-fitting and a little structured.

I do like certain aspects of the other outfits as well, but I'm happy to go ahead with this as my initial design. I can always add further elements to her design as I work my way through the painting. Sometimes I'm pretty set on the initial idea and other times the idea progresses throughout the painting. I think either way can work well depending on the purpose of the character.

Step 04
Starting the color work

Now that I have my chosen design I can start adding color. I'm going for a very bright, high-contrast color scheme, as I think that will work well with the sci-fi theme. You can use any color scheme you like, but try and use colors that work well with each other; color wheels are great for seeing which colors complement each other (see step 09).

I add dark blue on a new layer underneath my character and then add a mid-tone skin color to my character. For her skin I choose a mid-warm beige tone that isn't too light or dark – I just want a starting point that I can then develop further with shadows and highlights in different tones. Always remember that the base color is likely to change a lot when you add further layers of color throughout the process, so there's lots of room for tweaking these colors along the way if you aren't happy.

Once I'm happy with my own base colors, I select both the character layer and any color layers relating to the character and merge them together, by selecting Merge Layers in the Layer menu (Layer > Merge Layers).

▲ At this point I tend to work on a layer above my character to keep things organized, plus I can erase any parts I dislike **05**

Step 05
Choosing a light source

Now that I've established my base colors, I can start thinking about the light source. I decide to have a light source under the character – it will add interest and contrast to the colors this way, rather than lighting her from above. So, on a new layer above the character, with a slightly brighter skin tone than the character's base color, I use the same brush I used for the base color (a regular hard-edged brush) to dab in strokes of paint where I think the light will hit the features of her face, such as her chin, and underneath her nose and eyebrows. Lower the opacity of your brush if you find blending difficult and build up the color gradually.

Step 06
Don't forget to flip!

I flip my canvas so often that it seems a given really, but don't forget to flip your image! Flipping is a great way to gain a new perspective on a painting. It really helps when noticing mistakes or areas that don't look quite right; they usually stick out like a sore thumb once flipped! Try and do this every hour or so; that way you won't reach the end of a painting and realize it looks terrible flipped the other way (Image > Image Rotation > Flip Canvas Horizontal).

▲ I flip my canvas all the time, way more than you need to! **06**

Step 07
A little bit of detail

Now that the color is progressing nicely I'm happy to start adding finer details. On a new layer, I use the same regular hard-edged brush as before, but at a much smaller size so that it's easier to paint details. I start to clean up her features. I want to add definition to them to bring out the form. For the majority of the detail work that I do, a lot of it is cleaning up the edges and features. My art can still be pretty rough at this stage as I'm still predominantly working on the very rough sketch that I started with originally.

Now that I'm adding detail to the character at a much higher resolution, zoomed in, the features can be fairly blurry. So, on new layers with my regular brush, I paint over her features and add further shadows and highlights and give certain features crisp edges (the highlights underneath her nose, lips, and chin, adding detail to the irises, pupils, lashes, highlights, freckles and so on). Doing this adds a new level of detail to the character.

Details can be a bit of a struggle for beginners, so try and push yourself but don't get too frustrated. It takes a lot of practice!

Step 08
Color transitions

While I'm adding detail to her features I'm also building up variations of color. I want to add plenty of contrast, and one of the best

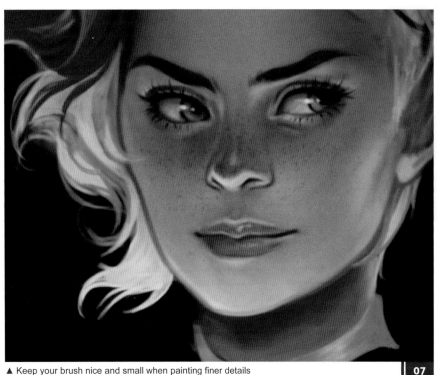

▲ Keep your brush nice and small when painting finer details 07

ways to do that is to really vary the amount of colors that you use when painting skin. In this painting, there is a gradient of light across the whole character, starting with the brightest colors at the bottom of the image and gently fading out to shadows at the top. This is something that I want to include in the color choices on her skin.

In image 08 you can see examples of color swatches for the different tones on her face, again starting brightest at the bottom and receding into darkness at the top. You should try having a few swatches visible so you can keep referring back to those colors to avoid your image becoming muddy.

It can be difficult knowing what colors to pick but in this instance, good choices are bright, warm, peachy yellows for highlights and then warm beiges, pinks, and colors with a slight hint of purple as you move into the shadows.

▲ Keep color swatches visible so you can keep referring back to those colors 08

Step 09
Color theory

I want to briefly touch on the subject of color theory, which is a whole kettle of fish in itself, really! I've gone for a fairly monochromatic color theme for this illustration, as you can see in image 04, which is centered on blue. If I kept everything in the image blue however, it would look very boring.

Adding a splash of vibrant pink in her hair and accents on her suit really helps to add some contrast to the image, and only adding a small amount means it just complements the blue theme and doesn't overpower it.

If you can't quite decide what colors to use, take a look at any color wheel to see which colors work well together. Blue and orange are technically the opposites that would work the best together, but pink is pretty close to orange and so still complements the blue nicely. Generally opposite colors work well, but just use the color wheel as a guide; there's always a little room for some artistic license.

Step 10
Starting on the armor

Now that the character is in full swing and I'm happy with the face and the progression of the color theme, it's time to start on the armor. Well, I call it armor, but I want it to look somewhere between padding and armor – perhaps the kind of structure you might find on motorcycle jackets. I'm going for something a bit more sci-fi looking, though.

I want to give it a segmented approach, so that it still allows for plenty of movement and isn't restricting. I'm giving the segments a kind of egg-shell look/texture because I think this will look the best. A good tip for making something appear like a matte surface is to leave out any strong reflections. Matte objects appear quite soft and they don't have particularly reflective surfaces, so I'm keeping everything soft and well blended. You can use soft brushes or even a bit of airbrushing. If you aren't completely sold on the outfit design, add another layer and just sketch over some rough ideas until you find something you like.

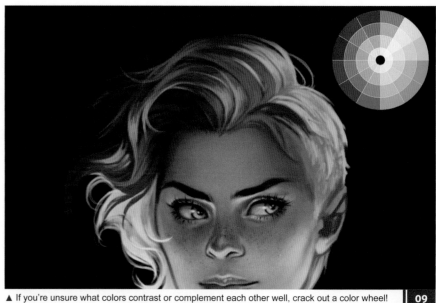

▲ If you're unsure what colors contrast or complement each other well, crack out a color wheel! | 09

▲ Create matte surfaces by keeping the blending soft | 10

Step 11
Lighting and form

At this stage I want to build up the form of the armor and lighting as I go. In order to do this, I take my regular brush as usual, and much in the same way that I added lighting to the character's face, I paint in the areas where the light will hit the armor.

You can block this in quite roughly if needed, but I also take some time to softly blend the transitions between the light and shadow. Like in step 05, you can always lower the opacity of your brush if you struggle with blending; this way you can add strokes of paint very softly and gradually, so blending should be easier.

As mentioned in step 10, I want her armor to appear quite matte and in order to achieve that texture, I avoid adding any "shine" to the armor. To understand where the light is going to hit the armor, I just think about the areas of her body that protrude further outward, and will catch the light – under her ribs and bust, for example.

Step 12
A little more lighting and texture

Up until now I haven't really paid much attention to the lower half of the character's body, so I spend a bit of time building up the form and lighting on her legs. Her legs are generally going to be a lighter color than the rest of her as they're closest to the light source.

So, with a lighter shade of her suit, I add some shape to her legs. It helps to think of them as a cylindrical shape when it comes to adding form. They are brightest in the center of the leg, along the shin, and then gradually transition into a darker shade towards the sides of her legs. You can also add a bright streak of color as a bounce light on the sides to contrast the darker shade and to clearly define the silhouette of the legs.

To add texture, you can either directly reference photographs of texture (fabric for her outfit, as an example) or lay it over the area you want to place it and experiment with different layer options and opacity levels.

▲ Use soft transitions between highlights and shadows to create form without adding shine　11

Overlay usually works best – a handy way to increase the brightness and contrast is to add in some highlights on an Overlay layer along with setting that layer to a clipping mask (page 21) – but try a few methods and see which gives you the best result.

Another option is to leave out photographic textures and experiment with different brushes and paintstrokes to emulate the texture instead. Even just a few scratchy marks can read as a worn texture when zoomed out.

▲ Add in some highlights on an Overlay layer and set that layer to a clipping mask　12

▲ Break the hands down into simple shapes

13

Step 13
Don't forget the hands!

Don't worry, I wasn't going to leave her without any hands! I may have done once upon a time, but seriously, don't do it. Hands can be fairly tricky to paint when you're a beginner, and unfortunately there are no magic tricks to make them easier aside from practice. The best way to improve at subjects/themes/body parts is to paint them; so no hiding them behind her back!

It helps to break the hand down into shapes. Think of the fingers as groups of cylindrical shapes connected together. It makes it far less intimidating. Then just using the same approach as lighting the rest of the character, think about how the light will affect those shapes. If you aren't sure of how something should look, reference it; if you're struggling with hands, take a look at your own!

Step 14
Just because I can...

The painting is pretty much in the final stages now. To add a bit of interest, I paint a few glowing features and particles. These are fairly easy to paint: take a soft airbrush and gently paint the rough shape of where you want the glow to be – it needs to be very soft and diffused to look like a glow rather than anything too solid (see the glowing ring above the character's shoulder in image 14). Then, in the center of the glowing area, pick an even brighter shade of that color and with a smaller brush, paint a more solid shape; the object should look like it's glowing. You

can even go over this with the same airbrush on an Overlay layer, in the same brighter shade or even white, to really make it glow.

Step 15
The final touches

I'm obviously loving the pink, as I couldn't stop myself from adding a few more touches! Pink aside, I add the final touches to the rest of the character, ensuring I don't neglect the feet and adding in some nice details to her shoes – possibly some sort of anti-gravity magnetic thing going on there (image 15)?

I finish the under lighting and add in another soft, blue rim light on her side, to help her "pop" a bit more. Rim lights are a nice way to outline a character; they're also a great way to introduce another splash of color. Just paint along the character's silhouette and then gently blend the lighting effect further onto the character's body. Rim lights can be as subtle or dramatic as you want them to be, it depends on the color intensity and opacity. Image 15 shows the final artwork.

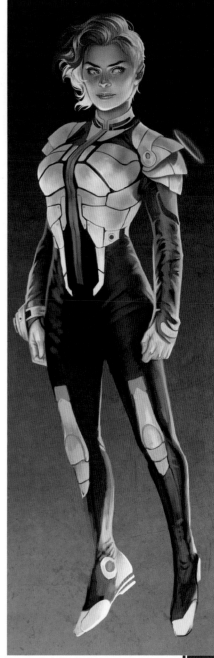

▲ Art is supposed to be fun, so if you want to add something ridiculous then do it!

14

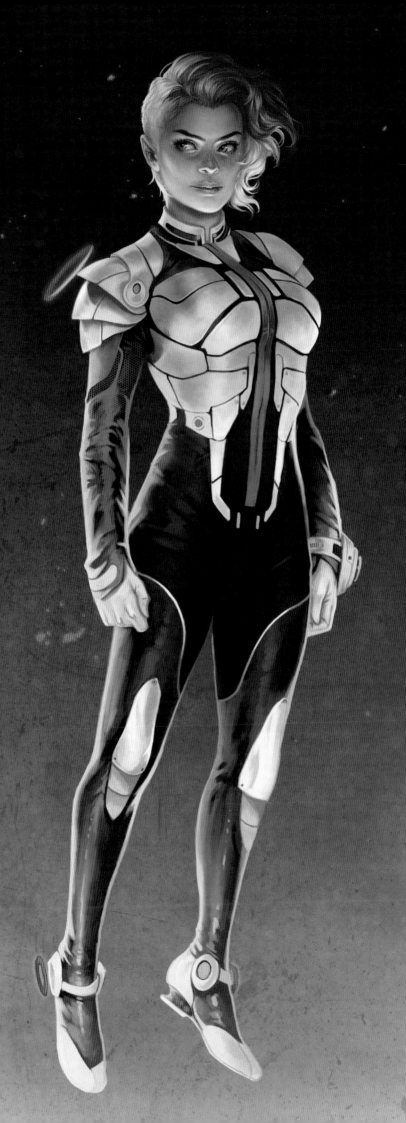

Medieval jester

Concept and illustrate a medieval jester

by Ahmed Aldoori

Research is an important foundation for creativity, so I find myself looking at old medieval paintings as a start. Sure, I could just copy a jester's costume directly from reference and call it done, but that would be boring; we as artists have the opportunity to take something and put an interesting spin on it to fit a character. In this chapter we will go from the development of loose pencil drawings into a more refined design at the end.

> "Even though they won't all make it to the final illustration, it's beneficial to feel that the character has emotion while you're designing the costume"

It's important to get a feel for the character's emotions. I want this jester to be a sinister type who despises everyone. He's a court fool, after all. Conveying this idea is supported by sketching facial expressions within the design process. Even though they won't all make it to the final illustration, it's beneficial to feel that the character has emotion while you're designing the costume. Otherwise it will feel like you're designing a costume tailored for a blank mannequin.

An understanding of anatomy is a required skill for this type of design.

▲ I don't render out tiny details early on because loose pencil work can indicate many possibilities | **01**

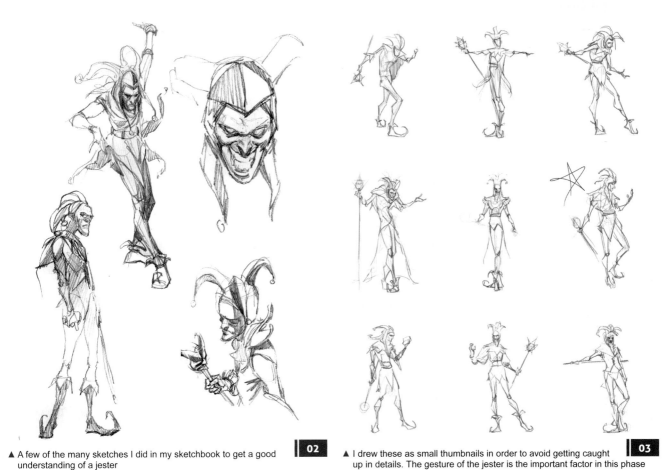

▲ A few of the many sketches I did in my sketchbook to get a good understanding of a jester

02

▲ I drew these as small thumbnails in order to avoid getting caught up in details. The gesture of the jester is the important factor in this phase

03

Without knowing how the human body works, a cool-looking costume in a still image could end up completely useless when it comes to being animated for human movement. Photoshop knowledge is also important for this process. I will be using layers, levels, and blending options to help me with my design.

> "A typical T-pose is an option but I want to make this look interesting, so I go with the more pensive stance. It's important to flush out a lot of different pose possibilities at this stage in the process"

Step 01
Exploration sketch phase
You'll find a variety of different jester designs from history. There are extravagant costumes that include all kinds of silk and silver bells, and there are simpler costumes that appear to be made out of rags.

In the sketches you can see in image 01, I am figuring out different hat designs, as well as fabric configurations. The expressions on the faces help me solidify the jester as a real character.

Props are important, too; a lot of the jesters had some kind of rod with a mask on it, representing a smaller version of them, to add to the whimsical entertainment they provide for royalty.

Step 02
More pencil drawing
In addition to using expressions to help solidify the character, the poses are important as well. It helps to think about the character in motion; in this case the jester could be performing in front of his audience.

In image 02 you can see that I've chosen to give him an angry look in order to indicate the resentment he holds towards everyone. The evil smile in the top right can really sell that idea of him being

truly sinister; it's universally understood. Stay away from anyone that looks at you like that! On the bottom right I have made a smaller version of him.

Step 03
Pose specific to the final image
Until step 07 we only need the basic Brush tool with pen opacity turned on.

The poses you can see in image 03 have been drawn with the final image in mind. Whatever the final illustration is it must showcase the costume completely for the art director or 3D modeler to understand its concept.

Keeping this in mind, I do my best to avoid poses that cover up important parts of the design. A typical T-pose is an option but I want to make this look interesting, so I go with the more pensive stance (marked with a red star). It's important to flush out a lot of different pose possibilities at this stage in the process.

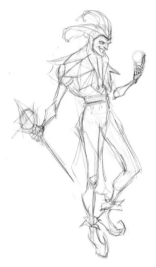

▲ The thumbnail beneath eventually fades away as I repeat this step on top of this drawing **04**

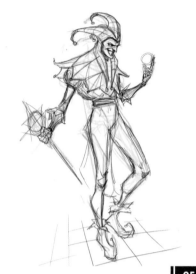

▲ This pass will slightly fade away as the next drawing pass comes into view **05**

▲ Still fairly loose here; it's not necessary to do a perfect line drawing **06**

Step 04
Pose refinement phase

I lower the opacity of the thumbnail from step 03 and make a new layer on top to draw another pass of the design. I take the creepy face I drew earlier and use it as reference for this, drawn at a different angle (image 04).

For the masked rod I draw a geometrical and symmetrical frame to act as a placeholder for the mask to be drawn in perspective. It's better to lay down a foundation to help guide your drawing, rather than trying to draw it without a framework.

Step 05
Refinement round two

I do the previous step again on top of the first drawing pass. This allows for another layer of precise detail. The main difference you can see in image 05 is form indication.

The jester hat is a complex object so it requires some planning. I have the hat shape drawn out from before; the form was slightly suggested, but here the wire-frame lines help make a clear statement of its volume. On the floor you'll see a grid sketched beneath him to indicate perspective. This will ground your figure so that he seems to be standing on actual ground rather than floating in the air.

Once again this pass will slightly fade away as the next drawing pass comes

into play. This is a building process; one step lays the foundation for the next.

Step 06
A bit of tone and value

Again, the opacity of the previous step is lowered. This time I draw in the triangular patterns on the jester's costume and fill it in with value. The value breakup will help you control the focal point.

It's important to be smart with value placement. If the darks are too evenly distributed you will lose movement and focus, unless having a bland design is the intention. We want this character to stand out. You'll notice in image 06 that I've drawn the mask on the side. This was easier to draw on a flat view, which will be put in place using the Free Transform tool in the next step.

Step 07
Transform into perspective

Up until now the only Photoshop tools I have used are the basic brush and layers. In this step I use the Free Transform tool to place the mask onto the rod in perspective.

Press Ctrl+T and a bounding box will appear: you can hold Ctrl and click and drag the corners into any perspective. Once you are happy with the placement, you can double-click within the box or hit Enter to finalize the transformation.

This is very useful for placing things into perspective. The Free Transform tool is also useful if you want to explore different proportions of your character. You can use it to squash or stretch him to your liking.

Step 08
Masking the jester

Making a mask for your design will make painting it a lot easier. The purpose of this is to make a sharp silhouette

▲ Using the Free Transform tool **07**

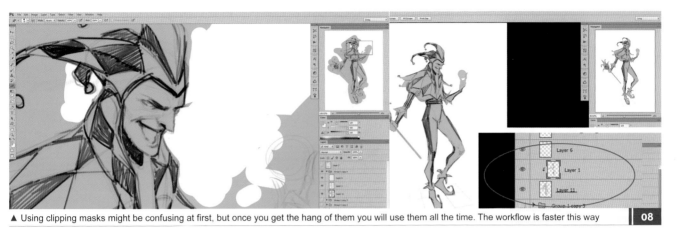

▲ Using clipping masks might be confusing at first, but once you get the hang of them you will use them all the time. The workflow is faster this way **08**

under the line drawing and to keep it on its own layer. I use a clipping mask layer above the silhouette to get the line drawing confined into the silhouette.

You can do this above any layer by holding Alt and clicking between the two layers in the Layers panel. You can create multiple layers this way and whatever you paint will stay within the silhouette. I have chosen green arbitrarily; it can be any color.

Step 09
Color thumbnail exploration – warm and cool

Coming up with a decent color scheme can be difficult at first. However, if you simplify the process to a few colors, you can come up with many variations to choose from. The first row of three you can see in image 09 is dominant with warm colors, green being a cool color accent. In the references I collected I have noticed that the majority of

jester color schemes contain reds, yellows, and greens. I want to make an interesting change to the typical colors, so I try making cool colors dominant, accented by a warm orange (second row of three in image 09). It seems out of place, and I like it.

Step 10
Blocking in colors

I place my color thumbnail in the corner of my big image as a reference. I use a basic

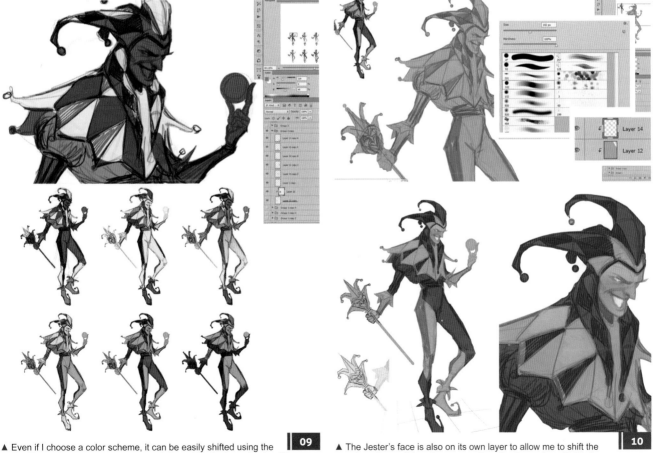

▲ Even if I choose a color scheme, it can be easily shifted using the Hue/Saturation menu to get more variations. This is shown in step 15 **09**

▲ The Jester's face is also on its own layer to allow me to shift the colors of everything else very easily without messing with his face **10**

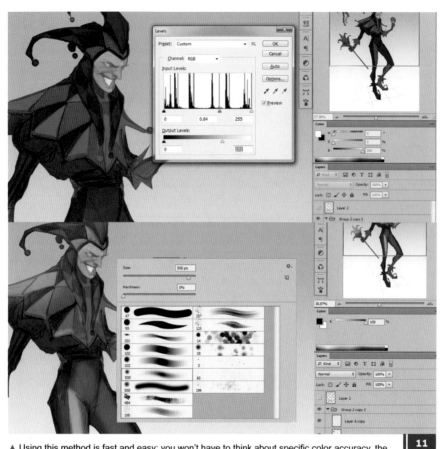

▲ Using this method is fast and easy; you won't have to think about specific color accuracy, the right value is already there

<div style="text-align:right">11</div>

▲ Always pay attention to clothes and the many ways they wrinkle in real life. It comes in handy when you're drawing or painting clothing

<div style="text-align:right">12</div>

round brush to block in the colors in the clipping mask. It might be helpful at first to keep each color set on its own layer: blues on one layer, yellows on another, and so on.

At this point there is no need to model or render the forms. Flat coloring will set the local color for the design, which will then be manipulated using Levels adjustments. I recommend avoiding fancy texture brushes when doing this.

Step 11
Lighting and form

Here's a secret method to help you move forward very quickly by creating volume and form. Simply duplicate your flat, blocked-in bits of color and use Levels adjustments to make them 50% darker. This will make all the shadows equally dark, setting a unified value range for all the darks. You then simply erase out where you want light to go. I use the Airbrush as an Eraser to shine light onto the costume. Instead of using just the Eraser, you can also use a Layer mask (see page 78). Both methods work well.

Step 12
Clothing indication and bounce light

Clothing has thickness, and should be portrayed as such. Once again I use a basic

▲ Painting some more of the costume's design elements

<div style="text-align:right">13</div>

round brush. Wherever the cloth meets at a seam, I indicate a lip where the stitching might be. Wrinkles are indicated slightly as well. The purpose of this is to avoid having a design with flat shapes that are seamless.

Bounce light will assist you in showing the form of the clothing as well. I use the Airbrush to paint a soft light coming from below. This also helps indicate the cloth's material, which in this case has a silky reflectivity.

Step 13
Costume refinement and details
I now paint some more of the costume's design elements. Jesters always have interesting patterns and shapes. I highlight the triangular design language on the hat by outlining the dark shapes with a yellow line. This could end up being some kind of embroidery or just flat color, depending on the level of detail that the video game allows.

I start painting the face, which also has an angular language to flow with the rest of the design. I don't want to over-paint the face since the more important factor for this project is the costume the jester is wearing.

There is still no immediate need for any texture brushes or texture overlays. The round brush look will suffice as a preliminary design sketch.

Step 14
Shadows in perspective
Here is a neat trick that will make your character seem placed in an actual space. Since I already have the silhouette cut out from the early steps, it will suffice as a semi-accurate shadow shape. Simply duplicate the silhouette and use Free Transform (Ctrl+T) to squash everything down beneath the character (top part of image 14).

You can then paint in a solid gray color onto the whole thing using the same clipping mask methods as in step 08. You can erase away any parts that do not make sense, such as the shadow of his leg sticking out. You can also blur the shadow using Filter > Gaussian Blur to have a softer lighting setup for your character (bottom part of image 14).

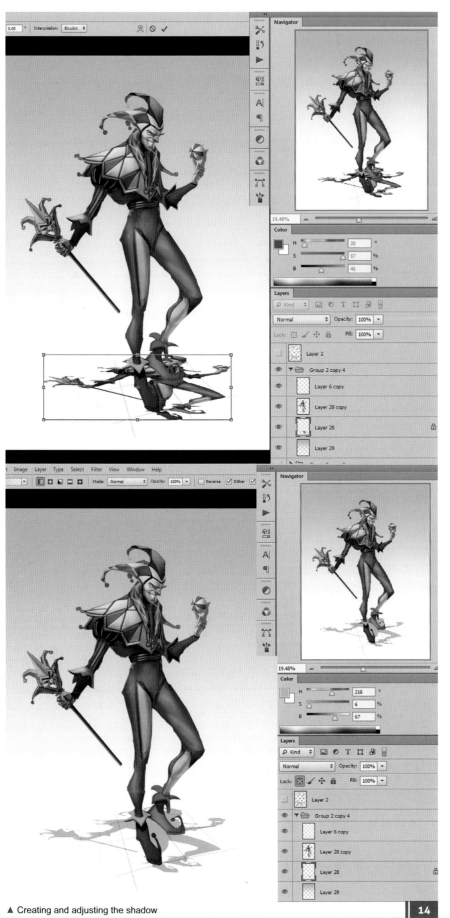

▲ Creating and adjusting the shadow

14

Step 15

Three paintings in one

Earlier in this chapter I mentioned the option of color shifting your costume in order to explore other colors. This is a really quick way of generating other color ideas for a client.

Since we have the face separate from the costume, we can turn that layer off and mess around with the Hue shift (Ctrl+U). This will expose new color schemes that you may never have thought of or seen. There is also a drop-down menu within the Hue/Saturation window (see image

15), so you can select specific colors to change; if you want only the blues to shift it will lock every color except blue.

You can see the final illustration of the medieval jester on the right-hand page here, shadow and all.

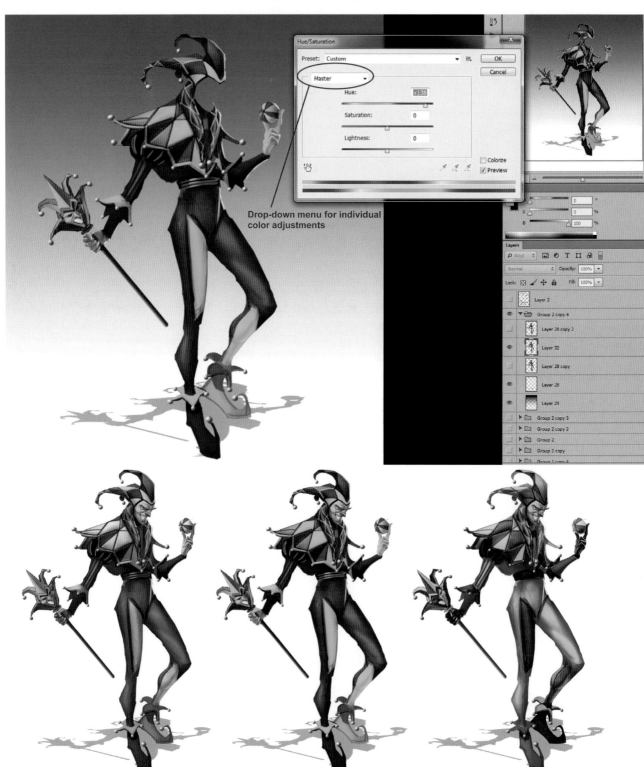

Drop-down menu for individual color adjustments

▲ This color-shifting method will work on anything, from props to characters to landscapes. There is no limit to what you can do!

15

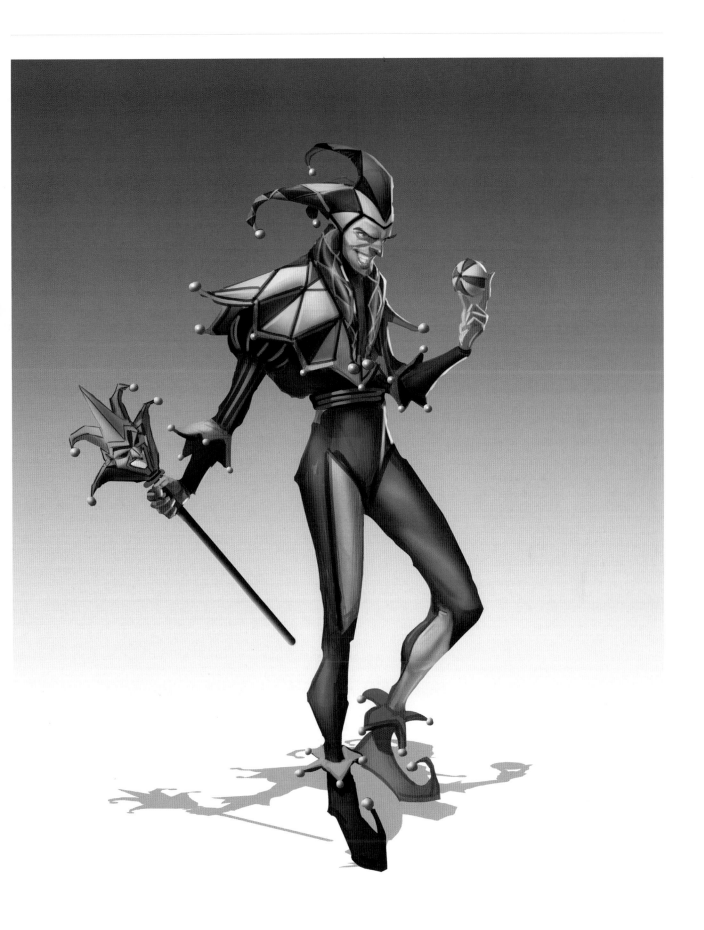

Merchant trader

Use custom brushes to add finer details to your character's costume

by Markus Lovadina

Let's start with a merchant trader character description: based on a few hundred years ago, this is someone who has come from a distant foreign country and settled in the West. He now runs a business from a busy trading port. He is a confident man, unscrupulous and calculating when it comes to money. He is intelligent and sharp-witted, with an eye for detail and a nose for profit. His physique displays his success and conveys his taste for rich food and wine, which he has in plentiful supply.

The first thing that came to my mind was the "good old masters". Referring to the old painting masters is always a great starting point. If you observe some of the old images you can learn a lot, especially in terms of brushstrokes, lighting, colors, and composition. This time I decided to research some Dutch painters, who have a great sense for color and lighting (as many others have too). I wanted to go for a sort of painterly feel. You can find great reference images by searching the web.

It is very important to start by searching for references – not only for the design, but to get a feel for the specific theme. The more I know regarding materials, patterns, fabrics, and so on, the easier the design and painting process will be. After looking at a range of references

▲ Laying down the first colors

01

and reading articles regarding costumes, I was ready to fire up Photoshop.

"If you're afraid of painting on a blank white canvas, start with the background"

Step 01

Background

Painting the background is a good way to get a better feeling for where the character should be placed and to set the mood for the entire image. If you're afraid of painting on a blank white canvas, start with the background. The painted background could also be used for showing the color theme you'd like to work with. A brown tone gives the feel of an old canvas and will contribute to the overall look I want to achieve.

Laying down the first colors can be hard, but keep in mind that you can always change them using Color Balance (see step 15 of this chapter for more information).

Don't be afraid of playing around until you're happy with the first look.

Step 02

Brushes for the background

I paint the background with a simple round, textured brush (image 02a), set to Transparency mode, Texture, and Shape Dynamic (image 02b). I mostly use a huge brush size and keep the strokes quite loose. The main focus for now should be the overall color theme and the composition.

▲ The simple round brush settings | 02a

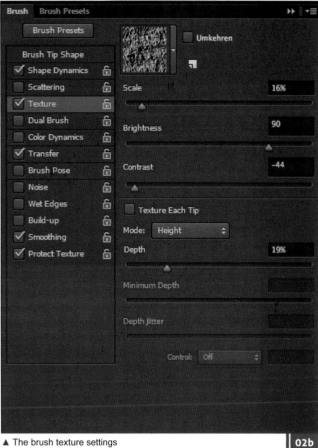

▲ The brush texture settings | 02b

★ **PRO TIP**

Research, research, research!

Nothing is more important than research, especially if you have to work on a topic that is out of your comfort zone or has to be as realistic and believable as possible. It is absolutely worth spending a lot of time researching and making notes. This will help you to save time later on. It will also allow you to focus more on the really important things during the painting process, such as details, mood, color, and so on.

Squares created for floor

▲ Adding the floor is a simple way of getting your first depth into the images **03a**

▲ The floor pattern will be one of your guidelines later on **03b**

▲ Always try to keep your image balanced between warm and cold tones **04**

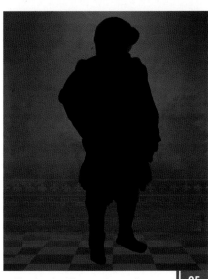

▲ Keeping the silhouette loose allows you to focus on the overall shape **05**

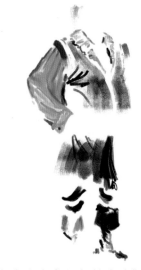

▲ Laying in the first color blocks defines the separate elements **06a**

▲ The colors give the initial idea of the different materials **06b**

Step 03
Creating the floor

For the ground, I make a square with the Selection tool and fill it with a grayish color. I duplicate the square a couple of times (image 03a) and move them to the position I want. All the squares are on separate layers.

Once I am happy with the look, I merge the layers and use the Transform tool to bring the floor pattern into perspective by pressing Ctrl+T. The next step is to right-click on the transformation and choose Distort. Move the upper edge down until the squares meet the floor level. Then move the transformation edges (small squares) – by

holding the Alt key – to the left or right until you get a nice depth and perspective.

Adding a layer mask, with a soft round gradient (black to transparent) will add more depth to the floor (image 03b). It might be that you have to repeat this a couple of times until you like the result. Ctrl+Z will be your best friend in such cases.

Step 04
Designing the wall pattern

I make the pattern on the wall with existing shapes in Photoshop, as the software provides a couple of simple and sometimes useful shapes. You can always produce

your own shape by creating your own path using the Pen tool, or by retracing shapes from a pattern you like, and saving the path as a shape. This shape will then always be available to you. Shapes are vector based so you don't have to worry about resolution. It's all based on the path you have drawn before.

Simply draw in the shape you like, duplicate it, and set the layer to Soft Light. I adjust the settings for transparency until I am happy. It is important to keep playing with layer settings – such as Soft Light, Multiply, or Lighten until you like the result. A nice effect might be to duplicate the layers and see if this adds another "touch" to the image.

As for the color of the ribbon on the wall, since the image has pretty warm colors so far, I decide to add some cooler tones into it. You should try to keep your image balanced between cold and warm tones. Warm and cold colors are on the opposite sides of the color wheel, so if you work with colors purely on one side or the other you will end up with a predominantly cold or warm painting. By keeping your selections balanced you will end up with a painting that is well-rounded.

The other forms are hand-drawn using the same round brush as in step 02, minus the texture option. The background is now set and so I am able to move on to the real challenge – the character and his costume!

Step 05
Rough character shape

For character or costume design, I sometimes start with rough pencil sketches or I just block in the rough shape of the character. This time I go with a rough shape.

If you don't feel comfortable or confident when painting a shape or silhouette of a character, create a new layer or try it on a new canvas. This will mean that if you don't like it, you can always delete it. The freshly painted shapes can be copied into your original file later on. The shape in image 05 was mainly painted with a round brush. Areas I don't like get erased with the same brush.

As for the shape itself, keep it loose! The first things you should focus on are the proportions and the overall idea. From the brief, I knew the trader should be corpulent so the shapes should be way rounder than those for a normal or skinny male. Again, keeping things loose and using a separate layer is a great way to change things on the fly, letting your imagination flow.

This workflow also has great potential for happy accidents. Each stroke you make could be an element of the character. Just play around with painting and erasing. As you can see in image 05, the rough shape already shows the pose and some elements of the character/costume (for example shoulder pads, bonnet, and boots).

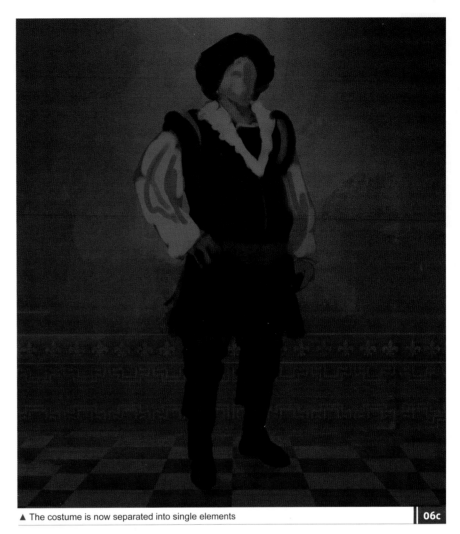

▲ The costume is now separated into single elements 06c

Step 06
First values and colors

Now it is time to paint in the first values and colors. Keeping the brushstrokes and form simple allows you to define certain areas without focusing on details. Details are the very last part of such a painting; at least to me. The important thing at this stage is to make sure the shape and values are clearly readable. These shapes and forms define different textiles that will be included, such as the shirt, vest, and trousers (image 06a). Each should have its own material (image 06b).

I use the same round brush that I used for the background and the shape. All colors and values are painted on a separate layer. I tend to use lots of layers during my painting process, as doing this allows me to go back and forth and to get rid of unnecessary elements.

"Study the way each material reflects the light or absorbs it"

When it comes to painting different materials, make sure you find good references for those specific materials. You can research on the web or just look around you – you'll probably have enough different kinds of materials in your wardrobe. Study the way each material reflects the light or absorbs it.

Again, keeping most of your materials on separate layers allows you to play around with painting and erasing. It is basically the same method we used for the initial shape. Use color-picking when painting on a new layer to get a pleasant blended effect with the shapes and colors underneath. Image 06a shows the color blocking which you could have on a separate layer. Image 06c shows you what the layers look like together.

"Adding the first details is great fun, but you should still keep in mind what they are for: showing the characteristics of the character"

Step 07
Defining the face

Happy with the base values and colors, I head off to paint the face and the expression of the character. The character is middle-aged and experienced. With this in mind, I paint in a beard to make him appear a bit older. The beard also reflects his social status. I initially paint the beard with the same round brush. I decide to make the first details with a customized brush made out of simple strokes and dots, set to Scatter and Transparency mode.

In image 07a you can see the initial dots and strokes that form the beard brush. You could always create a new brush depending on your needs. Like you learned on page 98, just create a new file – say 800 × 800 pixels – and start painting in some random dots, strokes, or shapes. This really depends on what you'd like to achieve with the brush. When you're happy with the look, go to Edit > Define New Brush.

Now create a new file, this time bigger than the brush file, and start playing around with settings, such as Scatter, Transparency, Texture, or Dual Brush (image 07b). Happy with it? Save it by selecting New Brush in the top-left corner of the Brush palette. Now you're good to go with your new brush. On top of that I add some more detail to the collar and the shirt.

Step 08
First details

Now it's time to add the first details to the costume. The character is a rich and almost famous trader; this should be represented by the clothes he wears. Important elements of clothing from this time period are the collar and the details attached to the costume. Adding the first details is great fun, but you should still keep in mind what they are for: showing the characteristics of the

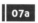

▲ The beard brush is made of random brushstrokes | 07a

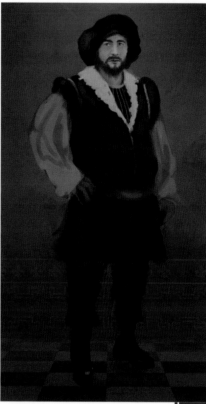

▲ Adding in the first costume details | 08

▲ The settings for my brush | 07b

▲ Speed up your painting process by creating your own custom brushes | 09

▲ A round edge helps the image feel more 3D | 10

character. Remember to keep the color tones (warm/cold) in a good balance.

Step 09
Creating a lace custom brush
For the sleeves I create a customized brush using a photo I took some time ago. You can do this yourself by importing a photo into Photoshop and changing the image to grayscale (Image > Mode). Then use the Selection tool and select the neutral gray around the ruffles. If you go to Selection > Similar, this will select all similar areas based on the color you have chosen before.

Repeat this a couple of times until you are sure that all the neutral gray areas are selected. Create a layer mask by clicking the Add Layer Mask button at the bottom of the Layers palette, or going to Layer > Layer Mask > Reveal Selection. What you have now is the base shape of your brush. Add a new solid white layer beneath the ruffles and play with the level correction

(Ctrl+L) until you have enough contrast. Now go back to top menu and create your new brush as described in step 07.

Step 10
Deforming
It wasn't necessary for the brush to make a seamless tile for the sleeve as we can use further tools to wrap it round the arm. To get the roundness I use the Warp tool and Liquify filter (see page 216 of the glossary at the end of this book). I duplicate the layer for the left arm (right in the image) and make it darker to achieve more depth.

Step 11
Boot details
I continue adding details to the costume. For my boots, I decide to have a gap in the upper fold (image 11a). I create this by painting over the existing layer. I use a darker color with a small round brush to define the fold/gap (the same brush I used for most of the painting so far). When you

> "This will give a 3D feel and adds a nice depth, which is absolutely necessary to making your costume convincing"

paint a fold or a cutting, make sure you add some highlights to the edges of the folds. This will give a 3D feel and adds some nice depth, which is absolutely necessary to making your costume convincing.

I also paint details such as the golden embroidery on the clothing. When painting in the brighter colors for the highlights, I always use the Color Picker and just change the values. Not only do I use a brighter value for the brighter color, I also add some gray to it. This color will blend in much better than if you just increased the brightness.

You could also make a transparent stroke using a brighter color, and color-pick from it to blend with.

▲ Extra details add some depth to the character's story | 11a

▲ The costume details are starting to come together at this point | 11b

Step 12
Creating the chain

The double chain you can see on my character is also made with a customized brush. Image 12a shows the chain brush and image 12b shows the chain brush settings. For the highlights and shadows I use a small round brush. I paint the chains on a separate layer; by holding Ctrl and clicking onto the layer, I can make a selection on that layer of the chain.

After the selection is made, I create a new layer (Shift+Alt+Ctrl+N) and blind out the selection (Ctrl+H), that is, I hide the selection lines while the area is still selected, so they don't get in the way of painting small details.

I start to paint in the highlights with a brighter color. If you use a mask for such tiny details you can be sure that you aren't painting over areas you don't want to. The shadow is just a duplicate of the original chain layer except for a small transformation which was made with the Warp option (Edit > Transform > Warp. You can see the result in image 12c.

Step 13
Patterns

For the costume patterns, I decide to reuse the wall pattern from step 04. This helps tie the character into the environment more and add some nice details to the costume. I duplicate the pattern layer from the background and

▲ Chain custom brush **12a**

use the Transform tool to match it to the shape of the costume. Again, one of the good things about layers is that you can

▲ Chain custom brush settings **12b**

▲ The final result of creating the chain effect **12c**

▲ Scaling down the pattern to reuse on the costume **13**

always go back and reuse some of the elements you painted earlier, as I do here.

Next I scale down the patterns with the Transform tool (Ctrl+T). When the scale matches the size of the costume, I press Enter. Then I use the Warp option again. Image 13 shows the line of pattern on the wall and then where I deformed it to fit around the belt area. When I am sure that the patterns follow

"The red stripes on the trousers bring in a bit more color variety and portray his military background. I also add wrinkles and more details to the boots and the costume"

the shape of the character's body, I create a layer mask and blend out the edges. I recommend you use a soft round brush, set to Transparency mode, for a soft gradient.

Until now, I've been keeping everything in separate layers and layer groups, so I can go back to these layers to add in the extra details.

The red stripes on the trousers bring in a bit more color variety and portray his military background. I also add wrinkles and more details to the boots and the costume.

Step 14
Altering the face

After flipping the canvas a couple of times, I suddenly realize that his face is still too young; adding more details to the beard and some darker values to his face resolves this. If you compare images 14a and 14b, you can see how adding in these darker areas has helped to add age to the character's face.

To create these darker areas, I paint on a new layer and set the layer to Multiply (about 50% layer opacity). On a new layer I paint in the smaller details for his beard – all with the same round brush I used before.

I also add more texture to the dark areas around his throat.

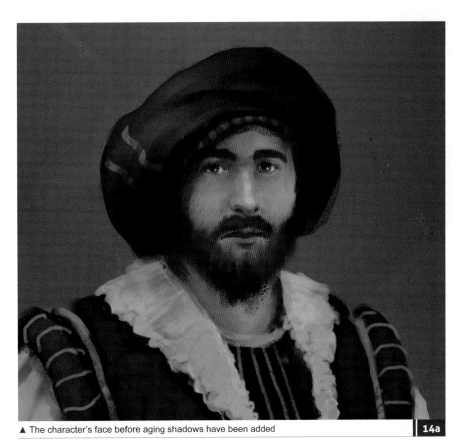
▲ The character's face before aging shadows have been added 14a

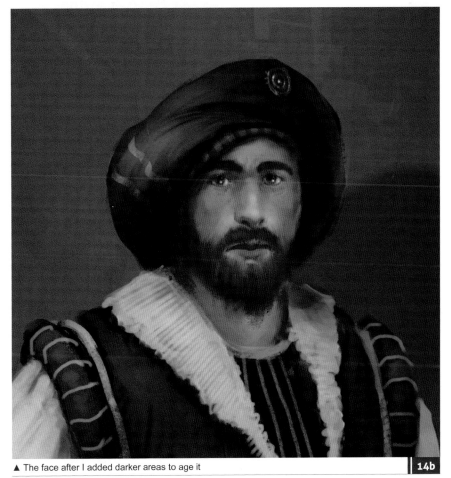
▲ The face after I added darker areas to age it 14b

▲ Color settings for Highlights 15a

▲ Color settings for Shadows 15b

Step 15

Final touches

At this point I am happy with the final
result, so I decide to put the image aside
and do something else. Taking a break
or just doing something that has nothing
to do with painting or creating is a great
way to get a fresh view on your work.

Back with fresh eyes, I add some more
details to the costume, such as the thin
stripes on the lower part of the belt and
also a leather bag for his money. The
stripes are on a separate layer and the
layer is set to Soft Light. Using layer effects
is a nice way to blend in elements.

Now it is time for some slight color
changes. I make these changes using the
Color Balance effect. To be honest, I'm
in love with this effect. I use it a hundred
times for my landscape paintings and
it's pure fun to add some color variety to
shadows, midtones, and highlights.

Using the Color Balance tool is not a
science – it is more about playing around
and finding a personal flavor. For sure,
the color should match the topic, but this
is all up to you. See images 15a–15c
for how I set up the Color Balance. The
important thing is to use all channels –
Highlights, Midtones, and Shadows.

Now it's time to merge all the layers,
save it, and call it a wrap!

▲ Color settings for Midtones 15c

★ PRO TIP

Create your own image library

One of the most important aspects of my painting workflow is my huge personal
image library. I try to have a camera with me all the time, in case an opportunity
arises to add to my library. This will be enough to capture a mood, a scene, a
color combination; you could use an image as a texture for one of your upcoming
paintings, or even create a custom brush out of it. It's also a good way to study
light and materials. And the best thing – those images and photos are all yours.

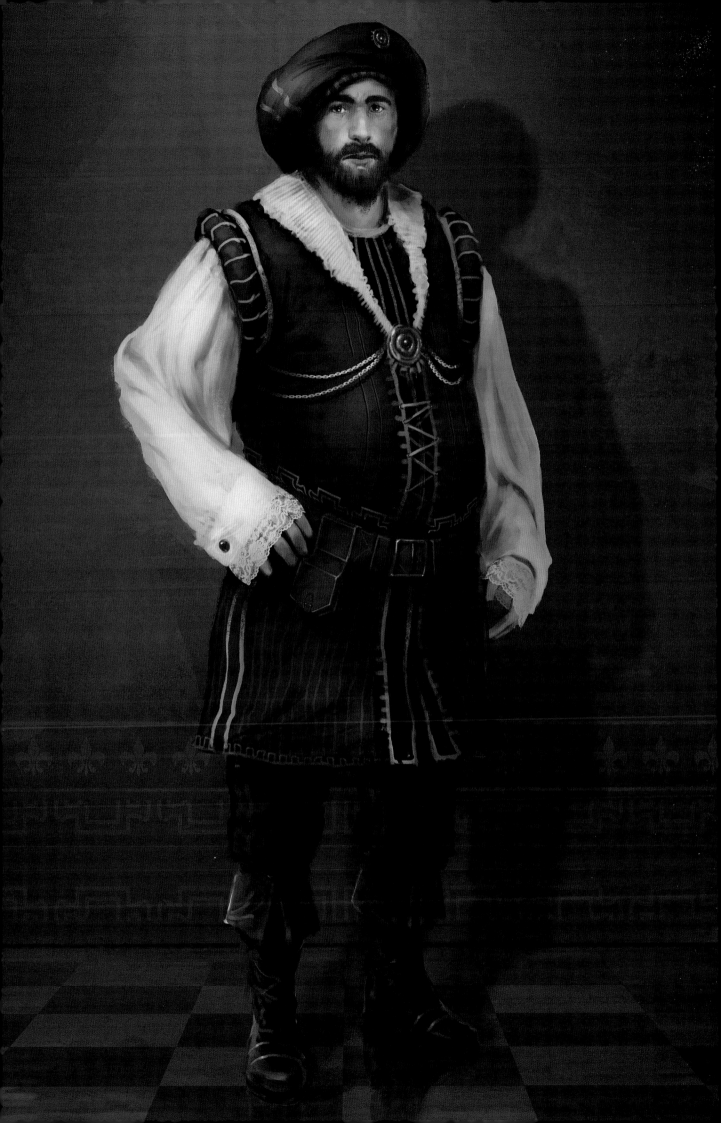

Quick tips

**Discover how to create common elements
used in character design.**

Characters are made up of many different elements that all
play a role in the believability of a design. The visual credibility
of these details can influence the success and quality of your
paintings, which can cause problems when you are trying to
paint something that you have never painted before. So, as a
beginner artist, it is useful and important to practice the art of
recreating convincing details and textures. To help you develop
these skills, this section will offer a myriad of approaches and
tips for creating common details and textures such as skin, hair,
and lace, all of which will help to improve your workflow.

Curly hair

by Bram "Boco" Sels

01 Line drawing

Curly hair is mostly characterized by locks of hair twirling and interlocking with each other. It's important to lay down an outline for each lock. In the example a lock of hair spirals down and gets pointier towards the end. To keep your curls organic make sure each turn follows the same direction as the last.

02 Masking the form

Create a second layer underneath the line drawing and use a regular round brush to block in the shape of the hair with a solid color. Typically curly hair has areas of white space around the edges, so try to create your locks so you can see the background (or skin) through the gaps.

03 Painting the highlights and shadows

Create a new layer on top of the line drawing and determine where the highlights are with a color slightly lighter than the base. Wherever a curl is pointed towards the light (see arrow) a highlight should be there. On the other side of the curl will be a shadow, so with a slightly darker color than the base, paint a shadow for each highlight. Locks that are behind other locks will be darker as well.

04 More curls!

Once the larger curls are blocked in, select a highlight color and start adding smaller curls behind and on top. Depending on how curly you want your hair to be, you can keep on going. To make bigger curls "pop", pick a color even lighter than the highlights and add little specular highlights to the top parts.

05 Details and overlays

Use a smaller brush to add extra small hairs that move through the maze of curls. Work from large to small, so keep these details until the very end. Make your colors shine by adding an extra Overlay layer and go over the highlights with a big soft brush and your highlight color.

01

02

03

04

05

Shading hair

by Tim Löchner

01 Blocking out the hair shape
Use the freehand Lasso Tool and make a selection based on your drawing. Now use the Paint Bucket Tool and fill the selection with a color on a new layer. Now you can use the shape like a stencil/mask if you turn on the Lock transparent pixels in the upper area of you Layers panel.

02 Base colors
Use a soft round brush to add the basic shadows and highlight onto your layer with the pixel mask. The highlight can be painted with a simple, horizontal, thick and soft line. The bright rim light gives the shape a nice outline.

03 Defining sections
With a hard round brush you now define smaller sections using your light and shadow colors. Use smaller strokes to add smaller and brighter highlights into the rough highlight line. Often a beginner's mistake is to think only about the overall hair texture. Thinking in bigger forms and sections will help you to create a better result.

04 Detailing
Now you can start thinking about the smaller details and the texture of the hair. Use a smaller and sharper brush to paint some hair texture and detail into the midtones. You can do the same to highlight areas, but in smaller areas than the midtones. To add more depth and realism to the hair, add smaller details and strands to it. Use a very thin and sharp brush and draw some bright hair lines here and there. Do the same with dark lines.

05 Natural hair ends
Use a brush with hard edges and the Opacity Jitter set on Pen Pressure to make the hard edges of the hair ends fade out naturally. Also paint some single hair tips here and there. This breaks up the hard edges, makes the hair look fluffier, and gives a hint of the structure.

01

02

03

04

05

To see this quick tip used in a final concept, go to page 202

Short hair

by Carlos Cabrera

01 Silhouette
Start with a silhouette to paint the bulky hair. Select the Lasso tool, draw the silhouette and use the Bucket tool to fill it with a gray color.

02 Volume and contrast
Select the Lasso Tool to create a hair shape selection. Pick a darker gray and with the Gradient tool apply from top to bottom. Create another small selection where the highlights will be and make another Gradient pass with a brighter gray color; remember to make smaller selections in each step.

03 Add detail to the hair
With a small brush at 2–5 pixels, pick a darker gray and start to paint the locks of hair with curved brushstrokes. Start with the darkest hairs and move to the brighter ones. This way your hair will look more realistic. Pick a smaller brush at 1–2 pixels and paint jittery lines in the middle section of your hair. Leave the perfect curved locks for the end.

04 Rough up your lines
Realistic hair has a lot of imperfections with different shapes and lines even when it is combed. So, deselect any selection you have, and with the Smudge tool start to paint over the edge of the hair. Set the Smudge tool to 90% and go crazy on each brushstroke.

05 Color the hair
Now we have our base values in gray, merge all the layers (Layer > Merge Down) and add a new layer in Overlay mode. Pick the base color of the hair and select an airbrush or soft brush at 40 pixels with a low opacity of 20%. Gently paint over the hair. Change the size of the brush when painting close to the edge, or make a quick selection. Now pick a brighter color (always move on the color wheel) and paint the highlights on another Overlay layer. To finish, merge all the layers and use the Dodge tool to increase the brightness of the hair.

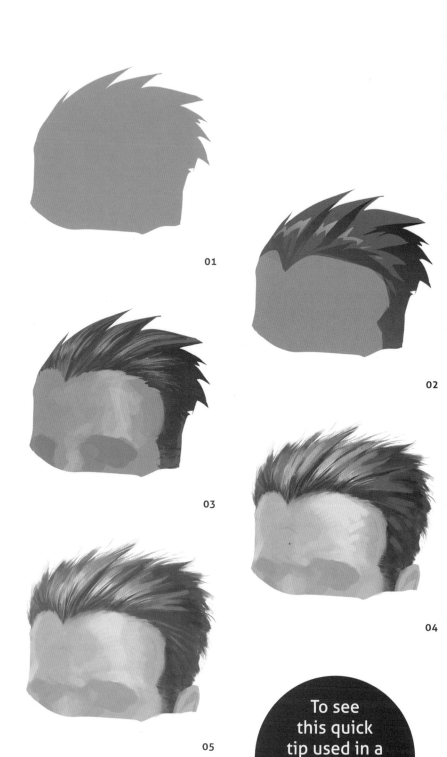

01

02

03

04

05

To see this quick tip used in a final concept, go to page 200

Straight hair

by Bram "Boco" Sels

01 Laying down the shape

When painting a hairstyle, it's absolutely mandatory to get the general shape right. If you want hair to look straight like in this case, you can't have curls sticking out of the sides. Even without adding brushstrokes you already get a good idea of what the hair will look like, just by looking at the shape. So start with a basic head and add a single color layer on top that defines the shape.

02 Adding shadows

Adding shadows can be done with a simple multi-lined brush (see image 02) with the Angle Jitter set to Direction (in the brush palette go to Shape Dynamics and set Angle Jitter to Direction). With a brush like this you can quickly paint several hairs at once.

03 Adding highlights

After you've added the shadows you can do the same for the highlights. Think about the color of the light while doing this. In my case there's a warm yellow light on the left and a colder yellow light on the right.

04 Boosting and refining

A great trick when you want to add volume to your hair is to select the Dodge tool; set it to Highlights and use a soft brush to go over the bigger shapes like the forehead (if there is a fringe) and the ends of the hair that fall over the shoulders or chest. It will automatically create an organic looking gradient that follows the shape of the head and body.

05 Stray hairs

Keep on refining the hair by going over the broad shapes with the multi-lined brush until you feel the inner shape is done. Then add a new layer on top in which you'll paint the stray hairs that move out of the big shape. Even though straight hair looks slick, there will always be some smaller hairs sticking out. Lastly, select the skin layer and make sure you add some shadows wherever the hair comes near the skin.

01

02

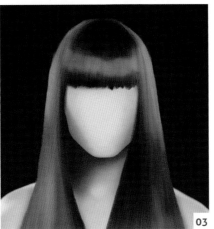
03

04

05

Painting fringes

by Bram "Boco" Sels

01 Laying down the shape

Just like with the straight hair (see straight hair quick tip on page 165) it's important to get the shape of the hairstyle just right. Fringe hair has a lot of locks that move over and under each other, but despite that the hair will still follow in a general direction, which is (obviously) down. When painting the bigger shape make sure you give it a lot of pointy ends so it looks natural.

02 Adding shadows and highlights

Using a multi-lined brush helps to quickly generate shadows and highlights where they're needed. In this case I went with a general light from the front, which results in shadows on the top of the head and behind the neck, and I used a strong back light from the right side.

03 Different locks

The most difficult part when painting a fringe is understanding how the hair wraps around the head and moves over and under itself. I think that it always helps to define it for yourself by quickly drawing some arrows on a separate layer just to point out how the hair flows.

04 Keep on highlighting

Once you know the direction of the locks, think about how they overlap. Wherever a lock moves over another, the top one should be highlighted, while the back one should get some shadow. Just like with straight hair, it's a good idea to use the Dodge tool to go over the bigger shapes like the forehead and bigger locks.

05 Overlays and specular highlights

Finally add a new layer on top and put its blending mode to Overlay. Pick a bright color, and with a small sharp brush, add some scratches and tiny hairs all over the haircut. These specular highlights help to make the haircut a bit more random and make it all the more convincing.

01

02

03

04

05

Youthful skin

by Bram "Boco" Sels

01 Base color and shape

Skin is an intricate material that gets its characteristics by the way light bounces on and around it. It'll be warmer in crevices and colder towards the environment. It's a good idea to start by creating a basic block-out on a separate layer and give it a solid color similar to the skin tone you're aiming for.

02 Adding values

Once you have your big shape, click on Lock Transparent Pixels in the top of the Layers palette and choose a highlight color (use the Color Picker to help). This color will be less saturated and lighter than the base color of your mask. With it (and a big soft brush) you can lay down the lighter parts of the skin. With a darker color do the same for the shadows.

03 Multiply

To add a tan you can use a Multiply layer (or alternatively a Screen layer for a paler look) on top to make the skin darker. Ctrl+click on the skin base layer in the Layers palette, add a new layer on top, fill it with a light brown, and set its blend mode to Multiply. You can tweak the effect with the Opacity slider.

04 Detailing

While looking at your reference, really focus on the skin tones and the light that affects it. Keep on pushing those values!

05 Noise and freckles

Skin has a lot of texture in it which can be created with a noise layer. Add a neutral gray layer on top; set its blend mode to Soft Light (it should become invisible if it's neutral) and click on Filter > Noise > Add Noise. Create a custom brush to add freckles. In a new document draw some round shapes in different values and sizes (image 05). Click on Edit > Define Brush Preset, open up the Brush palette, select your new brush, and click on Scattering. Now you can paint thousands of freckles without effort.

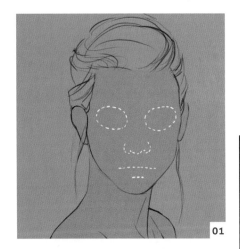
01

02

03

04

05

Aged skin

by Romana Kendelic

01 Basic shapes

Reference is the key to realistic depiction of human skin, so you can study the anatomy, light, and surface texture first-hand. Block in the very basic shapes, ignoring all of the details. Squinting at the reference or even blurring it slightly in Photoshop can help with understanding the underlying structures. It is important that the anatomy is solid before you attempt detailed rendering.

02 Aging skin

When we age, the skin grows thinner, paler, and translucent. It becomes dry, more fragile, with enlarged pores. It often develops pigmented spots (age spots). The most obvious changes are sagging skin and wrinkles. Two types of wrinkles are deep furrows and surface lines. Also in very elderly people you may notice that the face is not completely symmetrical.

03 Developing

With the basic form done, begin adding deep furrows on the forehead, prominent indentation on the side of the nose, and folding of the skin on the upper lid. Do not draw out the wrinkles. Try to paint the convex parts, bring out the volume of the folds and creases. Treat them like you would a slightly squashed cylinder.

04 Colors

For the very pale skin, stay away from black for the shadows. It will dull the colors, giving the skin a lifeless, grayish appearance. Observe the wealth of hues: saturated oranges in shadows, pinks and magentas where the skin is particularly thin on the lower lid – even pale blues and violets to accentuate the transparency.

05 Finishing touches

Deepen the furrows using hard-edged brushes. Add details like spots, pores, and fine lines. Finally paint in the fine speckled highlights for a life-like appearance.

01

02

03

04

05

Healed scars

by Carlos Cabrera

01 Choose your scar

Over a skin-colored base, make the shape of
the scar. Make a selection (using the Lasso
tool) or paint freehand. I chose a bullet scar,
so I paint a circle in the middle and a cross
cut on it. Pick a darker color than the base
skin tone and paint inside the selection.

02 Texturing the shadows

Pick an even darker color using the Color
Picker. With the Polygonal Lasso tool select
where the shadows will be on the scar; every
stitch and skin healed will give you a lot of
texture information, just simplify the shapes.
With the selection made, select an airbrush
or soft brush with a low opacity of 10% and
paint slowly and smoothly over the selection.

03 Lighting the scar

Select a hard brush at 5 pixels and 50%
opacity. Experiment with the basic brushes.
Pick a saturated skin color, in this case a
pale orange, and paint the opposite side
of where the shadows are. Remember
to let some of the base skin color in the
middle to emphasize the shadows.

04 Sometimes blur is better

Make a round selection using the Elliptical
Marquee tool that covers the entire scar
and hold Ctrl+Shift+C then Ctrl+Shift+V to
make a merged copy. Now go to Filter >
Blur to blend and smooth the scar; repeat
until it's blended together. Lower the opacity
of the layer until the two images blend
perfectly: 50% is a good place to start.

05 Texture the scar

Select a hard brush (a round hard brush is
perfect for this stage) set to 70% opacity and
pick a brighter skin color, a little lighter than
the highlights. Paint with short strokes over
the scar. Repeat in a new layer then lower
the opacity to 30%. In another new layer at
50% opacity, paint with the bright skin color
on the edges of the scar to create a bumpy
look. Use Color Dodge to add the final touch.

01

02

03

04

05

To see
this quick
tip used in a
final concept,
go to page
200

Open wounds

by Alex Negrea

01 Line art

With a default round brush I paint the line art, keeping it as simple as I can. I keep in mind the volumes that are going to be rendered in the next step, so I draw the wound wrapping around them properly.

02 Blocking in

I block in the areas that need separation later on in the process. I use a brush with Color Dynamics turned on to achieve some slight variation in the hue, value, and saturation of the skin. To turn on Color Dynamics, open the Brush engine (shortcut F5) and check the box next to Color Dynamics. Play with the sliders to see how they affect the brush that you are using. I move them just a bit to the right because I don't want a strong effect.

03 Initial details

Keep the inside part of it a dark red. Most of the work is done outside the wound. You can add some highlights to the edge of the skin to suggest the thickness of it. Adding some darker and saturated colors near it will indicate some trauma that the tissue near the wound is suffering.

04 Blood spatter

I use a brush with Wet Edges activated in the Brush Presets panel to paint some blood stains near the edge of the wound. I add some more variation to the dark red inside the wound by color-picking it and using a brush set on Linear Dodge (Add) mode. To change Brush mode on the fly use the shortcut Shift+right-click while using the Brush tool.

05 Highlights and extra details

I add some specular highlights with a default round brush and a color near to white. I add some more detail with some bruising. I paint bruises by setting a brush to Multiply and picking saturated green, blue, and yellows, and painting in the same layer as the skin so it blends well.

01

02

03

04

05

Tattoos

by Tim Löchner

01 Designing a tattoo

Create a new Photoshop file where you can design your tattoo. Just create the image, whether it is a tribal pattern or a colored picture, by drawing it with full opacity. At this point you don't have to think about the perspective distortion of it while being on the arm. Makes sure it's on a different layer to the background.

02 Placing the tattoo

You can place the tattoo into your character's document by dragging the layer of the tattoo into the workspace of your painting. Place it over the arm and size it to your liking using the Transform tool (Edit > Transform > Scale; hold down Shift to keep the proportions).

03 Wrapping it around the arm

For this task you need the Warp command. Go to Edit > Transform > Warp. Now a transformation framework is placed over your tattoo. Pull the anchor points to adapt the form of it to the roundness of the arm. You can also click and drag the cells of the grid to form your tattoo. Hit Enter after you're done.

04 Overlay

Now that you have put your tattoo into shape you can simply switch its layer mode to Overlay. Now it adapts the shading of the arm below and blends into the painting. You might want to adjust the brightness since it might have become a bit too dark depending on the original value of the tattoo. To resolve that you tone down the layer's opacity, which is placed in the upper area of the Layers panel.

05 Mirroring

If you want to extend your tattoo, you can add another layer with the same tattoo image on it. Drag and drop your original tattoo drawing again into your document and flip it horizontally (Edit > Transform > Flip Horizontal). All that is left now is to repeat steps 02–04.

01

02

03

04

05

To see this quick tip used in a final concept, go to page 202

Female ears and earrings

by Tim Löchner

01 Preparations

At first you have to think about what characteristics an ear has in general, especially for a young female. An ear has very thin skin, so in certain areas you see more red of the blood shining through when light falls on it, which makes the ear appear a bit more red. Later in the process you need to be careful to not over-detail the ear so it works together with the soft and kind appearance of the girl's face.

Use a big, soft round brush to roughly add the main colors and shadow. Remember to make the shadows more saturated and red.

02 Defining shapes

You don't have to go into too much detail here. Just tighten up some of the forms a bit. The ear has a pretty smooth surface on the inner forms, so you'll see a few more highlights here.

03 Masking earrings

To have a clearer separation from the skin of the character, it's helpful to create an extra layer with the earring shapes on so the different materials don't mix up. Just paint the shapes of the earrings on an extra layer and switch the pixel lock in the Layers panel on.

04 Shading the earrings

The earrings are obviously made of different material to the skin, so you need to show the contrast of this. Metallic materials have a very reflective surface, so the transitions from light to shadow will not be very smooth. Put a darker value right next to the light area. This strong contrast defines the material.

05 Additional details

You can add additional details onto the surface of the earrings to make them look more interesting. I add a golden color at the corners by just creating a new layer on top with the mode set to Overlay, and paint the colors with a sharp brush.

01

03

05

02

04

To see this quick tip used in a final concept, go to page 202

Female eyes and makeup

by Bram "Boco" Sels

01 The shape of the eyes

Draw the shape of the eye on a separate layer to use a guide. Note how the eyelids wrap around the eyeball and how they fit neatly into the eye socket. This is important because it will help you to determine what to shade and what to highlight.

02 Shading the eyeball

Another important thing to realize when painting eyes is that you are painting a round object. Note how the ball shape is rendered and how it catches a little highlight on the top. The eye itself will be shaded accordingly and the eyelid will be draped over it.

03 Eyelashes

Women often use makeup to increase the size of their lashes. To enhance that effect they also darken them and the eyelids around them. Use a dark brown to darken everything around the lids, especially in the crevices. Note how lashes become pointy towards the ends and by exaggerating that you can make the eyes seem even bigger.

04 Makeup magic!

Makeup is easy if you have the shape and values of the eyes blocked out correctly. Add a new layer on top, set its blend mode to Overlay, and use your preferred color to paint in the makeup where you want. In image 04 you can clearly see what the Overlay layer looks like without the blend mode on. Don't go overboard; I've exaggerated it for the sake of this quick tip, but subtlety is often the key.

05 Little specular lights

Because makeup is rather noisy and gritty it's a good idea to add little specular lights around the highlights to make the noise more convincing. Use a textured brush (like the standard Chalk brush), add a new layer on top, set its blend mode to Color Dodge, and use a dark gray to dot over the eyelids and the points where the eyeball meets the eyelid. Your eyes will feel polished in no time!

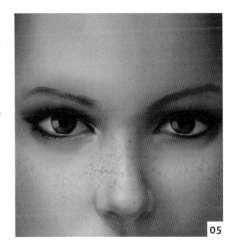

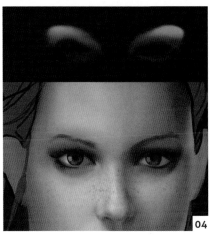

Male eyes

by Carlos Cabrera

01 Notice the difference
Create a new layer and pick a small 10-pixel brush to make a quick sketch. Paint the skin color with a bigger brush at 50 pixels with opacity set to 50% to blend the colors. Paint the skin color in another layer below the line art to keep the skin clean.

02 Volume plane
The face is divided into planes. On a top layer in Normal mode, paint the planes of the face with a big round brush. Paint the light with a yellow/bright skin color. Avoid black for the shadows. Use the Lasso tool to make the projected shadows over the face.

03 Shadow detail
The line art is still visible with the layer on Multiply, so change the line art color to dark brown. With Lasso tool, "draw" the shadows without losing the planes from step 02. Paint with a round brush at 25 pixels and opacity set to 20% to blend the skin color on the shadow areas. Work on the shadows, not the highlights.

04 Strong highlights
To add volume to your eye add some lights without dulling it. Now you have the color base for the shadows and skin tone, move to a yellower/brighter color, keeping it desaturated. Add a stronger highlight on the forehead, and transparent ones to the cheekbones, by making a selection of the highlight areas and using the Gradient Tool from the top (where you will have the strong color) to the bottom of the face.

05 Smudge it all
Now we have the highlights, the shadows, and some detail we need to smudge all the areas. With the Smudge Tool blend the highlights and shadows to create realistic skin. Select a 6-pixel brush set to 50% opacity and paint the highlights on the iris. With a smallest brush paint the hair on the eyebrows with little strokes.

01

02

03

04

05

To see this quick tip used in a final concept, go to page 200

Male ears

by Alex Negrea

01 Establish the proportions

I start with lines to establish the proportions and the design of the object that I am drawing. I use a default Photoshop brush. I think about the volumes that I am about to render: the ear is made mainly of cylindrical pieces. The silhouette of the ear could also be considered to be a half of a heart shape.

02 Start rendering

Once I have finished the line art, I use selections to define the entire silhouette of the object that I am rendering. In this case the shape is simple so I use the Lasso tool. Once I have the selection I fill it with a skin-toned color and lock the transparent pixels. I start blocking in the shadows, considering the volumes that I want to represent.

03 Sub-surface scattering

The ear is a thin layer of folded cartilage which allows light to enter the surface and bounce inside it, creating sub-surface scattering (SSS). This means that inside your shadow areas there will be some saturated light. To achieve this, color-pick the existing shadow color and, based on that, alter it so it's a bit lighter and more saturated.

04 Soften the surface

Because the ear is old I intentionally leave some rough textures from my initial brushstrokes. I use the Smudge tool to soften the surface with a default round brush with some Scattering. You can experiment with the Hardness option too.

05 Texture details

The older the person, the more textured and hairy the ear. I use Bevel & Emboss with a default round brush with Scattering for the tiny bumps. The effect is too strong at first so I rasterize the layer style (right-click on the layer and Rasterize Layer Style). I then apply a Gaussian Blur filter on that layer so the effect is smoother. I also add some white hairs coming out of the ear.

01

02

03

04

05

Delicate nose

by Bram "Boco" Sels

01 The shape of the nose
As with all facial features, you should plan ahead and lay down a sketch of what you're painting. Look for reference and using only a few lines, try to construct how the nose fits on the face. Keep your lines on a separate layer so you can still turn them off later.

02 Construction
When painting a complex shape it's often better to start out by dividing it into flat blocks and planes. Study how the bridge of the nose moves inward around the brow and jumps forward at the tip. This is especially true for young noses and is a big part of what makes kids and teens look sweet and innocent.

03 Blending the planes together
Once you've constructed the planes of the nose it's an easy task to blend them together and smooth them out. You can do this by either using a big soft brush to go over each corner or by selecting the Smudge Tool to push the pixels into each other. Don't worry about the noise and freckles you're losing, you can add them quickly again later.

04 Lines versus edges
Now it's time to turn off the line drawing and focus on the edges. The difference is that lines don't actually occur in nature, so you have to find a way to paint the transition between light and dark without using a hard line. Note that wherever a crevice occurs (such as beneath the nostrils), the shadows are darker and the edges sharper.

05 Detailing
Keep on working on those edges, but don't forget the large shapes. The tip of a small, young nose is often round and should be shaded accordingly. Look at how part of that round tip catches light, while the other side is much darker. You can also reconstruct the freckles around the bridge of the nose and paint in that small, fun highlight on the tip of the nose.

Thin lips

by Romana Kendelic

01 Blocking in
I start by blocking in with a soft round brush. Staying very blurred and loose helps with finding the right form and expression. Ensure you include the surrounding areas – chin, cheeks, philtrum (that little depression above the upper lip), and ridges on both sides of it. They are landmarks that help shape the lips.

02 Darks and lights
Keeping in mind the direction and color of light, begin establishing darks and lights. The upper lip is often darker because it faces away from light. Skin of the lips is naturally thinner than the skin on the rest of the face and that transparency is what gives it a characteristic reddish tone. I use a darker, more saturated, and slightly orange color.

03 Smooth forms
Develop the form, gently curving lines and volume. The upper lip has three forms: a central rounded protuberance and two side forms. The lower lip, often fuller, consists of two. There should be no edges, with forms flowing smoothly. You want them to feel fleshy and soft. Lips don't have an outline. Lipstick can change that but a vermilion border in natural lips is a mild transition, not a sharp line. There is often a highlight just above the border because lips curve slightly outward.

04 Sharpen up the shapes
Use a hard round brush with opacity set to Pen Pressure to tighten up the shapes. Add dark tones in the opening of the mouth and first highlights. Pay attention to the corners of the mouth, where some muscles attach and overlap. This is where changes in expression are most visible. Vary the hues as well as the value of colors for a more realistic effect.

05 Details
Paint in fine lines to give the lips texture. With a very pale pink add tiny speckled highlights on the surface. Don't overdo this unless you want the lips to look chapped and dry.

Voluptuous pout

by Tim Löchner

01 The simplified drawing

Before I put color and rendering into the lips, it's important to have a simplified drawing, which describes the design of the mouth and gives it its proportions and shape. You don't have to outline every detail, just the most important parts: the opening line of the mouth and some indications for the upper and lower lip. Don't draw the opening line too strong; it's only important to add the middle contact point of the lips and the mouth corners.

01

02 Adding rough colors

Use a large, normal round brush with 0% Hardness to fill in the basic light and shadow colors. Don't worry if you go over the lines – it looks more natural if the lips aren't completely separated from the skin around the mouth. Reduce the opacity of the line art layer beforehand. I usually base my lip colors on the character's skin tone and add more saturation and red to it. A strong red, too far from the skin tone, will look unnatural.

02

03 Detailing

I mainly use a brush with hard edges and the Opacity Jitter set on Pen Pressure. Use it to add details like very subtle folds in the shadows and small light strokes for the highlights on the lit side.

03

04 Hard edges

The separation of the upper and the lower lip is important. Use the freehand Lasso tool and select the upper edge of the mouth opening. Add a darker value with a small round brush with 0% Hardness. To increase this effect you can invert your Lasso selection and add a lighter value to the lower lip so the dark edge of the upper lip touches the part of the lower lip, which is a little bit brighter.

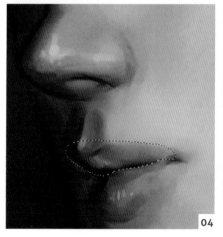

04

05 Removing lines

To give it a more painted and realistic look, I erased the lines of the drawing. I suggest adding a layer mask, which you can find at the bottom of the Layers panel.

05

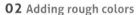

To see this quick tip used in a final concept, go to page 202

Male nose

by Alex Negrea

01 Rough line drawing

Here I start a rough line block-in. It's rougher because from this angle the only things that overlap enough to see form transition are the nostrils and the skin of the cheeks, which doesn't allow us to see all the nose parts. So I add some lines even though I don't see them (for example the bridge of the nose).

02 Lay down the first colors

To get some nice skin tones I activate the Color Dynamics on the brush that I am using. This creates variety in the values of the initial color you are using. I also paint the shadows inside the folds, even though they overlap with the line art at this point. This allows me to have that shadow already in, and not worry about it later.

03 Render the forms

The shapes of the nose are made of spherical and cylindrical volumes. Roughly knowing those shapes in your head will make it easy for you when it comes to rendering. To make the shadows deeper I use a brush set to Multiply.

04 Add in texture

Because my shadows were already too dark and because I am painting skin, I have to think about sub-surface scattering. I lighten them using a brush set to Lighten and with a color that is more saturated and lighter in value than the shadow. To add texture I use a default round brush with Scattering turned on to create all those tiny speckles without spending too much time on them.

05 Final details

To make the skin older I continue to add more speckles and imperfections to it. Because this is an old person's nose, I add some white hairs inside the nose to further push this feeling.

01

02

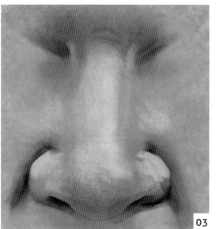

03

04

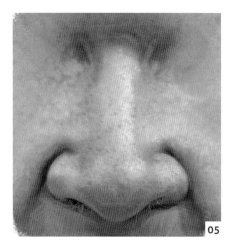

05

Mouth and teeth

by Alex Negrea

01 Line art

I start with line art to help me pre-visualize the subject that I am about to render. Having the teeth drawn out before the rendering is a huge help. The teeth marked with blue are flatter than the rest. That means that when I render them I will treat them like a box and not as a cylinder (like the rest of the teeth).

01

02 Block in the colors

I use the lines to do a clean selection using the Lasso tool so that later on when I need to paint on them, I don't worry about their edges. Once I make the selection I create a new layer and fill it with the foreground color and lock the transparent pixels.

02

03 Render out the values

I use a soft round brush to paint everything in this stage. I set it on Multiply for the interior of the mouth so I can paint some darker values. I keep the colors saturated and close to reddish and orange-ish colors. I pay attention to the volumes I want to render. The lips are like cylinders that wrap around the mouth and the tongue is like a stretched sphere.

03

04 Paint the teeth

Even though teeth are solid they allow small amounts of light to pass through them. That means a sub-surface scattering effect is going to be visible. Meaning that parts of the transition edge of the shadows will be more saturated and lighter in value than the shadow. I try to remember this so I don't destroy that saturation.

04

05 Specular light and depth

I leave the specular lights for the last part of the drawing. They add the glossy feel of the teeth and the other wet surfaces like the tongue or the lips. Note how I keep the interior side of the mouth edges very soft to push the idea that it's a soft material and not hard like the teeth. It also adds depth, making the teeth appear more forward than the rest of the mouth.

05

Fur

by Romana Kendelic

01 Types of fur

There are many different types of fur, not just in color or length but the texture, too. There is bristly, woolly, soft and plushy, silky, tangled, and so on. Also lots of animals have layered fur: a softer undercoat (downy hair) and a coarser top layer (guard hair). This top layer is usually strongly pigmented including a whole range of patterns (for example as seen on big cats).

02 Basic shapes

I block out shapes with a soft brush. Start with the placement of light and shadow. Paint in the basic color and tone, and pattern if any. Fur of some lengths naturally clumps together and this is what you should paint thick sections that overlap and separate. Use loose brushstrokes and leave all detailing for later. Keep in mind that fur has depth and weight. Paint in the direction of the growth.

03 Clumps of fur

Define the edges of the clumps of fur. Check a reference to see how they move – is it soft fur with gentle curves, or coarse and bristly which would benefit from sharper, straighter lines? Instead of rendering every individual hair you are trying to give an illusion of detail.

04 Details

Refine the fur. Start by adding more defined highlights and shadows. Do not lose the clumps; just add more definition to them. There may be cast shadows to darken, or overlaps to highlight. If the fur is not the focal point of your painting you can safely stop here.

05 Guard hair

Finally add the guard hairs. Usually they are coarser single hairs protruding through the coat. Use a hard-edged brush on a separate layer. Sharpen filters may help separate the soft undercoat from the firmer top layer (Filter > Sharpen). If the fur is glossy, now would be the right time to add highlights.

To see this quick tip used in a final concept, go to page 204

Lace

by Bram "Boco" Sels

01 Dressing up

When painting translucent materials such as
lace, the background they're draped over is
what makes them convincing, as it shows
off the transparent parts. In this quick tip
we start with a pair of legs which we'll soon
dress up with a fantastic-looking lace skirt.

02 The base of the skirt

Start out by painting a convincing base
without worrying about the details. In this
case I went for an opaque white skirt; you
can change the base color to whatever
color you want. Keep in mind that the
shape of the skirt should wrap around
the legs as convincingly as possible.

03 Opacity

Next, duplicate the layer then hide the back
layer and select the top layer. At the bottom
of the Layers palette click Add Layer Mask
and press Ctrl+I to invert the layer mask.
Notice the skirt disappears – this is because
your layer mask is now empty (black). If you
now select the layer mask (click the black
rectangle next to the layer's thumbnail) and
paint in that mask with a white brush, your
layer will show through wherever you paint.
Finally, unhide the second skirt layer and set
its opacity to 50% to get a see-through skirt.

04 Painting in the lace pattern

Select the upper skirt layer (which is still
invisible due to the black mask), click
on the layer mask (the black rectangle),
change your foreground color to white
and you can now use a regular brush
to paint in the lace pattern. Everywhere
you paint in the layer mask, the opaque
top skirt will appear in your canvas.

05 An extra detail layer

Finally, create an extra layer on top of the
others and paint in the rest of the details.
Don't do this in the masked layer, as lace
patterns tend to be bumpy and uneven, while
the masked layer is clean and straight.

Leather

by Bram "Boco" Sels

01 Background color

Fill your background layer with your chosen
local color and use a big brush to create a
general direction for the light. I used brown
with a top light, so lighter browns will be
in the middle, while the outside is dark.

02 Leather texture

Add a new layer, fill it with white and, with
a dark brown foreground color, go to Filter
> Filter Gallery > Texture > Stained Glass.
By changing the Cell Size you'll get a larger
or smaller texture. Now use Filter > Filter
Gallery > Brush Strokes > Spatter. Select
Accented Edges to get rid of the stiff edges.

03 Bevel & Emboss

With the white texture layer still showing,
click on Channels in the Layers palette.
Ctrl+click on the blue channel. This selects
everything white (the leather cells), so go
back to the Layers tab, click on the brown
background layer and do Ctrl+C and Ctrl+V
to copy/paste the cells from the background.
Hide the top white layer and double-click
on the new layer. You'll see the Layer
Style window – click on Bevel & Emboss.
This will make all the leather cells pop up
with a nice highlight and shadow color.

04 Multiply

Unhide the white leather pattern and set
its blending mode to Multiply to accent the
crevices of the leather. The pattern is rather
horizontal, so select both your Multiply layer
and the Bevel & Emboss layer and rotate
them a bit. You may have to resize them
to fill the empty space from the rotation.

05 Dirtify!

To make your texture more convincing add
some scratches and dirt. Create a new layer
on top and use some rugged brushes to
paint over the layers below. Add some broad
strokes of dirt with big soft brushes, and
some rougher scratches with smaller, sharper
brushes, to achieve a less digital look.

Silk

by Bram "Boco" Sels

01 Local color, light color

Silk is fairly reflective, so lighting conditions are important. Choose the color of the silk (local color), and the color of the light in the environment (light color). In this case the silk is red and the light is bluish, so the highlights of the silk will be purplish/pink (red mixed with blue). The shadows will turn out to be a warm kind of brown.

02 Shadows and folds

To make your silk shine it has to feel organic and folded. Start with the shadows, and use just one color to paint the shapes. Every shadow you paint will be lower than the rest, so try to create a logical transition between the red shapes.

03 Highlights

Once you've painted the shadows, do the same for the highlights. Think about how folds intersect with one another; your highlights will form lines that flow over into each other. For each shadow painted in the previous step, paint a highlight near it.

04 Blending and smoothing

Once your basic colors are laid down, it's time to start blending them. Shadows will be darkest where they are furthest away from the camera and will gradually flow over into the midtones; the same goes for the highlights. The sharper a fold, the sharper the highlight on it, so in places where the silk takes sharp turns you can use the Lasso Tool to get some tight edges.

05 Texture

Although silk feels smooth, it still has a little texture and noise in it. A quick way to get this texture is to press Ctrl+A to select all, and Ctrl+Shift+C to copy, then Ctrl+V to paste a merged version of your painting. Now go to Filter > Filter Gallery > Chalk & Charcoal and press OK. Finally hit Ctrl+Shift+U to desaturate the layer and set its blending mode to Soft Light.

01

02

03

04

05

Jewelry

by Romana Kendelic

01 Sketch

Start with the sketch. It does not have to be particularly detailed; an accurate outline with basic placement of cast shadows will be fine. Try to find a pleasing composition.

02 Blocking in

Set your sketch layer to Multiply. Create another layer below and start blocking in the basic colors in a midtone range. Note the light source and how the value changes across the forms. There are two light sources, one on each side – a closer one and one further away. Establish the midtones, core shadows, and light areas on the spherical gems. On the cubes find the sides that are light and ones that are dark. Learning to paint basic shapes is an essential part of creating a successful illusion of 3D objects on a 2D canvas.

03 Developing the forms

Lower the opacity on the sketch layer and start developing the forms; pay attention to how different materials act. The elliptical gem on the ring is semitransparent – see how the light enters the gem from the right and above then pools on the opposite end. The light that shines through takes the color of the gem. The spherical gems are opaque; they do not transmit the light. The core shadow is colored due to the reddish surface.

04 Metal

Turn off the line layer (click on the eye symbol next to it) and concentrate on the metallic parts (ring and wires in the earrings). See how hues shift from slightly greenish to a range of ochers to yellow highlights. Darken the shadows; contrast is the key here.

05 Highlights

It's all about well-placed reflections and highlights. The harder and smoother the surface, the more reflective it is. Pick the lightest color, almost white, and with a hard-edged brush pinpoint your highlights.

01

02

03

04

05

To see this quick tip used in a final concept, go to page 204

Weapons

by Carlos Cabrera

01 Don't lose the shape and line

Draw everything in one layer (line art layer). Create another layer below this. Make a quick selection with the Lasso tool, fill with the Paint Bucket tool, and using the same selection apply a gradient to create light and shadow. Change the layer mode to Multiply to see the line over our base layer.

02 Simplify with boxes

When painting the light and dark areas, simplify the shape. You can do this in another layer. The strongest lights are followed by a darker shade to give a flat and deep feeling to the shape. Use the Polygonal Lasso selection tool to create the faces and the Paint Bucket tool to fill them with gray colors.

03 Add detail to the object

Using the Brush tool and a brighter color than the base, paint the weapon with an almost white color to achieve a metallic feeling; note where metal reflects light. Paint soft shadows on the holster to emulate the fabric. Use the Dodge tool to add the highlights and create softer lights.

04 Colors

Add a new layer in Color blending mode and paint with a desaturated blue. Pick a green and paint only the shadow side of the weapon and holster. In a new layer set to Normal mode, paint where the highlights will be with a round brush at 20 pixels. Smooth out the light and shadows on the gun to make it realistic.

05 More detail and realism

Add contrast to color to create better volume. Soften the fabric with the Smudge tool to create a realistic texture. With a 10-pixel round brush, paint highlights on the metal and blend the reflections. Add saturation to the shadow area with a layer set to Overlay. Add small details, like seams and creases with a small 2–5-pixel round brush set to 100% opacity.

01

02

03

04

05

To see this quick tip used in a final concept, go to page 200

Glasses

by Bram "Boco" Sels

01 Designing the glasses

The selling power of your image comes from the design of the glasses. In this case I went for an old model that sits on the nose, and I started out by creating two separate layers for it; one with a dark color for the frames and one with a gray color for the glass.

02 Deciding on the color

Once you have both layers you can decide what material your glasses will be made of. The glass itself is easy to do, just put the layer's opacity to 20% (or more if you want thicker glass), and that's it. The frames are a bit more difficult, but to begin we'll decide on the color we want. I give them a gold/brass kind of color by pressing Ctrl+U and fiddling around with the sliders until I am satisfied.

03 Bevel & Emboss

For shapes that are thin and small like this one, Bevel & Emboss can get you started really quickly. Double-click on your frames layer in the Layers palette, choose Bevel & Emboss in the pop-up, and change the colors of the highlights and shadows from white and black to browner colors. Hit OK and right-click on the layer to Rasterize Layer Style. This merges the effect into the layer.

04 Highlights

Bevel & Emboss can only get you so far, though. It's a digital effect and therefore looks like one, so it helps to go back in and manually paint over the effect. Also think about where the light is coming from (in my case from the top-left) and accent the frames with some bright highlights in that direction.

05 Cast shadow

To make your glasses even more convincing, paint in the cast shadow it leaves on the face. It helps to ground the glasses on the nose and makes it all the more convincing. Finally you can also add some little scratches and bumps to the model to make it a little more worn and used.

01

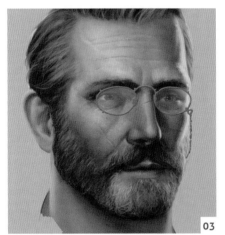

02

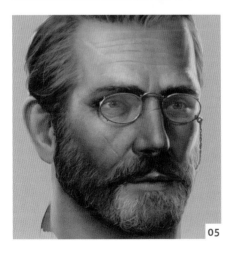

03

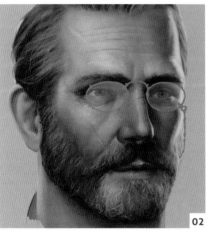

04

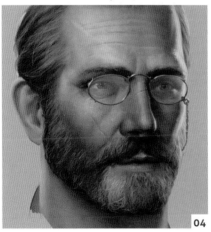

05

Breakdown gallery

**Find inspiration for your own creations
with a gallery of diverse characters.**

In this section you will discover a stunning gallery by a
selection of talented artists, which will also uncover the
visual progression of each image as they reveal the steps
behind their process. This will enable you to understand how
different elements covered in this book can be combined and
built upon to produce a top-quality character painting.

Subterranean man

by Chase Toole

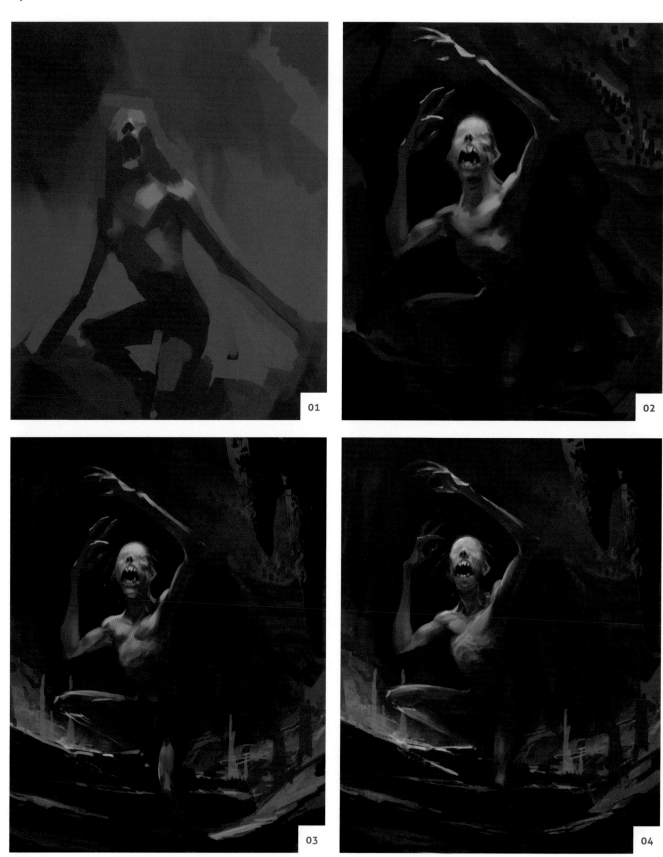

01

02

03

04

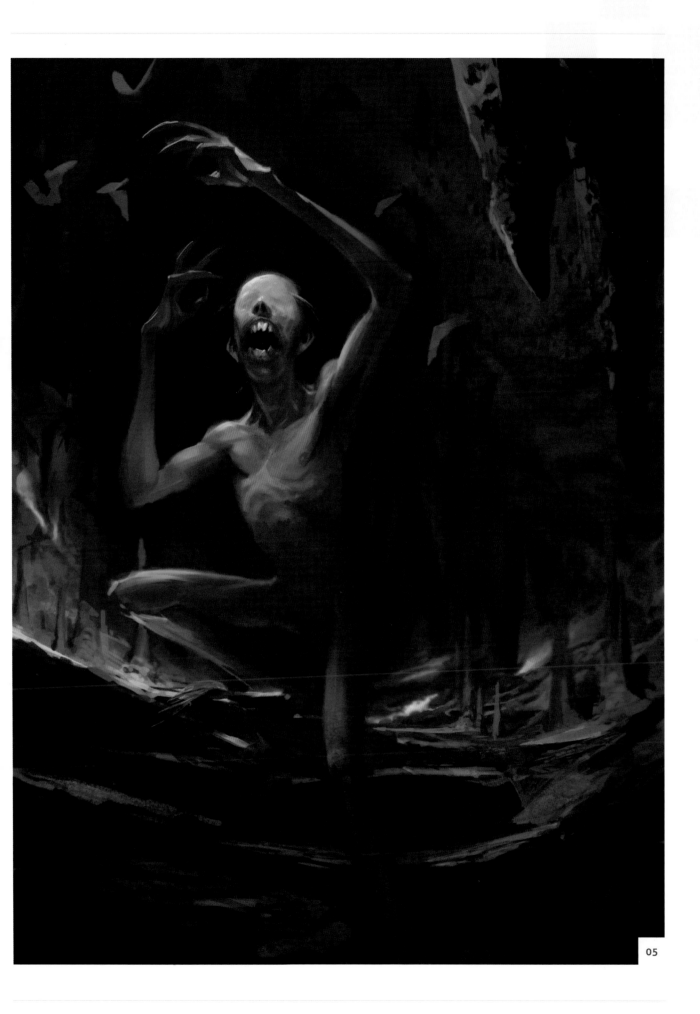

05

Alchemist

by Andrei Pervukhin

01

02

03

04

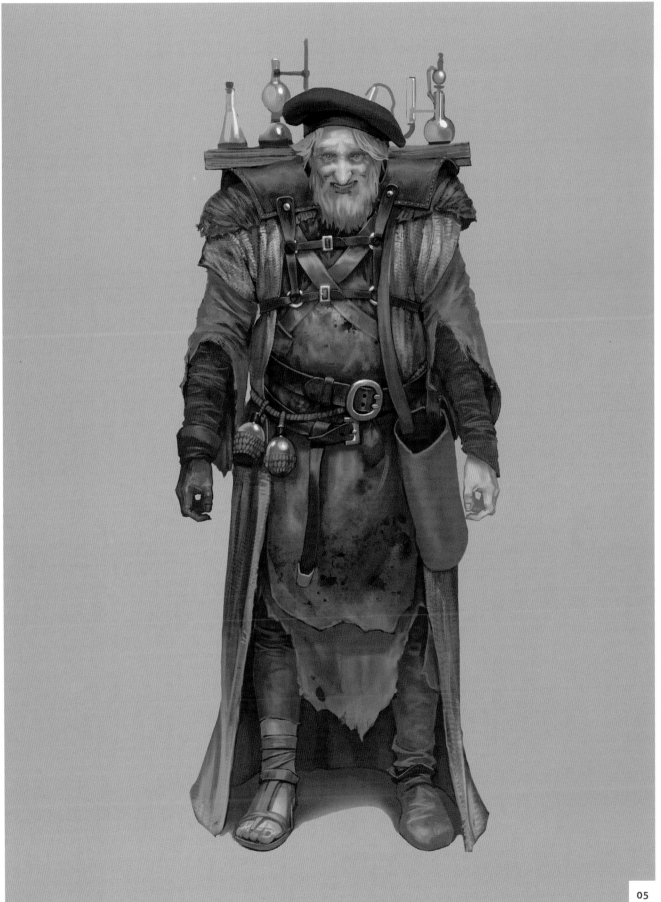

Femme fatale

by Pyeongjun Park

01

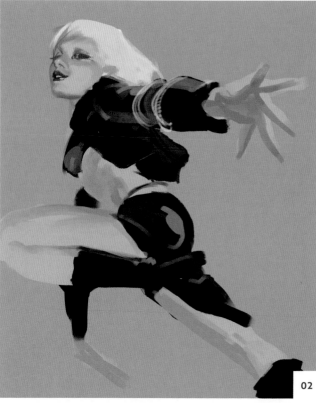

02

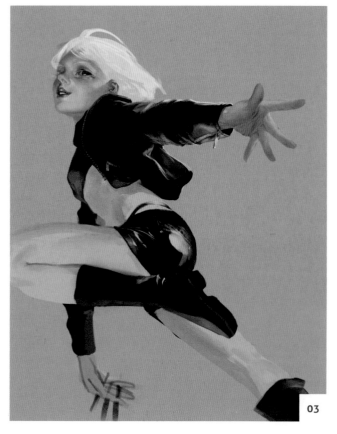

03

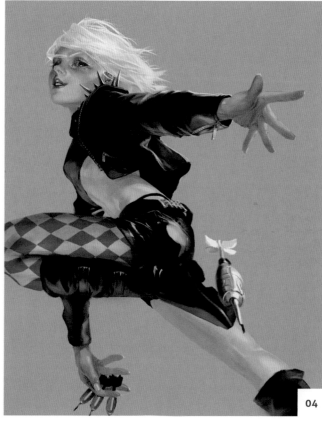

04

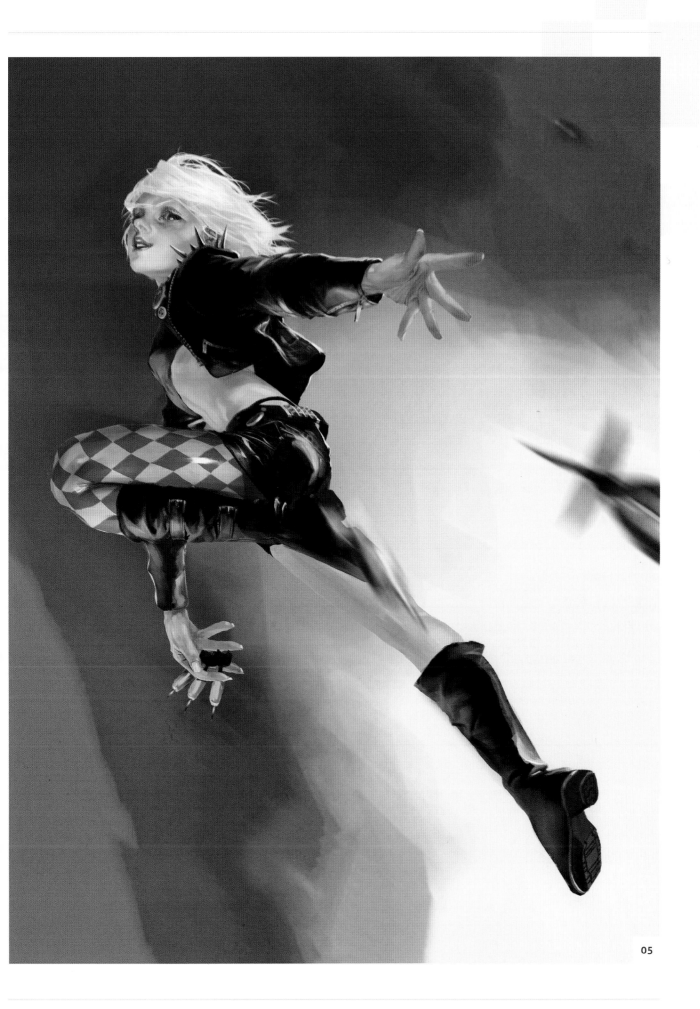

05

Warrior elf

by YongSub Noh

01

02

03

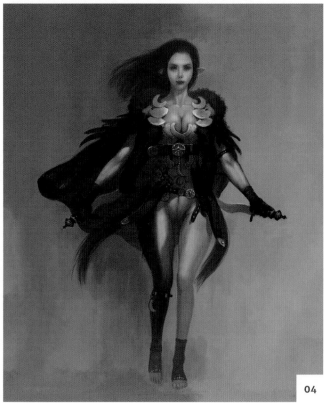

04

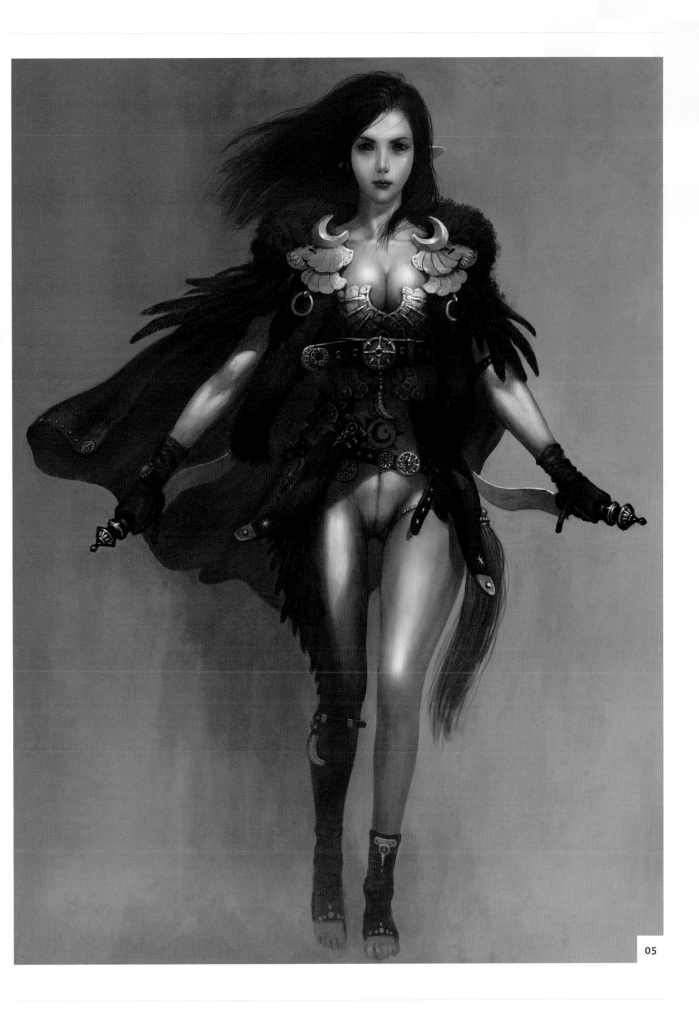

Bio-mechanoid

by Gerhard Mozsi

01

02

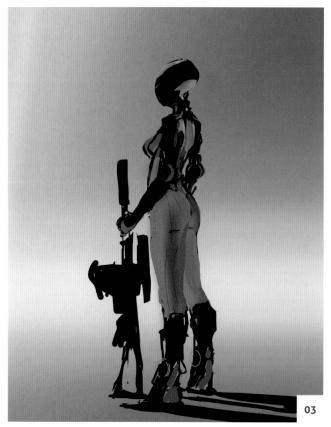

03

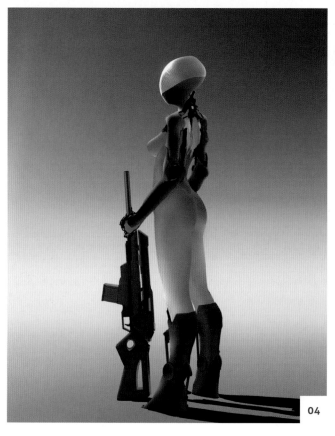

04

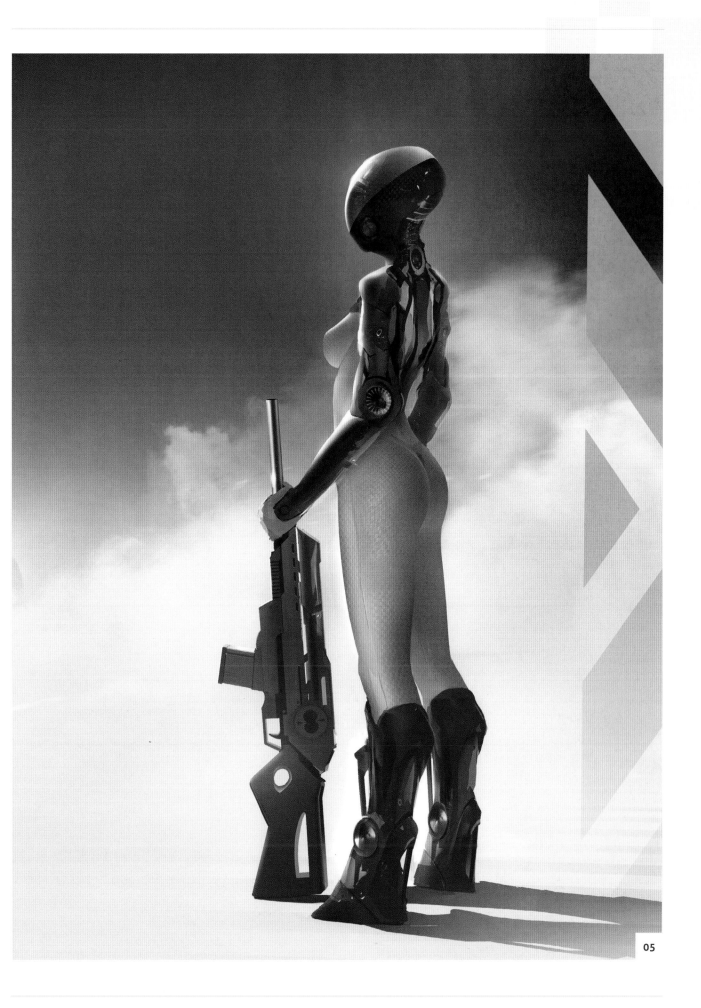

Sci–fi soldier

by Carlos Cabrera

05

Tattooed girl

by Tim Löchner

01

02

03

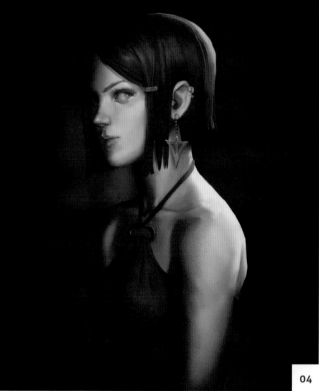

04

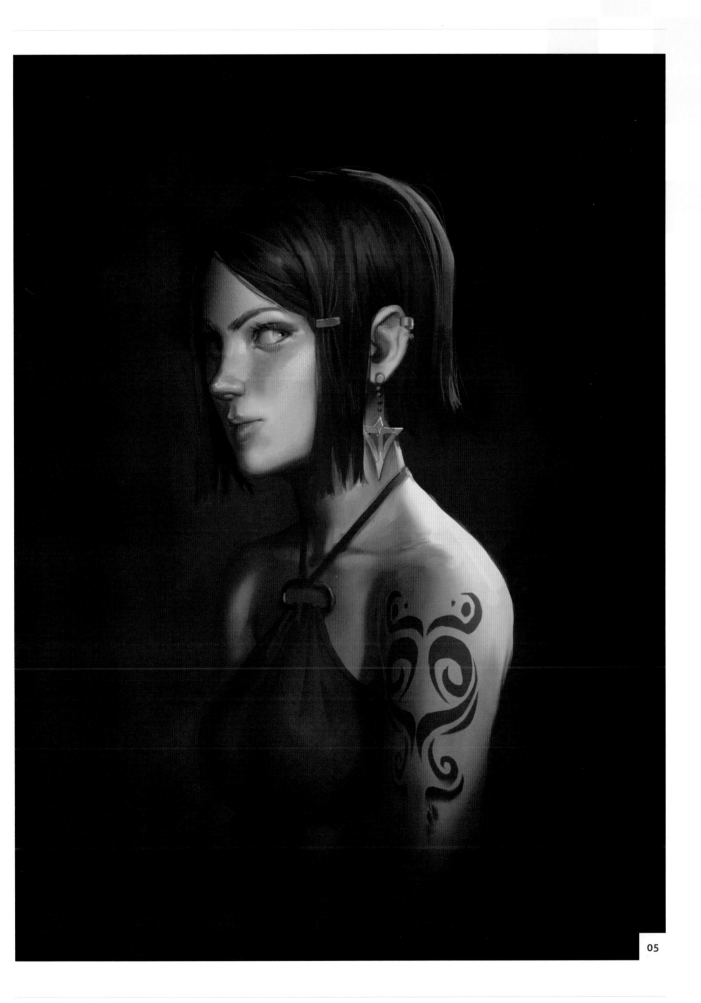

05

Regal old man

by Romana Kendelic

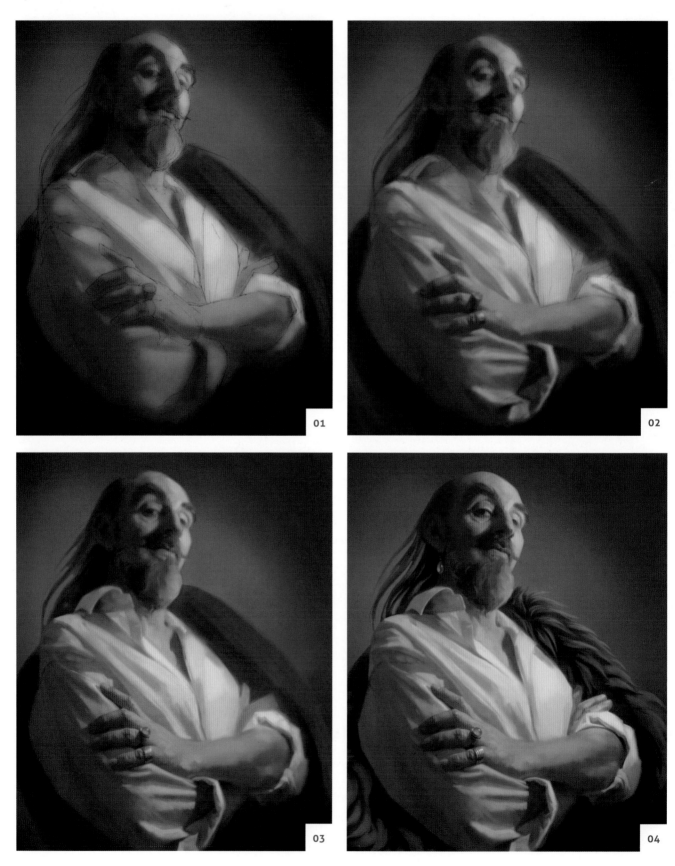

01

02

03

04

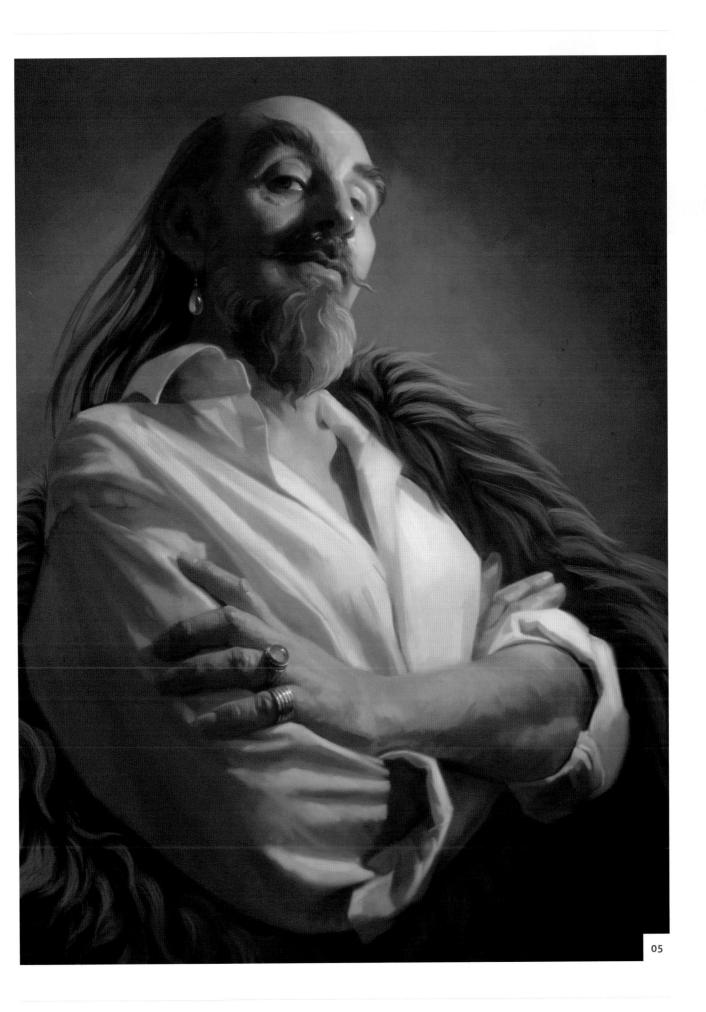

05

Moonshine villain

by Charlie Bowater

01

02

03

04

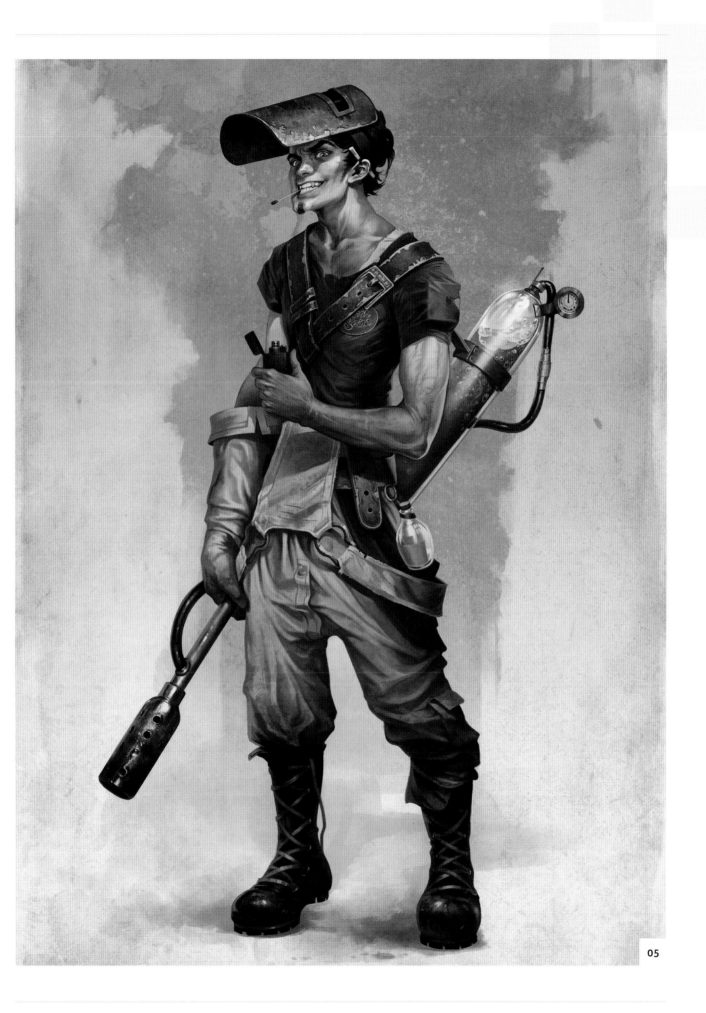

05

The socialite

by Devon Cady-Lee

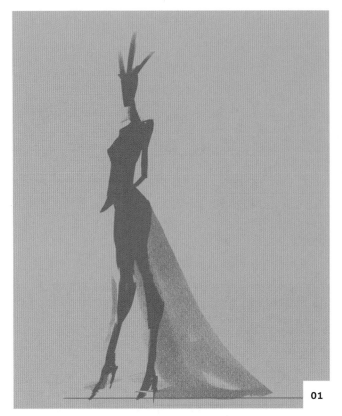

01

02

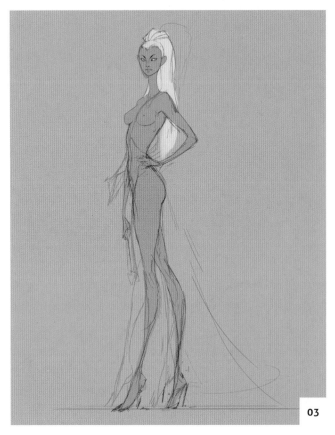

03

04

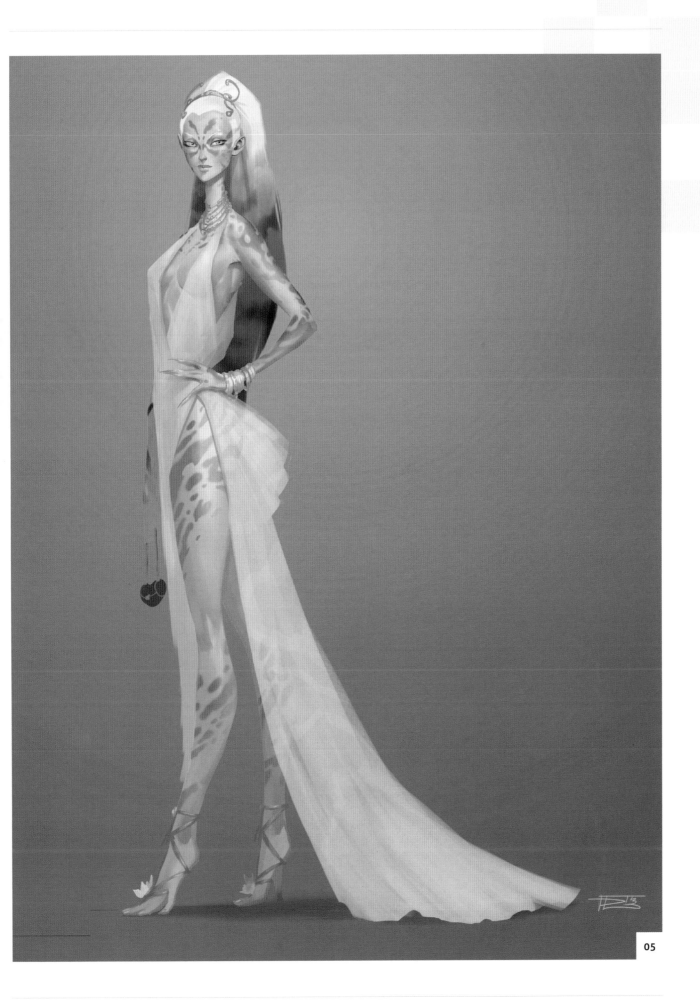

Glossary

A

Adjustments layer palette

Above the Layers palette (if it's missing go to Window > Adjustments) you'll find the Adjustments layer palette. Each of the buttons here quickly creates a new adjustment layer on top of the layer you have selected. What an adjustment layer does is change the way all the layers below it look. You have adjustment layers to change brightness, contrast, levels, hues, colors, and so on. The benefit of using these layers is that you quickly tweak your image without actually changing the information in the layers below. In other words, you can always go back and change or delete the adjustment layer later if you're not happy with the results.

B

Background

The Background layer is the bottom layer of the layer stack. It's partially locked because you can't put anything below it and it can't be directly edited either. It is always at the very bottom of the image and fills up the entire canvas (see **Canvas**). It functions as the foundation on which you build your image – every new layer will be "built" on top of it.

Blur

Blurring is a technique that's mostly used to reduce details and noise in an image or layer. In Photoshop there are typically two ways a blur can be applied: the first, via Filter > Blur (Gaussian Blur being the most notable here); the second via the Blur tool, found in the tool bar under Smudge. While the first applies an equal blur to the entire layer, the latter can be used as a brush in different places. Note that once you apply a blur it's irreversible, so it's a good idea to always keep a backup layer before you start blurring away.

Blur effect

Bounding box

The bounding box is an invisible box that holds the content of a layer. You can easily turn it visible by clicking on the Select tool and checking the Show Transform Controls box. Now your layer will be surrounded by its bounding box. The Transform Controls on the side of the box can be used to quickly rotate and resize the bounding box, simultaneously rotating and resizing what's in it as well (see **Rotate** and **Scale**).

Brush tool

The Brush tool can be used to paint lines, shapes, and textures in any color. It's important to set your brushes up in a way you're comfortable with. Something that can help you tweak the brushes to your liking is Shape Dynamics. Shape Dynamics can help you mimic real-life brushes by altering the brush settings (see image). Putting the control of the Size Jitter to Pen Pressure mimics the effect of a real paintbrush. When you press hard on your stylus a lot of "paint" will appear on the paper and when you press lightly only a little will appear. This option is great when doing line art, but also when filling larger areas and you want your work to have a traditional textured look.

Burn/Dodge tools

The Burn/Dodge tools are basically brushes, but instead of laying down paint they darken or lighten the paint that's already there. This is really helpful when you want to darken or lighten a specific area rather than the entire image. Two important settings to keep in mind here are Range and Exposure. Range let's you pick what it is you want to darken or lighten and Exposure how hard you want to change it. Say for instance that the darkest tones of the shadows in your painting are too bright: select the Burn tool, set its range to Shadows and quickly brush over the shadows you want to boost. It'll quickly darken it up while leaving the mid-toned and highlight parts of it intact.

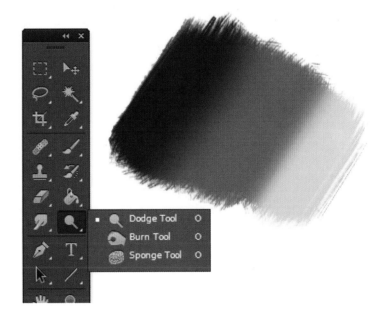

Canvas

The Canvas, much like a traditional painting canvas, is the surface you work on. The Canvas has nothing to do with the resolution of the image (see **Resolution**), but is merely a guide to show you where your painting begins and where it ends. Unlike a real canvas, you can easily increase your canvas size while working via Image > Canvas Size.

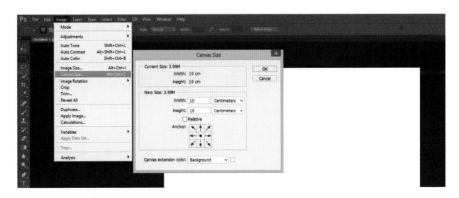

Clone Stamp tool

A great way to duplicate patterns, textures, or brushstrokes is with the Clone Stamp tool. If you hold Alt with the Clone Stamp tool selected you'll notice the cursor changes to a cross. If you now click anywhere on your image that spot will become the starting point for the duplication. Release Alt and now you can "paint" with the part you've just selected. Another useful trick is to change the sample in the top bar to Current Layer, which will keep your clone restricted to what's in that layer. It's a cool trick to duplicate silhouettes and edges.

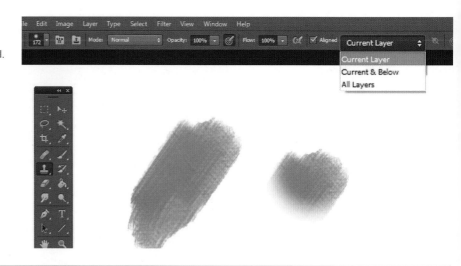

Color adjustment layers

These three adjustment layers are Hue/Saturation, Color Balance, and Selective Color. They are mainly used to change the color of the underlying layers.

Hue/Saturation gives you the option to slide the entire color scale of the layer at once, and also lets you saturate and desaturate it.

Color Balance is a bit different, since instead of changing the entire color scale at once, it lets you hone in on a specific range and change just that range. Say for instance that you feel your shadows are too cold: select Shadows as your tone and move the Yellow–Blue slider towards yellow and the Cyan–Red slider towards red. In no time your shadows will feel a lot warmer.

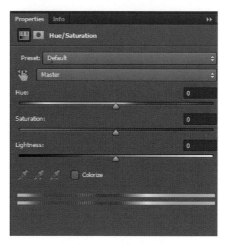

Finally, Selective Color goes even further and lets you pick a specific color and change just that color. Feel your Greens aren't lush enough? Just select Green under colors and tweak it from there.

Color mode

Simply put, the Color mode is the method in which the pixels in your image are organized. Standard printers only have four different inks: cyan, magenta, yellow, and black (CMYK) and they create different colors by combining those four inks. So in Photoshop you can organize your image in a way that a printer knows how much of which ink it needs to recreate a color similar to what you see on your screen.

That's where the Color mode comes in. A good rule of thumb is when your image will be used on screens use RGB and when it will be printed use CMYK.

Contrast

In Photoshop, Contrast stands for the difference between light and dark. Increasing contrast means the dark parts of your image become even darker and light parts even lighter. Lowering the contrast will do the opposite and will result in a neutral, more grayed-out image. You can increase the contrast of a layer via Image > Adjustments > Brightness/Contrast. It's a great way to make your values more readable.

Crop

Cropping an image is a way to resize your canvas (see **Canvas**) by cutting off parts of it. In short you select the part of your image you want to keep and everything outside of that selection will be deleted. So in contrast to Resize Canvas, it also deletes all the information outside the borders of the canvas, clearing up unused parts of layers and as a result decreasing the file size. There's a quick and simple selection tool you can use to crop an image, which can be found in the toolbar or by pressing C.

F

Filter

Filters are mostly used to add specific artistic effects to images, like making a layer look hand-painted, appear in an impressionistic style, or look as though it was drawn with charcoal. Some of these filters can be used as smart filters, leaving the layers to which they are applied intact, but most of them will irreversibly change the layer, so use them with caution and keep a backup.

Flatten

Flatten simply means all your layers are combined and merged into the background layer (see **Background**). Needless to say, it's something you only want to do if you are absolutely sure you don't need your layers anymore.

G

Gaussian Blur

Gaussian Blur (Filter > Blur > Gaussian Blur) is an easy-to-use filter that blurs your selected layer. It's a great tool to virtually create depth of field. Remember, blurring a layer is irreversible so use it carefully; Gaussian Blur is a filter, which means it's a digital calculation and will therefore look digital – if you want a realistic/traditional feel, it's best to create the effect without a filter. It's a useful tool in a production pipeline where things need to go quickly and efficiently.

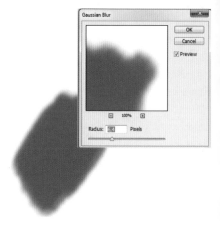

Gradient tool

The Gradient tool, much like the Paint Bucket tool (which will fill an area around the pixel you clicked with your selected color), either fills the entire layer or just the part you've got selected, and creates a gradual blend between two or more colors. The standard gradient consists of the two colors you've selected as foreground and background colors, so you can quickly create new gradients by using the Color

Picker. Alternatively you can also click on the gradient in the options bar on top to

open the Gradient Editor and to manually modify it to blend more or different colors.

Grayscale

Grayscale is a Color mode (see **Color mode**) that turns your entire image to black and white, deleting all color information but making your file size much smaller. What's

important to know about Grayscale is that the Histogram is based on it, and it's a scale that consists of 256 different values, ranging from black (being value 0) and white (being

value 256). Every type of gray can be found between those two values. The same scale is used by other Color modes too, but there each value also has a color applied to it.

H

Highlights/shadows

Each image can be turned to black and white and seen as a combination of different values (see **Grayscale**). It is in these values that we find the highlights and shadows. Everything that's dark can be considered shadow, and everything light a highlight (in between are midtones). In Photoshop these terms are used to let you know where the effects are applied – if you use Color Balance, you can change the tone to shadows and only apply the effect to the darker parts of the image.

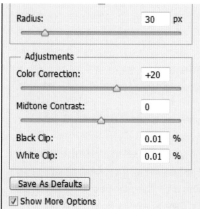

Histogram

The Histogram gives you an overview of the values in your image. You can find it under Window > Histogram. It's an especially useful tool to keep your values in check. From left to right it shows how your values are divided. On the left are the dark values, on the right are the light. In the extended view you can also see the values for each separate color channel. When using the Histogram there are a few things to consider. Is the flow of the graph more or less fluent? If there are big spikes, there's probably a value that's too prominent and should be broken up into a few more subtle values. Another thing to keep in mind is that your values should stay away from the absolute left and absolute right – those values are pure black and pure white and they have the tendency to create flat and dull looking images.

Keyboard Shortcuts (Actions)

Keyboard Shortcuts work in the same way as Actions (see pages 18–19 in the first chapter of this book). Using Keyboard Shortcuts efficiently can save you a lot of time. When you get comfortable with a working method you'll notice that you often repeat the same steps over and over and in that case it pays to have a shortcut for it. Click on Edit > Keyboard Shortcuts and here you can change the way you access most of the tools found in Photoshop.

Lasso tool

Getting sharp edges becomes easy when you use the Lasso tool. Simply select part of your image using the tool, create a new layer, fill it with a color and click on Lock Transparent Pixels (see **Layers palette**) and you'll have a sharp silhouette, which you can fill with whatever you want. There are two important Lassos: the basic Lasso, and the Polygonal Lasso, which does the same but with straight lines. You can quickly alternate between the two by pressing Alt. It takes a bit of practice, but it absolutely pays off!

Layers palette

The Layers palette is your friend! It's one of the most important features Photoshop has to offer so try to make good use of it. The basics are simple: think of layers as stacks of paper, if you cut a hole in the top paper the paper below becomes visible. The Layers palette is a visual representation of that stack of paper. One of the most important buttons here is the Lock Transparent Pixels button at the top. You can quickly toggle it to lock everything in the layer you haven't painted on and if you paint on the layer now it will only change the parts that have pixels in them. Other useful buttons are at the bottom. Drag and drop layers on them to respectively create a folder, duplicate, or delete them.

Liquify

The Liquify filter allows you to push, pull, and deform your selected areas as if they were wet paint. You can find this option in Filter > Liquify where a separate preview window will appear, so you can view the effects before you make them permanent.

O

Occlusion shadow

The darkest parts of the shadow are usually at points of contact, where secondary sources can't reach. These are called occlusion shadows. Occlusion occurs where the main shadow meets the cast shadow and it is usually very dark.

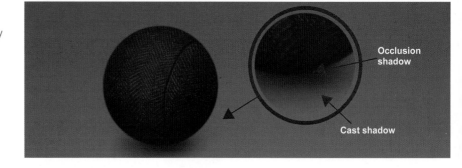

Opacity

Each layer (see **Layers palette**) in your layer stack can differ in opacity. Basically, opacity (which is expressed in %) tells you how opaque your layer is. A layer with 100% opacity is a solid layer you can't see through, so every pixel in that layer will completely hide the pixels below it. Turn it to 50% and that pixel will show 50% of itself as well as 50% of what's below.

P

Patterns

When you double-click on a layer in the Layers palette, the Layer Style window will open. In it you'll find the Pattern Overlay option, which is used to fill the entire layer with a pattern. You can use these patterns to give your image a texture by changing the Blend Mode of the pattern to Overlay, Soft Light, or Multiply.

Creating your own patterns is also easy. Simply open up an image from which you'd like to create a pattern and click on Edit > Define Pattern. You'll now find your new pattern in the Layer Style window. Tile-able images work best for this since they'll seamlessly flow over into each other. On sites such as **http:// freetextures.3dtotal. com** and **www.cgtextures.com** you can download tons of tile-able patterns for free.

R

Resize

Resizing your image means you either decrease or increase it in size. Which of the two you do is important though, because in the case of the first you'll ask Photoshop to use the pixels you have to make the image smaller, which is usually not a problem, but in the case of the latter you'll ask it to space out the pixels you have and "invent" the open spots that'll turn up between them. Increasing the image size is usually not a good idea, because you'll end up with a blurry image as the pixels become more spread out. It's always better to start out big and resize your image later, than to do the reverse.

Resolution

For a lot of people the resolution is a complicated concept because they often confuse it with the resolution of their screen. But think about it like this: an image of 10 × 10 pixels in Photoshop (that's not zoomed in or out) will exactly use 10 × 10 pixels of your screen, regardless of how high the resolution of the file is. Why are there different options there then? Other hardware, such as a printer, does not know what pixels are. So in your file you can include information as to how it should deal with those pixels. "ppi" stands for pixels per inch, and simply tells your printer how many pixels it should print on 1 inch of paper. The rule of thumb here is that images for print should have a resolution of 300 ppi. Images for web have enough with 72 ppi.

Rotate

Rotate is used to literally rotate the layer you've got selected. By turning on the Transform Controls (see **Bounding box**) and hovering your cursor over the corner of a layer, you will see that it changes into a bent arrow. With it you can turn a layer 360 degrees around to whatever position you want. This is useful when you've got different objects on different layers and you feel some of the objects lack dynamism or don't feel like they fit right in the composition.

S

Scale

Scale is another word to describe the size a layer has in your image. In other words, how big it is compared to the other layers. You can quickly change the scale of a layer by turning on the Transform Controls (see **Bounding box**) and dragging the control points that pop up. Quick tip: holding Shift while dragging on the corners keeps the proportions of the layer intact.

Selection

A selection in Photoshop is immediately recognizable by the "marching ants" surrounding it (moving dashed lines). It's an important feature in Photoshop because what you've got selected is the only part of the image or layer that will be affected when you work in it. Selections can be tweaked and modified by right clicking in them and clicking Refine Edge. By doing this you can see exactly what you've got selected and change how soft or smooth the edges of that selection are.

Sharpen

Sharpen is a filter that locates the edges in your image and then increases the contrast (see **Contrast**) around them, making them appear more defined and crisp. The most regularly used Sharpen is the Unsharp Mask, which you can find under Filter > Sharpen > Unsharp Mask, but you can also use the Sharpen tool the same way you'd use the Blur tool (see **Blur**). You might be tempted to think of it as a way to reverse blurring, but nothing is more wrong. Blurring is a way to reduce details and noise, but Sharpen can never reinvent all that lost detail; instead it will result in an image that's blurred, but with very high contrast.

Smudge tool

The Smudge tool does exactly what the little icon shows; it pushes your paint around. It's like putting your finger in wet paint and smearing it around. It might sound a bit messy, but it's a useful tool for several reasons. First and most important, it helps you to be able to generate different types of edges – instead of having only straight, sharp edges, some of your edges could be blurry and blend with the background. Second, when you are painting materials that have a smooth surface, it helps you to blur the surface without losing that painterly feeling which you may be looking to achieve.

Swatches

It's a good idea to keep a collection of swatches. Sites like **http://color.adobe.com** can help you find and save the perfect colors for your work (there's also a separate palette for that site built directly into Photoshop under Window > Extensions > Kuler). If you have a color selected, simply open up the Color Picker (by clicking on the color in the Tools palette) and click on Add to Swatches. You'll now find your new color in your Swatches palette. Look for color palettes consisting of five colors that fit well together and then add a black Swatch to separate it from the next five. You'll then have quick and easy access to a few super solid color combinations.

V

Value adjustment layers

The first three adjustment layer options are your go-to layers to change the values of your image. Brightness/Contrast is by far the simplest, and provides you with just two sliders that you can use to adjust the tonal range of the image. The Levels panel shows a histogram for the image. On the left you see the dark values and on the right the light values. With the sliders you can easily change a specific part of the values without touching the values you're happy with. The Curves panel is the most complicated, but it does the same as Levels (it's more expansive if you want to micromanage your values). It shows you the same histogram, but instead of using sliders it uses a curve to alter the values.

Vignettes

Vignettes have been used in the photography and film industry for decades. It's a technique in which the periphery of an image is darkened, which helps to guide the focus to the middle of the image, towards what is important. In Photoshop a quick way to do this is to create a new layer on top of the layer stack, fill it with white, then set its blend mode to Multiply and go to Filter > Lens Correction. Then just click on Custom where you can change the Vignette slider; moving it to -100 works well.

Warp tool

Sometimes a shape just doesn't feel 100% right and needs to be altered a little to fit. In that case the Warp tool is the way to go. You can find it under Edit > Transform > Warp. What the Warp tool does is cover your layer with a grid that has 16 anchor points in it. You can drag and move each of those points to transform the layer exactly how you want it. Alternatively, in the same menu you can also find Distort and Perspective, two other great ways to manipulate your layers.

Z

Zoom

The Zoom function is another great Photoshop feature. Instead of having to move back from and forward to your canvas (like traditional painters used to do), you can have Photoshop do it for you. There are a few ways to zoom in or out in Photoshop, but the most commonly used is the wheel of a Wacom tablet, or by pressing Ctrl and + to zoom in, or Ctrl and - to zoom out.

Meet the artists

Ahmed Aldoori
Concept artist
www.medsketch.blogspot.com

Alex Negrea
Freelance illustrator
www.alexnegrea.blogspot.com

Charlie Bowater
Illustrator and Atomhawk concept artist
www.charliebowater.co.uk

YongSub Noh
Freelance concept artist
www.artstation.com/artist/YONG

Carlos Cabrera
Freelance concept artist
www.artbycarloscabrera.com

Pyeongjun Park
Freelance illustrator
www.totorrl.deviantart.com

Romana Kendelic
Illustrator
www.alisaryn.deviantart.com

Andrei Pervukhin
Freelance concept artist and illustrator
www.pervandr.deviantart.com

Devon Cady-Lee
Concept artist and illustrator
www.facebook.com/DevonCadyLee

Bram "Boco" Sels
Freelance illustrator
www.artofboco.com

Tim Löchner
Freelance illustrator and concept artist
www.timloechner.com

Derek Stenning
Concept artist and illustrator
www.borninconcrete.com

Markus Lovadina
Senior concept artist
www.artofmalo.carbonmade.com

Chase Toole
Illustrator and concept designer
www.chasetoole.com

Gerhard Mozsi
Concept artist and matte painter
www.mozsi.com

Benita Winckler
Freelance concept artist and illustrator
www.benitawinckler.com

Index

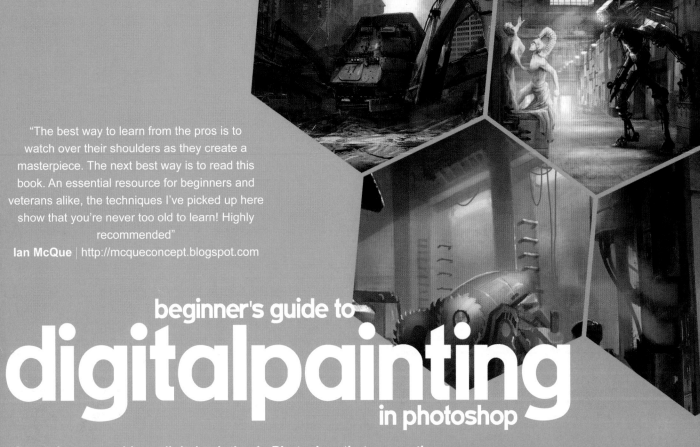